HOW DO WE KNOW THE SKY ISN'T REALLY GREEN AND WE'RE JUST COLORBLIND?

PUBLISHED BY
Hatje Cantz Publishers
Senefelderstraße 12
D-73760 Ostfildern-Ruit
Tel. 00 49 / 7 11 / 4 40 50
Fax 00 49 / 7 11 / 4 40 52 20
Internet: www.hatjecantz.de

DISTRIBUTION IN THE US
D.A.P., Distributed Art
Publishers, Inc.
155 Avenue of the Americas,
Second Floor
USA-New York,
N.Y. 10013-1507
Tel. 0 01/2 12/6 27 19 99
Fax 0 01/2 12/6 27 94 84

ISBN 3-7757-0993-2

PRINTED BY
Dr. Cantz'sche Druckerei,
Germany

© 2000 Joan Grimonprez and
Hatje Cantz Publishers

Printed in Germany

PRODUCTION
zap-o-matik
<history@online.be>

EDITOR
Johan Grimonprez

EDITORS AT LARGE
Onome Ekeh
Daragh Reeves

ART DIRECTOR
Alexander Kellas
for Pandiscio Co, NY
Represented by Walter
Schupfer Management

DESIGNERS
Timothée Letouzé
Boris Valentinisch

ILLUSTRATORS
Peter Stemmler
Ritsko Uchida

PHOTOGRAPHY
Rony Vissers

WITH THE GENEROUS SUPPORT OF

Musée d'Art Moderne de la Ville de Paris, Paris
Stedelijk Museum voor Aktuele Kunst, Gent
Anthony d'Offay Gallery, London
Deitch Projects, New York
Erna-Hecey Gallery, Luxemburg
Deste Foundation, Athens
Frankfurter Kunstverein, Frankfurt
Centro Galego de Arte Contemporanea, Santiago de
Compostella
Nicolai Wallner Galleri, Copenhagen
Europalia, Brussels
Deutscher Akademischer Austauschdienst, Berlin

SPECIAL THANKS:

Herman Asselberghs
Nathalie Bookchin
Christina Chow
Ricardo Dominguez
Jeffrey Deitch
Anthony d'Offay
Don DeLillo
etoy
Hans de Wolf
Cendrine du Welz
Onome Ekeh
Clarence Fon-sing
Geraldine Grimonprez
Susanna Greeves
Katerina Gregos
Noel Godin
agent.GRAMAZIO
Sören Grammel
Markus Hartmann
Erna Hecey
Jan Hoet
Ida Kierulf

Isabelle Kolegnako
Luk Lambrecht
Paul Lichty
Diane Ludin
Hans Martens
Friedrich Meschede
Suzy Meszoly
Hans Meijers
Hans Ulrich Obrist
Manuel Olveira
Richard Pandiscio
Bruno Ricard
Mark Sanders
Angeline Scherf
Dirk Schutyser
Lina Theodorou
Barbara Vanderlinden
Jan Vromman
Nicolai Wallner
Tom Wallman
Chris Ziegler

Inflight

TEXT CREDITS:

Excerpts from *White Noise* (© Don DeLillo, 1984-1985) and *Mao II* (© Don DeLillo, 1991) are used by permission of the author and the Wallace Literary Agency Inc. / Chechen gangster quote from: *Governing the last Continent?* by Takakazu Akahane in: *Subetage*, Sabotage Communications 1999 / *'Fore!'* by William S.Burroughs; originally published *Cities of Red Night* is reprinted with the kind permission of Henry Holt Publishers, 1981 / Parts of NOMAN'S LAND were compiled by Herman Asselberghs and Johan Grimonprez appeared initially under the title *NERGENSLAND* in *Dietsche Warande & Belfort*, Leuven, October 1997 / Khaled, Leila:, *My People Shall Live: Autobiography of a Revolutionary*; London, Hodder & Stoughton,1973 /*Weapons Gave me Words* originally published in *Der Spiegel* under the title: *Die Waffe gab mir Würde. Die ehemalige Luftpiratin Leila Chalid über Palästina, den Frieden und den Tod*, Spiegel –Gespräch; *Der Spiegel* #11/1996, Redakteur: Jürgen Hogrefe, S.; pp.158-162; reprinted with the kind permission of *The New York Times* Syndicate, Translated by Kimi Lum / "First Recorded Hijack", excerpts from *The Story Of Air Piracy*, 1973, by David Phillips are reprinted with the kind permission of Harrap publishers / "These Ears of Crime," excerpt from: *D.B. Cooper, The Real McCoy*, by Bernie Rhodes; reprinted with the kind permission of University of Utah Press / "Men in Swimming Trunks," excerpted from *Odyssey of Terror*, Blair, Ed (with Captain William R. Haas) Broadman Press,1977 / "I Have a Feeling We're Not in Havana Anymore", excerpt from *Terror In the Skies*, by Thomas M. Ashwood, 1987, reprinted with the kind permission of Stein & Day publishers / 'Samurai Hajakku', excerpt and other quotes from the *Sky Pirates*,1972, by James A. Arey are reprinted with the kind permission of Simon and Schuster / Quotes are made from *Prisoner of Love*,1992,Jean Genet, with the kind permission of Pan Books./ 'I Think This Guy is Asking For a Credit Card!', is taken from *Triumph Over Terror on Flight 847*,1987,by Captain John Testrake (With David J. Wimbish) and is reprinted with the kind permission of Fleming H. Revell Company a division of Baker Book House Company / 'Your Words Have Reached My Ears', quote taken from *Hijack, 144 Lives in the Balance*,1975 by Bunsei Sato, of Gateway Publishers. / 'Do Your Famous Disappearing Act', excerpt from *Flying Scared. Why We are Being Skyjacked and How to Put a Stop to it* by Elizabeth Rich, 1972, Stein and Day Publishers / 'Gravity as a Psychiatric Construct, First Step Towards A Theory',and 'Lovers Pack Suits and Set Off to 'Catch' Plan', are excerpts from *The Skyjacker, His Flights Of Fantasy*, 1971, by David G. Hubbard, The Macmillan Company. / 'Delta Is Ready When You Are', excerpt from *Crusaders, Criminals and Crazies*, by Frederick J. Hacker, 1976, WWNorton. / *Supermarket History*; Johan Grimonprez Interviewed by Catherine Bernard; republished with the kind permission of Parkett #53,1998 / 'Set Your Vacation For 747,' excerpt from *The Wonderful Wizard of Oz*,1960 by , Frank L. Baum is reprinted wth the kind permission of Dover Publications / Excerpts from *Television And The Remote Control Grazing on a Vast Wasteland*, 1996 by Robert V. Bellamy and James R. Walker, The Guilford Press / Extract from *The Satanic Verses*, 1988,by Salman Rusdie, Viking Press. / 'Jet Hits Town ',excerpt from *Their Darkest Day. The Tragedy of Pan Am 103 and its Legacy of Hope*, 1992, by Mathew Cox & Tom Foster, Grove/Atlantic Inc. / 'No Place Like Home', excerpts from *Aliens in America. Conspiracy Cultures from Outerspace to Cyberspace*, 1998, by Jodi Dean, Cornell University Press 1998 / "Phaser Envy", extract from *The Official Alien Abductee's Handbook*, 1997, by Joe Tripician, Andrews and McMeel / 'Gary Stollman Hack Reporter', extract from '*Secret & Suppressed, Banned Ideas & Hidden History*: 'My Father Is A Clone', by Gary Stollman and its introduction by the book's editor Jim Keith ',1993; reprinted with kind permission of Feral House / 'Beep' Theory', extract from *Stalking the UFO Meme Internet Underground*, 1996, by Richard Thieme, St. Martin's Press / *Wired For Warfare: Rebels and Dissenters are Using the Power of the Net to Harass and Attack their More Powerful Foes*, Time Vol.154, No.15, October 1999, by Tim McGirk, is included with the kind permission of Tim McGirk and Time/life Syndication / *Paper Airplanes*, by Duane Ediger, *Mexican daily La Jornada*, January 3, 2000, printed with the kind permission of author, Ricardo Dominguez & The Electronic Disturbance Theater / *Hacker Site*, by Chris Ziegler, is part of a bigger article: *Hacktivism. The New Digital Resistance*, originally published in *Punk Planet*, Lumberjack Distribution Inc., Issue 33, September/October 1999; pp.66-73 / *How The Etoy Campaign Was Won*, 2000, by Reinhold Grether, translated by David Hudson, originally published in*Telepolis* February 9, 2000, used with kind permission / *Cream and Punishment : The Revolution Of Everyday Pies*, by Mark Sanders, originally published in *Dazed & Confused*, issue #42, May 1998; used with kind permission / Endquote from *The Media And Disasters. PAN AM 103*, by Deppa, Joan (with Maria Russell, Dona Hayes and Elizabeth Lynne Flocke) is included with the kind permission of New York University Press 1994

IMAGE CREDITS

Pictures on pages 1, 2, 4, 6, 10, 11, 13, 14, 19, 20, 24, 26, 28, 32, 36, 39, 40, 42, 44, 46, 47, 48, 49, 58, 59, 61, 62, 63, 64, 66, 69, 81, 82, 86, 88, 112 and cover: *Dial H-I-S-T-O-R-Y*, Johan Grimonprez, 1997; Photography Rony Vissers. Pictures on pages 10, 11, 13, 14, 19, 20, 24, 26, 28, 32, 36, 39, 40, 42, 44, 46, 49, 58, 59, 112 and cover: courtesy ABC News Videosource, New York.

Then there was the
finger I had received in the mail.
I kept it around a while, a ring
finger I guessed, gone mummy-brown,
and I used to look at it and
wonder what it meant.
But that was long ago and I'd
lost the feeling I might walk out of
the post office and see he'd turned
come diagonally toward me
showing the world that he's
been preparing for years...

FORE!

By William S. Burroughs

THE LIBERAL PRINCIPLES EMBODIED IN THE FRENCH AND AMERICAN REVOLUTIONS
AND LATER IN THE LIBERAL REVOLUTIONS OF 1848 HAD ALREADY BEEN CODIFIED AND
PUT INTO PRACTICE BY PIRATE COMMUNES A HUNDRED YEARS EARLIER.

Here is a quote from *Under the Black Flag* by Don C. Seitz:

"Captain Mission was one of the forbears of the French Revolution. He was one hundred years in advance of his time, for his career was based upon an initial desire to better adjust the affairs of mankind, which ended as is quite usual in the more liberal adjustment of his own fortunes.

It is related how Captain Mission, having led his ship to victory against an English man-of-war, called a meeting of the crew. Those who wished to follow him he would welcome and treat as brothers; those who did not would be safely set ashore. One and all embraced the New Freedom. Some were hoisting the Black Flag at once Mission demurred, saying that they were not pirates but liberty lovers, fighting equal rights against all nations subject to the tyranny of government, and bespoke a white flag as a more fitting emblem.

The ship's money was put in a chest to be used as a common property. Clothes were now distributed to all in need and the republic of the sea was in full operation. Mission bespoke

them to live in strict harmony among themselves; that a misplaced society would adjudge them still as pirates. Self-preservation, therefore, and not a cruel disposition, compelled them to declare war on all nations who should close their ports to them. "I declare such war and at the same time recommend to you a humane and generous behavior towards your prisoners, which will appear by so much more the effects of a noble soul as we are satisfied we should not meet the same treatment should our ill fortune or want of courage give us up to their mercy...

The Nieustadt of Amsterdam was made prize, giving up two thousand pounds and gold dust and seventeen slaves. The slaves were added to the crew and clothed in the Dutchman's spare garments; Mission made an address denouncing slavery, holding that men who sold others like beasts proved their religion to be no more than a grimace as no man had power of liberty over another..."

Mission explored the Madagascar coast and found a bay ten leagues north of Diego-Suarez. It was resolved to establish here the shore quarters of the Republic, erect a town, build docks, and have a place they might call their own. The colony was called Libertatia and was placed under Articles drawn up by Captain Mission.
The Articles state, among others things: all decisions with regard to the colony to be submitted to vote by the colonists; the abolition of the death penalty; and freedom to follow any religious beliefs or practices without sanction or molestation.

Captain Mission's colony, which numbered about three hundred, was wiped out by a surprise attack from the natives, and Captain Mission was killed shortly afterwards in a sea battle. There were other such colonies in the West Indies and in Central and South America, but they were not able to maintain

themselves since they were not sufficiently populous to withstand attack. Had they been able to do so, the history of the world could have been altered. Imagine a number of such fortified positions all through South America and the West Indies, stretching from Africa to Madagascar and Malaya and the East Indies, all offering refuge to fugitives from slavery and oppression: "Come to us and live under the Articles."

Imagine such a movement on a worldwide scale. Faced by the actual practice of freedom, the French and American revolutions would be forced to stand by their words. I cite this example of retroactive utopia since it actually could have happened in terms of the techniques and human resources available at the time.
Had Captain Mission lived long enough to set an example for others to follow, mankind might have stepped free from the deadly

impasse of insoluble problems in which we now find ourselves.

The chance was there. The chance was missed. The principles of the French and American revolutions became windy lies in the mouths of politicians. The liberal revolutions of 1848 created the so-called republics of Central and South America, with a dreary history of dictatorship, oppression, graft, and bureaucracy, thus closing this vast, under populated continent to any possibility of communes along the lines set forth by Captain Mission. Your right to live where you want, with companions of your choosing, under laws to which you agree, died in the eighteenth century with Captain Mission. Only a miracle or a disaster could restore it.

Excerpt from: *Cities of the Red Night*
New York, Holt, Rhinehart & Winston 1981

*Quoted in *Governing the Last Continent?* by Takakazu Akahane. In: *Subetage*, Sabotage Communications 1999, Vienna

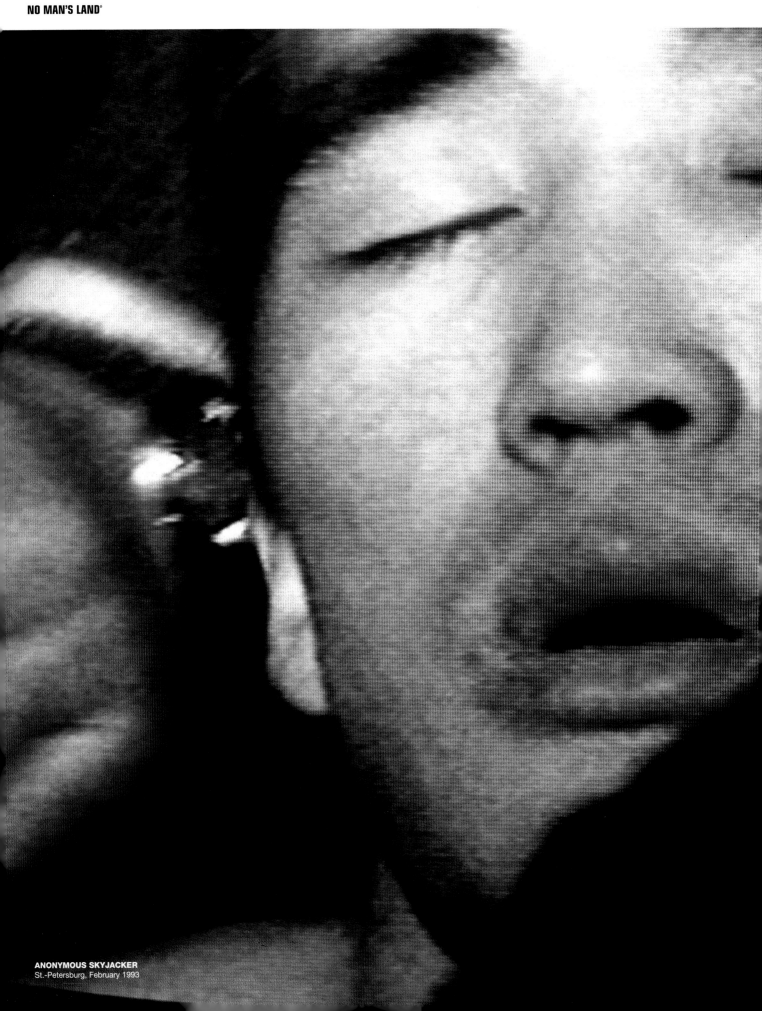

ANONYMOUS SKYJACKER
St.-Petersburg, February 1993

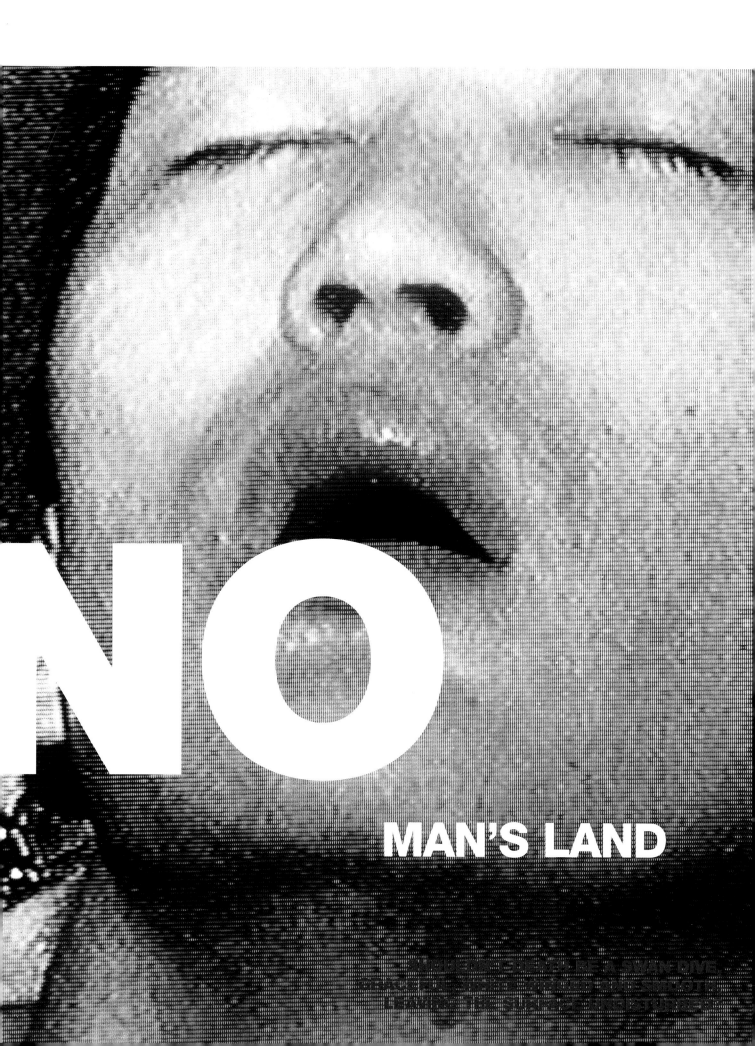

NO
MAN'S LAND

WHAT DO YOU DO WITH A BOEING
ONCE YOU'VE STOLEN IT?

August 29, 1969: A stylishly clad Leila Khaled in white bell-bottoms and matching wide-brimmed hat, boards American airliner TWA B-707 on its way from Rome to Tel Aviv. Once airborne her other accessories appear: a pistol and a hand grenade. As she makes her way toward the cockpit, her companion, Salim Issawi, announces that the Popular Front for the Liberation of Palestine is now in command of the very first American airliner to be hijacked in the Middle East. Captain Carter, looking down the barrel of a pistol, is obliged to agree.

MY PEOPLE SHALL LIVE**
LEILA KHALED'S SKYJACK JOURNAL

1. SEVEN MINUTE DETOUR

I had trained for every conceivable contingency; I had mastered most operational details of the great Boeing 707. There was something, however, I did not train for: the human situation. How to deal with idle or curious conversation alists. How not to arouse their suspicions or be rude to a seatmate. I had to improvise and felt very uncomfortable. I imagined that all the Westerners aboard knew about my mission. My seatmate from Beirut to Rome was a clean-cut sociable American on his way to New York. I knew that Americans, like most other tourists, like to make casual conversation about everything under the sun. I didn't realize that they posed personal questions so directly and so nonchalantly. Mr. Holden must have been bored, and he wanted to talk. "Where are you going?" he asked to open the conversation. "I am going to Rome," I said. "Why are you going to Rome?" he continued.
I paused momentarily to fabricate an answer, and said with simulated shyness, "I am going to meet my fiancé who is coming from London to meet me in a few days." I suddenly realized I had made a slip. What if he too were going to Rome, and asked me to dinner or something while I was waiting for my "fiancé". I swiftly corrected my mistake by adding, "It is quite possible that he might surprise me and be waiting for me at the airport." Then I asked him, "Where are you going?" "To New York," he said, much to my relief. He was determined not to let the conversation lapse. "How on earth would an Arab girl be going to Rome to meet her fiancé alone and get married?" he asked. I answered in a superficially self-assured tone, "I've know him since we were children, and we've been engaged for several years; besides we are modern, not traditional Arabs." "That's good," he said, and started telling me how he and his wife had eloped because her parents had disapproved of him. As I assured him that I was not eloping, the stewardess cheerfully announced that there was

a newly married couple on the plane and they had a huge cake they would like us to share. "Who would like to have some cake?" she said. Everybody, including Mr. Holden and I, chanted in a chorus of "I would."

I spent two days at the hotel fending off invitations for personally guided tours of Rome. During these two days, I walked the streets of Rome alone. It is strange, but I had no desire to purchase anything, see Rome's ancient glory, or even go to a film. I only walked and walked, contemplating my mission and reciting its details to myself.
Early on the morning of August 29, I checked out of the hotel and caught a bus to Fiumicino Airport on the outskirts of Rome. Happily, the only snag was a half-hour flight delay.
My associate, whom I recognized only from a

A GREAT YET ALMOST SILENT ROAR OF LAUGHTER FROM A WHOLE NATION HOLDING ITS SIDES, YET FULL OF REVERENCE WHEN LEILA KHALED, GRENADE AT THE READY, ORDERED A TWA PLANE

JEAN GENET, *PRISONER OF LOVE*

photograph, appeared on schedule and we exchanged pre-arranged signals. His name was Salim Issawi; he was a Palestinian from Haifa who had been raised in Syria. Salim sat quietly nearby and we tried to ignore each other.
All was going smoothly when suddenly the human element threatened our careful planning. A few seats away there was a little girl with a button on her dress cheerfully proclaiming "Make Friends". That message brought me up short, forced me to remind myself, as I watched her playing with her little sister, that this child had committed no crime against me or my people. It would be cruel to imperil her life by hijacking a plane, the symbolic meaning of which she had no conception – a plane that

could explode during our attempted seizure or be blown up by Israeli anti-aircraft fire when we entered the "Israeli airspace".
While these qualms pricked my conscience, the whole history of Palestine and her children came before my eyes. I saw everything from the first day of my exile. I saw my people homeless, hungry, barefoot. The twice "refugee" children of Bagan camp near Amman seemed to stand, a humiliated multitude, in front of me saying, "We too are children and we are a part of the human race." The scene strengthened me enormously. I said to myself, "What crime did I and my people perpetrate against anyone to deserve the fate we have suffered?" The answer was "None". The operation must be carried out. There can be no doubt or retreat. My children have spoken.*
On the bus across the field to the Boeing 707, another unscheduled problem developed.
A handsome man in his early thirties came up to me and said "Hello" in a most jovial, enthusiastic manner. "Hello," I replied nonchalantly, as I calmly tried to read My Friend Che by Ricardo Rojo. He seemed very eager to talk and asked me who I was and where I was going. I couldn't very well repeat the marriage tale and couldn't invent anything quickly enough. I said, "Guess." He tried, "Greek, Spanish, Italian?" I asked him where he was from. "I am from Chicago," he answered, and continued his questioning.
"You wouldn't be South American, would you?" Now that I knew where he was from, I figured it was safe to say that I was a South American. I thought it might end his questioning, at least. "From Brazil?" he asked, looking admiringly at me, and ogling my whole body. "You're getting closer," I said.
"Bolivia?" "Yes," I replied, "but how did you know?" "It's your book that gave you away," he declared. I asked him what he thought of Che. "Good man," he said. "Where are you going?" I countered, trying to change to a less controversial topic. "To Athens, to see my mother.

▷

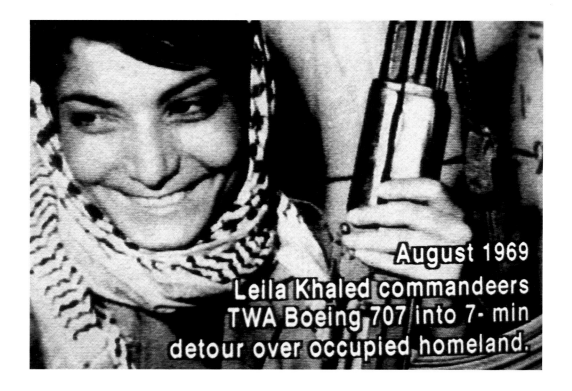

August 1969
Leila Khaled commandeers
TWA Boeing 707 into 7- min
detour over occupied homeland.

My eldest son Badr came home from kindergarten and puzzled me with the question if I was a thief.
His teacher had told him that I had hijacked an airplane, and now he was wondering where I was hiding it.

WEAPONS GAVE ME WORDS

Der Spiegel: Ms. Khaled, do your sons Badr and Baschschar know that their mother is famous?
Khaled: They were bound to find out somehow. One day my eldest son, Badr, came home from kindergarten and asked me if I was a thief. His teacher had told him I had hijacked an airplane, and now he was wondering where I was hiding it.

Der Spiegel: Do you condone the terrorism practiced by Hamas?
Khaled: Acts of this kind are not committed for no reason. Our territory is still occupied despite the Oslo accord. Even the Charter of the United Nations ensures a person's right to resistance in such a case. Our people must continue the fight against the occupation force.

Der Spiegel: But after so many years of war and terror, wasn't it a great step forward when the Israelis and the Palestinians began talks?
Khaled: In the Gaza Strip and the West Bank our people live in ghettos. The Israelis can block off our cities and throw us in prison whenever they feel like it – they have done it before and now they are doing it again. They can do anything they want to us. Is that what you call peace?

Der Spiegel: And that makes it justifiable for Hamas to send suicide bombers to attack civilians?
Khaled: I believe it is legitimate to fight against the occupation force.

Der Spiegel: In August 1969 you shocked the world when you hijacked a plane from Rome to Damascus and then blew it to bits right there on the runway. Are you still able to justify this kind of terrorism?
Khaled: What I did then served to help my people. After the hijackings the whole world began asking: Who are these people? Why are they doing this? We showed that the Palestinians weren't just an impoverished nation looking for humanitarian handouts of flour and sugar. After the hijackings it was unmistakably clear to the world that my people had a reason to fight.

Der Spiegel: Later you flew as a normal passenger on numerous occasions. How would you have reacted if a freedom fighter, for example from East Timor, hijacked your plane?
Khaled: (laughs) I would have remained perfectly calm. I know perhaps better than anyone that there's nothing you can do when you have an armed terrorist standing in front of you.

Der Spiegel: In 1972 the retired Israeli General Ezer Weizman warned that you would never feel safe in Lebanon or anywhere else in the world. Did Mossad try to seize or kill you?
Khaled: Yes, in 1970 the Israelis fired six missiles at the house I was staying in Beirut. And once in 1971 I came home to find a bomb under my bed. I don't know why I happened to look under my bed that night, but lying there was a bundle of TNT. I assume it was the Mossad.

Der Spiegel: Your beauty also made a great impression on the world. Rumor has it that you underwent plastic surgery to change your facial features.
Khaled: Yes, that's right. After the first hijacking everyone knew my face. In order to capture the El Al airplane, I had to alter my appearance.
Der Spiegel: Where did the plastic surgeon make changes?
Khaled: On my nose and chin.
Der Spiegel: You sacrificed your beauty for the revolution?
Khaled: (laughs) Upon closer inspection you'll find that meanwhile everything is pretty much the way it was before.

Excerpts from an interview in *Der Spiegel: Die Waffe gab mir Würde.*
Former Hijacker Leila Khaled on Palestine, Peace, and Death.
Der Spiegel 11/1996, pp. 158-162, editor: Jürgen Hogrefe.
Translated by Kimi Lum.

August 1970
Amman, Jordan

New found celebrity Leila Khaled prepares for next hijack with facelift.

▷
I haven't seen her in fifteen years. I bet she's there already, waiting for me at the airport." I was astounded, and almost told him, "You bloody fool, you'd better get off this plane, because it isn't going to Athens." I tried to ignore him and closed my ears to keep his voice from penetrating my inner conscience. I plunged into a nervous reading of My Friend Che.

The plane was airborne for only twenty minutes before the hostesses were graciously trying to serve their five first-class passengers. Neither Salim nor I was anxious to eat. The stewardesses were very solicitous. They offered us drinks and peanuts. Anything we wanted. I settled for a coffee, Salim for a beer. But they made us nervous, as they kept returning and asking us if we wanted anything else. I pretended that I had stomachache and asked for a blanket. I innocently placed it over my lap, so I could take my hand grenade out of my purse and put my pistol right in the top of my trousers without being noticed. Salim asked for an aspirin tablet. I was afraid the stewardess might suspect something had she realized that two passengers opposite each other on the first row were sick. In any case, I dreaded the prospect of having a companion with a headache, so was relieved when he merely pocketed the aspirin. Seconds after the only other male passenger in the first class section returned from the small lounge, I gestured to Salim to proceed to the cockpit. Just at that moment, another hostess carrying the crew's lunch trays was opening the door of the cockpit. Salim seized the opportunity and leapt in ahead of her.

She screamed, "Oh, no!" and her trays flew in the air, causing much noise but no injury. I was behind Salim and ordered the stewardess to get out of the way. She did, quivering and watching us over her shoulder. Salim was so huge that he blocked my view, and I couldn't see the reaction of the crew. I could however, hear him say that the plane had been taken over by the Che Guevara Commando Unit of PFLP, and announce that the new captain was Shadiah Abu Ghazalah.
In the middle of his speech, my pistol slipped down the leg of my trousers and, as I bent down to pick it up, I saw the bewildered looks on the crew's faces. I suppose all they could see was part of my wide-brimmed chic hat. I felt ridiculous for a moment, laughed at my ineptness, put the pistol away, and entered the cockpit solemnly brandishing my hand grenade and declaring I was the new captain. The crew was completely shocked to see me there, but they showed no fear. To demonstrate my credibility, I immediately offered my predecessor, Captain Carter, the safety pin from my grenade as a souvenir. He respectfully declined it.

I observed that the plane had swerved off the course I charted for it. I ordered the captain not to play games if he wanted to reach our destination safely and put him on course again. Then Salim reminded me that fifteen minutes had elapsed since the passengers were asked to hold their hands behind their heads. I quickly advised them to relax and to drink champagne if they so desired, and offered an apology for inconveniencing them.

The pilot asked, "What shall I do now?" I said, "Let's take a seven-minute tour of the fatherland." My father's image appeared before my eyes, and I could hear his voice saying, "When will we return home?" My whole world came together. I was silent. I looked out at the greenery and mountains of Palestine. I could see Tel Aviv below. I wept out of affection and longing, and said softly, "Father, we shall return. We shall redeem your honor and restore your dignity. We shall become the sovereign of the land some day." Suddenly, I remembered that the mission preceded personal emotions. I instructed the pilot, "Go to Lebanon, where my people live as refugees." The Israeli planes continued to pursue us. At the Lebanese border, they zoomed anyway. I called Cyprus and sent greetings to its heroic anti-imperialist fighters, and sent messages to my people in South Lebanon. The pilot interrupted. "We must ask for clearance from Beirut." "We don't need to ask for clearance," I said. "This is an Arab country." We circled Beirut briefly before I ordered the pilot to go on to Damascus. He objected, "The airport there couldn't accommodate the Boeing 707." "Look, do you think we're so backward that we couldn't handle your damned plane?" I said strongly. He didn't respond. I took the microphone and addressed the passengers for the last time: "Evacuate immediately on landing; have a happy holiday in Syria."

SEPTEMBER 6 1970:

AFTER A CELEBRITY-TOUR OF THE ARAB WORLD, LEILA KHALED UNDERGOES FACIAL PLASTIC SURGERY TO PREPARE HER FOR HER SECOND RENDEZ-VOUS WITH HISTORY.

EVER SINCE THE 1969 TWA HIJACK EPISODE, KHALED'S PICTURE PLASTERS0 THE WALLS OF AIRPORTS WORLD WIDE, YET THERE IS HARDLY A GLIMMER OF RECOGNITION AS THE VETERAN SKYJACKER BOARDS AN EL AL FLIGHT 219 BOUND FOR NEW YORK. THIS TIME HER COMPANION IS PATRICK ARGUELLO AND SHE WEARS A 'WONDERBRA' MADE OF TWO GRENADES. THEY ATTEMPT TO DIVERT THE PLANE TO JOIN THEIR COMRADES AT A DESERTED MILITARY AIRSTRIP IN THE JORDANIAN DESERT. ON THIS INFAMOUS 'SKYJACK SUNDAY', A QUADRUPLE HIJACK SCENARIO WAS MASTERMINDED BY THE PALESTINIAN FRONT, BUT THE EL AL HIJACK IS FOILED AND LEILA KHALED APPREHENDED. THREE DAYS LATER, THE PFLP SEIZES A 5TH PLANE TO NEGOTIATE HER RELEASE FROM PRISON.

2. DESTINATION: REVOLUTION AIRPORT

I was obsessed with the idea of my mission. I rehearsed it every hour of my waking days. I roamed the city of Frankfurt for a few days, bored with the waiting; then I went to Stuttgart briefly and on to Amsterdam. Our rendez-vous with history was approaching: all plans had to

be translated into action; history was ours to write; Patrick Arguello was to write it in blood, I was not so honored.
I met Patrick Arguello for the first time in September 1970, in front of the air terminal at Stuttgart. We briefed each other on our mutual assignment and reviewed the plan thoroughly. The following day we flew together to

Frankfurt. At Frankfurt airport, Mr. Diaz (Patrick) was inspected as I watched the passengers of a TWA Tel Aviv-bound flight being thoroughly searched. I felt very happy that we were causing the enemy so much trouble."

As we waited PanAm Flight 840 arrived and I

▷

MY RENDEZ-VOUS WITH HISTORY WAS APPROACHING...

▷

happily remembered TWA flight 840 of August 29, 1969. I was not aware at that moment that two of our comrades, having been barred in an earlier attempt by the Israelis, were in their own to seize PanAm Flight 840 a half-hour after take-off. They took the 747 to Cairo where they blew it up as a declaration of Palestinian independence. Neither Patrick nor any of the other five male hijackers knew that three planes were our targets that day. Only the three female Palestinian captains and a handful of other leaders knew of the entire plan. We lingered in the waiting room until about twelve-o-five. There was still no sign of the El-Al counter staff. Suddenly an armed police officer in Israeli uniform emerged.
"Why are you late?" he demanded.
I accommodatingly explained, "We arrived at ten o'clock, officer," and suggested that he ask the KLM hostess, who vouched for us.
"Your passport please," he said. Both Patrick and I showed our passports without comment. The officer carefully examined each page. He looked at my photograph and then back at me several times. He paced back and forth as he addressed us. He asked me to empty my handbag and identify every item in it, which I did. I looked completely normal. Patrick was wearing a business suit and I was dressed in a mini-skirt and jacket.
I did not pretend to be other than calm Maria Sanchez from Honduras. Routine questions went on for several minutes. Suddenly I heard loud voices. I saw three Arabs walking in my direction. My heart sank. I knew and recognized one of them. What if he greeted me? We would be exposed immediately. Fortunately the Israeli officer had his back to them. Since we were already holding hands for his benefit, I quickly threw my arms around Patrick. He seemed a little surprised, but what man will rebuff a woman under such conditions? The embrace lasted until my Arab friend passed by unnoticed by the El-Al officer or anyone else.
The officer seemed untroubled by us. Politely he invited us to go with him to the basement to check our baggage. "Officer, our luggage is open, you could inspect it any time you like," I said. "Regulations state, Madam," he explained, "that owners must be present." We happily agreed. The officer was no amateur. He systematically went through every item not once, but twice.
He asked informal but pertinent questions as he inspected our possessions.
Then he pointedly turned to me and asked: "Has anyone given you any gifts?" "No," I replied emphatically. "Do you have anything sharp or dangerous?" "Such as?" I said. "Such as a pistol, a knife or anything sharp?" "No Sir. What would a girl like me ever do with a pistol or knife, officer?"

As we re-entered the hall, I saw some thirty or forty youngsters waiting to board EL-Al flight 219. I was shocked and secretly lamented that once again I had to face the agonizing problem of what to do to avoid hurting children. I love children and I know they are free from guilt. Although I remembered the children of Palestine napalmed by the Israelis and Dr. Haddad's child running out of his flaming room, I nevertheless vowed to do my utmost not to jeopardize the lives of passengers needlessly.

At that moment Patrick prepared his hand grenade and pistol, and I pulled the safety pins off my two hand grenades and rushed forward through the first class section and towards the cockpit. We shouted "Don't move," as some of the passengers tried to take over. Three stewards were in front of us wielding handguns. In a couple of seconds I could count six guns. But we had anticipated a battle: A hostess fell to the ground crying to me in Arabic. I threatened to blow up the plane if anyone fired at us. I displayed my two grenades and dropped the safety pins on the floor hoping to convince everyone we intended business and to avert a bloody battle. Patrick held the armed stewards and the passengers at bay. "Go ahead, I'll protect your back," he instructed me. I forced the hostess to stand up and walk ahead of me. The moment she opened the door, she staggered forward in a state of panic. I couldn't see the captain or crew. Shots were fired. There was another door before we could reach the pilot's cabin. Both of us banged on the door. No one opened the door. Suddenly someone was looking at us through a spyhole. I brandished my hand grenades and ordered him to open the door or else. I heard more shots and the plane went into a spin. Several people attacked me at the same moment. I thought the plane was disintegrating. The firing continued and suddenly I found myself besieged by a pack of wolves, El-Al staff as well as passengers. Someone screamed "Don't shoot at her! She has two hand grenades." No one fired at me. But some people were kicking me, others hitting. A few just stepped all over me. Two were holding my hands and trying to take away the grenades. One finally succeeded in prying one grenade from me without exploding him and the plane. I held tightly the other until I was knocked unconscious for a second and was overpowered. At first I didn't know what was happening to Patrick. Within a few minutes I was dragged to the first-class compartment where Patrick was lying, bleeding profusely and breathing heavily. I could see he was still alive. The Zionists were acting like mad dogs. They trampled over every part of our bodies. By the time Patrick was too week to resist. I was fighting like a caged lion. I fought until I was completely exhausted. Then a vicious thug pounced on me, pulled my hair mercilessly, called me a wicked bitch, a malicious Arab and all sorts of obscene names. I spat contemptuously in his face. I bit his hands. He and others around me beat me incessantly for several minutes. The plane was travelling smoothly; the remaining passengers were staying in their seats. Suddenly an Israeli guard emerged from the cockpit area. Patrick was lying on his side. The man turned him over on his stomach and started tying him up with wires and a necktie. Someone asked, "How are they?" A voice replied "We don't know. He is … we're not sure. She's threequarters dead." The man stepped on Patrick's hips and Patrick looked at me in agony, his hands tied behind his back. Then the Zionist guard fired four shots into Patrick's back. Someone screamed from the back of the plane "Please stop the bloodshed. Please, Please, Please!" The four shots that were fired into Patrick's back were fired from a distance of less than one foot. Patrick looked at me, gave me a deathly smile, and bid me an eternal goodbye.

THE SKYJACK JET SET: FIRST TRANSATLANTIC HIJACK

NOVEMBER 1, 1969: VIETNAM VET, RAFFAELE MINICHIELLO, FORCES A TWA FLIGHT 85 OUT OF LOS ANGELES TO MAKE A DETOUR ACROSS TWO CONTINENTS AND AN OCEAN. TWO DAYS AND 6,869 MILES LATER THEY ARRIVE IN ROME, ACCOMPLISHING THE WORLD'S LONGEST SKYJACK. HE HAD SPENT $15.50 ON HIS PLANE TICKET.

Once in Roman airspace, Minichiello radios in a request for an unarmed police official to await him with a car on the runway. The plane touches down: Minichiello, brandishing pistol and carbine, gets into the car, and orders the policeman to drive southwards to Naples. Next: Four police cars escort Minichiello. This makes him mad: he boots his hostage out of the car, drives on into the woods. The abandoned vehicle is found in the Italian countryside. Hundreds of Italian *polizzi* with helicopters and dogs spread out over the Appian hills in vain. Five hours later Minichiello is found taking haven in a country church—the Sanctuary of Divine Love. He is wearing Bermuda shorts, and it is his 20th birthday.

VIETNAM VET IN ITALIAN WESTERN.

Raffaele's skyjacking was acclaimed as the most exciting event since the eruption of Mount Vesuvius. Touted as victim of the imperialist American war machine, he became an instant celebrity. Marriage proposals poured in. In Roman tabloids, movie starlets and models tearfully confessed their love. Movie rights were sold and Minichiello was offered a leading role in an Italian spaghetti western. His inspired sister started training with an international airline company to become a flight attendant.

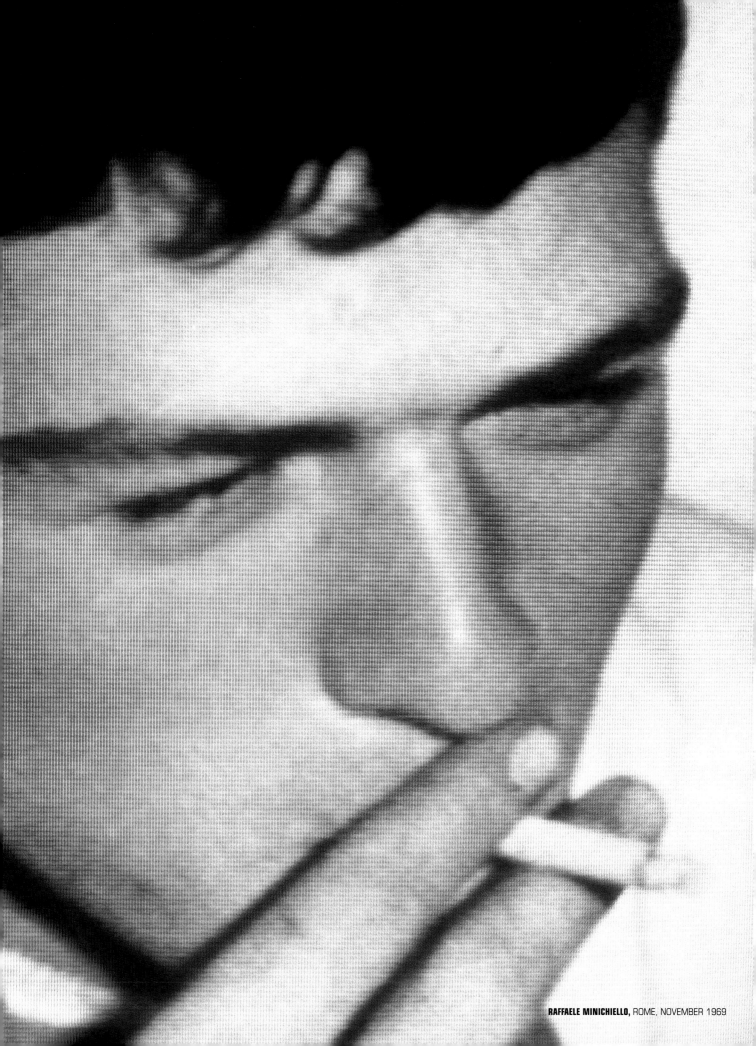

RAFFAELE MINICHIELLO, ROME, NOVEMBER 1969

May 8, 1972:
Incognito, in wigs and forged passports, four members of the Black September Organization board a Sabena jet at Brussels Airport. Overpowering the aircraft, they touch down in Tel Aviv demanding the release of 317 Palestinian commandos held in Israeli prisons. Of the four, two are Palestinian girls, Rima Tannous Eissa, 21, and Therese Halaseh, 19. Both girls wear special girdles made of highly explosive material; each have a hand grenade hidden in their beauty-cases with the detonators tucked in their bras. Approaching Sarajevo, the girls go to the washroom to remove their girdles: Rima handles the explosives, while Therese announces to the passengers over the intercom that they are being skyjacked by the Black September unit of the Palestinian guerrilla organization. They ask that their demands be met, or else they will blow up the plane with the passengers. In the first successful assault carried out on a passenger airliner, Israeli soldiers, disguised as mechanics, storm the plane and shoot the two male commandos and one passenger.

THEY STARTED KISSING EACH OTHER TO SAY GOOD-BYE THERE WERE TEARS IN THE EYES OF THE GIRL. AND I REALIZED AT THAT MOMENT THAT THEY WERE GOING TO TOUCH OFF THE FUSES TO THE EXPLOSIVES
—Captain Levy
of the hijacked Sabena airliner

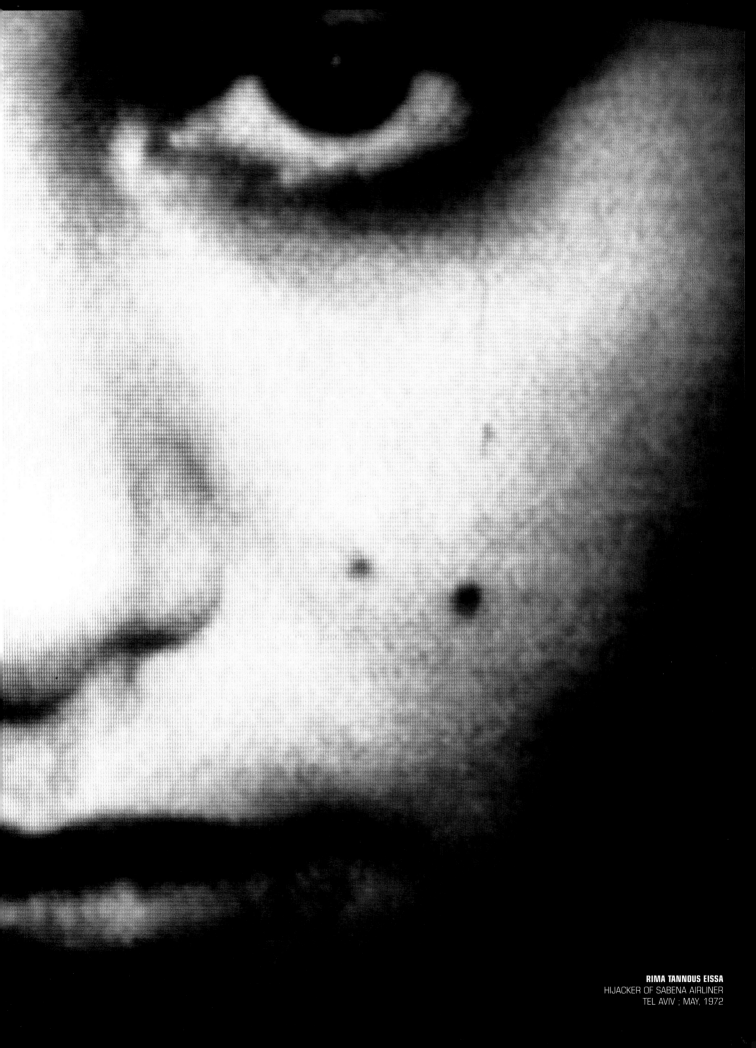

POLITICS IN THE SKY: FIRST RECORDED HIJACK

Byron Richards was one of the PanAm pilots who pioneered the first direct air links between North and South America. It was during a South American revolution that Richards discovered then, as now, politics and piloting fly side by side. The Peruvian revolution of August 1930 was over in four days, ending with the eleven-year dictatorship of President Augusto Leguía. The leader of the revolt, Lt.-Col. Sánchez Cerro, stormed the capital from Arequipa, in southern Peru where the revolt began. He arrived in style – by air; a large crowd greeted his plane as it landed on the lawn of a Lima Country Club. The speed of his appearance foiled the plans of a rival junta, based in the capital itself, to seize control. Fifty years earlier in the Pacific War, troops based at Arequipa failed to reach Lima to fight Chilean forces because of the formidable geographic distance between the two cities. Now a colonel could be airlifted to a dictatorship in less than three hours. Planes had become the artillery of revolutions – this was duly noted.

Six months later Richards flew into Arequipa as part of his regular mail run. It was Saturday, February 21, 1931. 'Arequipa was a one-strip airport – it looked deserted. I was landing from south to north and the hangar was down at the north end of the field and the little terminal building was up at the south end, so I had to turn around and just as I did so, armed soldiers rushed out.' They surrounded the plane and told me to cut the engines. They didn't speak English but I could speak enough Spanish to get by.'

'I was greeted by an officer who asked me to leave the plane and go with him to the Prefectura. When I asked him why the unusual reception he said there was a revolution and that the junta in Arequipa refused to let planes leave. The plane was to be detained for their use – either to transport officials or to drop propaganda over cities in Peru.' Richards had been seized by the world's first skyjackers.

Quoted from: Skyjack. *The Story of Air Piracy*, Phillips, David; London: Harrap 1973

FREQUENT SKYJACK BONUS
August 3, 1961: Leon Bearden and his sixteen-year-old son Cody, seize a Continental Airlines en route from Phoenix to El Paso. Shortly before the scheduled stop the father-and-son team, Cody packing a .45, his dad, a .38, march stewardess Lois Carnagy up to the cockpit. Captain Byron Richards, veteran hijackee of the first known air piracy incident once again had guns trained on him. Destination: Cuba.

HIJACKER HIJACKED
In 1960 Captain George Prellezo diverted his Cuban Aeropostal plane out of Havana to defect to the US. In the course of time he was granted American citizenship, married a Puerto Rican girl, and got a job piloting for American Southeast Airlines. However on June 29, 1968, during a scheduled flight out of Miami, a hijacker entered the cockpit and ordered Captain Prellezo to fly the plane to Havana at gunpoint. And so the Captain found himself back to square one.

MORE FREQUENT FLYING
National Airlines pilot Carl Greenwood earned the dubious distinction of having been hijacked on three separate occasions in 1969 and 1970, each time to Cuba. (Blair 1977:295)

1947-1958: PROPELLER YEARS: ALWAYS THE "WRONG SIDE" OF THE IRON CURTAIN

From the get go, hijacking planes had strong potential for political exploitation. With their capacity for speed and lift off, planes were able to transgress political boundaries, very easily undermining the concept of nationhood*. Between 1947 and 1950 there was a rash of hijacks involving the crossing of the iron curtain— the hostile divide between the communist ruled "Eastern bloc and the "capitalist West". For political dissidents escaping communism, the best route to freedom was to flee to neighboring Western states for political asylum.

In July 1947, the first hijack after the Second World War featured three Rumanian army officers forcing a Rumanian plane on domestic run to land in Turkey. In September 1948 a group of armed Greeks tried it the other way: from West to East— a Greek commercial airliner was forced to land in communist Yugoslavia. For the West it was the first time an airline had been diverted to the "wrong side" of the iron curtain, there was no applause. Surely, people escape to freedom, not from it! (Arey 1972) The vocabulary evolved accordingly: skyjackers fleeing the commies became "freedom fighters" or potential "refugees". People seizing a plane to the 'wrong side of the iron curtain', were branded criminals or spies.

1958: ENTER THE JET SET AND A NEW WORD: 'HIJACK!'

By 1958, PanAm and BOAC jets were flying trans-Atlantic commercial routes. That year also marked the beginning of modern day skyjacks. On February 17, a DC-3 flying from Pusan to Seoul, was diverted across the 38th Parallel to Pyongyang in North Korea by Red sympathizers. In the ensuing stories about the Korean affair The Times adopted the term 'hijack' to describe the act of seizing a plane (February 19). The word was popular slang during the Prohibition, when alcohol was contraband within the US. When one bootlegger robbed another, during the hold-up he'd say: "Hi, Jack, raise your hands!" or: "Raise your hands high, Jack." **

In that same year (1958), Fidelistas initiated hijacking as a guerrilla tactic to overthrow the Batista regime in Cuba—spawning the Jet Age of sky piracy. In years to follow, hundreds of planes will change course to Havana, turning it into a Skyjacker's Haven.

1958: FIDELISTAS SKYJACK CUBA

While the Iron Curtain shaped the Cold War in Europe, Fidel Castro literally skyjacked Cuba into the Russian camp. The enemy appears on the US's doorstep and skyjacking enters the sphere of American politics. In the spring of 1958, as commander of Column Six of his brother Fidel's revolutionary forces, Raoul Castro built a temporary air base in the jungle deep mountains of Cuba's northern Oriente Province. Two planes, owned by Cuba's domestic airline, were diverted to this destination, thus initiating the skyjack as a guerrilla tactic. Posing as passengers, the armed members of Column Six, seized the first plane to the camouflaged airstrip on October 21, 1958. Two weeks later, in an attempt to disrupt the Cuban presidential elections there was a repeat performance with a second DC3.

BOOMERANG

Ironically, on January 1, 1959, the day Fidel Castro won the revolution, there was a ricochet effect. A Cubana Airlines was hijacked to New York by supporters of ex-President Batista's regime. On April 16, 1959 the US granted political asylum to the first Cuban skyjacker.

Summer 1960: US IMPOUNDS CASTRO'S JET

Fidel Castro, invited to New York by the United Nations, lodges at the Hotel Theresa in Harlem. Television audiences watch as Castro and Soviet President Nikita Khrushchev embrace, surrounded by Black onlookers in front of the hotel. Castro's speech exposing the CIA's plot to invade Cuba is cut from TV. Khrushchev argues his own case by pounding his shoe on the podium at the UN. The US impounds Castro's plane by legal action. Khrushchev offers Castro a Soviet jet to fly him back to Cuba.

1961-1972: HONEY, WE'RE GOING ALL THE WAY—TO CUBA!

This situation was reversed once more in the 1960s. There was a flux of homesick Cubans diverting American commercial airliners as free rides home to Havana— since there was no air service between the island and the US. On May 1, 1961 the US was stunned by the news of the first hijacking of an American plane by a regular passenger. A knife and pistol wielding Castro sympathizer, Antulio Ramirez Ortiz, took over the cockpit of a National Airlines carrier on its way from Miami to Key West and forced the pilot to head for Cuba.

He had checked in under the alias of Elpir Cofrisi and had asked to add the letters "a-t-a" to his first name – Elpirata Cofrisi. The ticket counter personnel missed the joke: Elpirata Cofrisi was a notorious 18th Century pirate on the Spanish Main. By the end of the 1960s, a whole generation of American El Piratas followed. Of a total of 364 planes hijacked worldwide between May 1, 1961 and December 31, 1972, about 159 American planes were involved in skyjack incidents; 85 of those diverted to Havana.

1969: HIJACK INN

By 1969 the restaurant and gift shop at the Havana airport expanded their business to take care of the unexpected flux of visitors brought in by the skyjackers. Landing fees were inflated and the runway was enlarged to take care of the unscheduled joyrides to the Caribbean island.

A routine pattern established itself. Hijackers were lodged in the 'Casa de Transitos' ('Hijacker's House') in Havana's Siboney district. Pilots and crew rested briefly, smoked cigars, and then flew their empty planes back to the US. Cubans wined and dined the Americano tourists and took them on a sightseeing tour of socialist Cuba. After this memorable side trip, generally enjoyed by the visitors, they were boarded on a return trip to the US, laden with rum, cigars, revolutionary literature, sombreros and pictures of Che Guevara. Castro forwarded the bills to the American airline companies: for every hijacked airliner to Cuba an additional $2,500 to $3,000 cover charge was due for landing fees, fuel, plus food and accommodation for the passengers.

* See: Beer, Gillian: *The Island and the Aeroplane: the Case of Virginia Woolf*, in: Homi K Bhabha, *Nation and Narration*; Routledge 1992, pp. 265-90

** See: Ayto, John: *20th Century Words. The Story of the New Words in English over the Last 100 Years*; Oxford University Press; 1999; see also: McWhinner 1987:7 + Phillips 1973:259 + St.John 1991:191

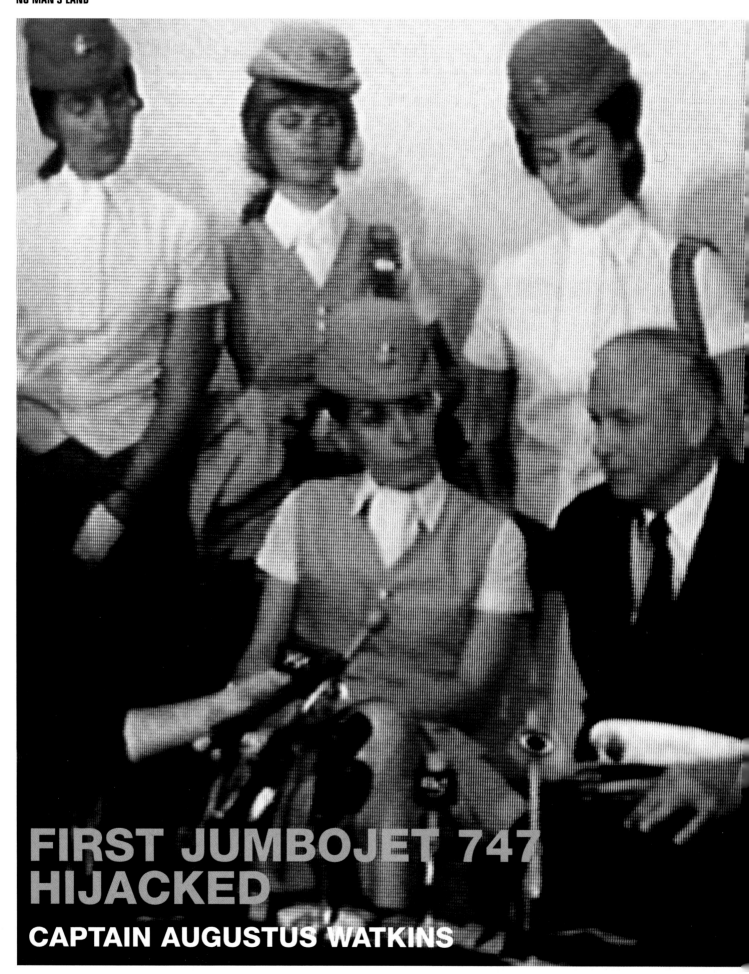

FIRST JUMBOJET 747 HIJACKED
CAPTAIN AUGUSTUS WATKINS

FIRST JUMBO JET 747 HIJACKED

Rudolfo Rivera Rios, of Puerto Rico—by way of the Bronx, made history with the first 747 skyjacking. The Pan Am Jumbo jet left John F. Kennedy Airport, New York late on the night of August 1st, bound for San Juan, Puerto Rico. There were 360 passengers aboard, just two short of full capacity, and nineteen crewmembers. About 200 miles and twenty-six minutes away from San Juan, the hijacker—who was later described as resembling a pint sized Che Guevara—got up forced a stewardess to take him to the cockpit. There, armed with a pistol, a switchblade and a bottle of something he claimed was nitroglycerin, the hijacker told the captain that he wished to be taken to Cuba.

Captain Augustus Watkins changed course and notified New York. When the plane landed in Cuba, Premier Fidel Castro himself hurried to José Marti Airport to admire it. The hijacker got off the plane and disappeared; Captain Watkins got out and talked to Castro. Everyone else stayed on board.

Castro was fascinated with the gigantic craft. Could the hijacker get his luggage off the plane? Sorry: the 747 required special baggage-handling equipment, which was not available in Havana; the man's luggage would be shipped back to Havana on another flight. Then Captain Watkins asked if Premier Castro would like to board the plane to see how it looked inside? Castro graciously declined: "I would probably scare the passengers," he said.

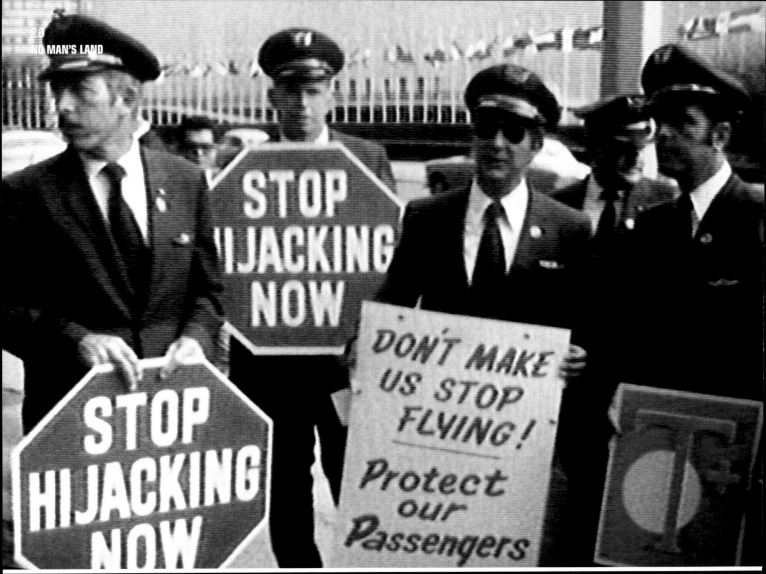

GENERAL STRIKE OF AIRLINE PILOTS
United Nations, New York, June 19, 1972

MISS—I HAVE A BOMB HERE, AND I WOULD LIKE YOU TO SIT BY ME
— DB Cooper's note #1 to stewardess

**I WANT $200,000 BY 5:00 PM IN CASH—PUT IT IN A KNAPSACK
I WANT 2 BACK PARACHUTES AND TWO FRONT
PARACHUTES NO FUNNY STUFF, OR I'LL DO THE JOB**
—DB Cooper's note #2 to stewardess

**GRENADE-PIN PULLED. PISTOL-LOADED
IT'S A LONG WAY TO THE GROUND**

**WE WANT $ 500,000 IN CASH—DIFFERENT DENOMINATIONS
FOUR COMMANDER PARACHUTES WITH STOPWATCH AND WRIST ALTIMETER
GET THEM FROM PERRY STEVENS EQUIPMENT COMPANY IN OAKLAND**
— McCoy's notes to the stewardess

**DEAR CAPTAIN, THIS FLIGHT IS GOING TO HAVANA
I HAVE A GUN AND NITROGLYCERINE
I'VE STUDIED CHEMISTRY**
— Note to pilot, Eastern Air Lines

THESE EARS
OF CRIME

SCOTCH TAPE HAD WORKED BEFORE TO KEEP MY EARS FROM STICKING OUT

While the other passengers were boarding, Richard went straight to the aft cabin rest room. He had calculated the timetable: "Less than five minutes to put on my dark makeup, wax and curl my mustache, then there was the wig. That darn wig. Karen had cut it short and dyed it black at least tried to—leaving it hard and stiff. I had a can of hair spray with me, just in case, and felt it would work. The idea of course was to get the wig over my ears. These ears of mine would be one thing, I knew witnesses would later remember. Scotch tape had worked before to keep my ears from sticking out so far from my head, but this time I decided to use one of Denise's headbands under the wig." Richard was working away, a hand towel wrapped around his neck to prevent hair spray and water from running into his makeup, when the loud male voice announced from the ceiling speaker, "Has someone aboard United Flight 855 left a manila envelope in the boarding area?" Richard froze. The unsealed envelope contained

hijack notes he and Karen had tapped out on Denise's typewriter. "What on earth do I do now?" Richard thought to himself. "Do I dare claim them or not? Someone probably opened the envelope looking for a name and read the notes. If someone did, and I step up to claim them, you can bet I'll be marched off Flight 855 in leg irons and handcuffs at gunpoint. And if I don't, airline security will have to read them and then everyone on the plane will be led off at gun point."
He decided to take the chance. Stewardess Diane Sugomato had walked down the aisle and was holding the envelope over her head near the back seats. Richard edged part way out of the rest room door and waved to catch her eye, coughing and gagging as though he were already motion sick.
He could feel blue-black water from the dyed hairpiece cutting through heavy tan makeup as he mopped and concealed his face with a fistful of blue and white United Airline towels. Snatching the envelope from her outstretched hand, he

immediately disappeared again behind the bathroom door. The huge 727 suddenly lurched forward just as the toilet seat slammed shut. A man's authoritative voice ordered, "Get out of there at once. We're ready for takeoff." Richard unlocked the door and snaked his way past Second Officer Kent W. Owens to seat 20D. Wearing a fresh layer of dark shiny makeup, a waxy-looking wet hairpiece, and a bright blue and red sport jacket, Richard looked as if he'd been dressed that morning by the cast from West Side Story. But despite this series of hitches, Richard was calm. Thirty thousand feet above the ground, racing west at six hundred miles an hour, the big Boeing 727 and eighty-five unsuspecting passengers were about to become hostage to the eighty-sixth.

Excerpt from: *D.B. Cooper, The Real McCoy*, by Bernie Rhodes

MISS — I HAVE A BOMB HERE, AND I WOULD LIKE YOU TO SIT BY ME

November 24, 1970: D.B. Cooper holds up a 727 commercial airliner out of Seattle for ransom. He demands a parachute and a bundle of dollars. While airborne he uses the back-exit to bail out. And so Cooper vanishes into the night sky. In his knapsack: an apple, a chocolate bar and $200 000 cash. D.B. Cooper had perfected a new caliber of career crime: PARAJACKING.

A cult emerges; D.B. Cooper's dropout innovation has all the mythical glamour of a latter-day cowboy.

This 'Robin Hood of the jet set' finds his way into the criminal Hall of Fame. Like Jesse James, Al Capone and Billy the Kid his legendary coup ends up on Hollywood celluloid. An alarming number of wannabe's bail out of passenger planes mid-air— but are all apprehended, by now, the parachutes are rigged with tracking devices.
Cooper's new twist on hijacking is so appealing that during a 17-week period in 1972, the 'skyjack buzzer' at the Air Transportation Security Office in Washington hits alert every single Friday.

The last day of the workweek became known as "Skyjack Friday". (St. John 1990:48)

One Friday a year later— April 7, 1972, Richard Floyd McCoy Jr., parajacks United Airlines Flight 855 with half a million money dollars. However McCoy is captured and D.B. Cooper is still officially on the loose, despite the claim of Bernie Rhodes that McCoy and D.B. Cooper were actually one and the same. Both tried to hide a strikingly similar set of ears sticking out of their heads. (Rhodes 1991)

ANONYMOUS SKYJACKER PANAMA, JANUARY 1970

MEN IN
SWIMMING TRUNKS

IN 1972 BATHING TRUNKS BECAME STANDARD UNIFORM FOR FBI AGENTS. ON NOVEMBER 10, THREE BLACK MEN: HENRY JACKSON AND HIS TWO HALF-BROTHERS— LEWIS MOORE AND MELVIN CALE, OVERPOWERED CAPTAIN WILLIAM HAAS OF A SOUTHERN AIRWAYS FLIGHT 49 OUT OF BIRMINGHAM, ALABAMA. PARANOID THAT THE OTHER MALE PASSENGERS COULD BE CONCEALING WEAPONS, THE HIJACKERS HAD THEM ALL STRIP DOWN TO THEIR UNDERWEAR. THE WOMEN WERE ORDERED TO THROW THEIR PURSES IN THE AISLE. DURING THAT TIME THEY ALSO SERVED DINNER. THE HIJACK TURNED INTO A TWO-DAY ORDEAL ACROSS THE US, CANADA, CUBA AND THE ATLANTIC; MAKING NINE FORCED STOPS, TWO OF THEM IN HAVANA.

Jackson and Moore had a bone to pick with the mayor and police of Detroit. They had unsuccessfully sued that city for $4 million, on the count of police brutality. They could hardly believe it when the city offered to settle for $25: for them, it was clearly a matter of race discrimination. They decided to resolve the matter by hijacking a plane and seek ransom as a settlement, by now their demand was upped to $10 million dollars. They threatened to crash-land into the atomic plant at Oak Ridge, Tennessee, if their demands were not met.
In the meantime the FBI and the White House get

involved, and plans to bring in the Air Force are underway. The Atomic Energy Commission evacuates 200 employees to a drive-in cinema, shutting down three nuclear reactors. It is at this particular moment that a FBI-agent, wearing only swimming trunks, is obliged to deposit the ransom money beneath the plane. There are also requests for parachutes, 7 bulletproof vests, pep pills and two dozen buckets of fried-chicken.

After refueling the plane finally takes off for Cuba. Upon arrival they are denied an audience with

Premier Castro, whom they have asked to see in person. The upset hijackers make a 180° turn back in the direction of the US. Upon landing, the tires of the aircraft are shot flat by the FBI. Incensed, the hijackers force Captain Haas to take off once more in spite of the flat tires—back to Cuba. The nerve-wracking 29-hour ordeal ends with a crash landing onto a carpet of foam laid out at Havana airport for the disabled plane. The following is an account of the conversations aboard the hijacked Southern 49 as reported by Ed Blair and Captain William Haas in: *Odyssey of Terror*.

WE'LL BLOW THIS THING UP RIGHT HERE

Around 7 PM on Nov. 10, 1972, 5 minutes after take off, a gunman shoves a .38 caliber against the captain's cheek:
CAPTAIN - THIS IS A HIJACKING"

Stewardess to Captain Haas:
It's for real, -Billy Bob-he's not kidding.

To the passengers in the cabin:
Don't nobody move-we're not gonna harm you as long as you do what we say—Take your clothes off.

We mean for only the men to undress down to their shorts. We're not trying to steal your money. Just put your clothes in the aisle. And you women toss your purses into the aisle. If you got a gun on you, toss it in the aisle or we'll kill you.

After refueling at Jackson, Mississippi.
Captain:
We need to know where we're going.
Hijacker:
We'll take care of that later. For now, either turn around and take off or there won't be any need to know where we're going. We'll blow this thing up right here.

Captain to stewardess Donna:
Are the passengers all right?"
Stewardess:
Yes, sir. They just don't have on any clothes.

To ground authorities while on their way to Detroit airport:
Listen down there, this is Henry Jackson, and I've got me a planeload of passengers up here. If you don't want them killed, you do what I say.
Traffic controller:
Yes, sir-what is it we can do for you?
Hijacker Jackson:
We are going to hold these passengers and this aircraft until they get us 10 million dollars and ten parachutes.

LOU-I NEED TO GO TO THE REST ROOM

The money is to be delivered at Cleveland:
Be advised there should be no one - repeat - no one but one man coming to the aircraft to fuel the plane and to bring the money, the parachutes, and the stimulants. Only one man, and he is to have on swimming trunks.
Cleveland Airport, Jackson to co-pilot Harold Johnson:
Tell them to get that fuel truck out immediately or watch as the dead bodies of the hostages will be thrown out the windows one by one.

Southern 49 sets course to Toronto without fuel.
Captain Haas to hijacker:
Lou-I need to go to the rest room.
Hijacker:
Sure—go ahead.

Captain Haas to Henry Jackson after returning from the toilet:
Henry, you must be getting pretty tired by now.

Hijacker:
Yeah, man, this is like that restaurant work me and Lou used to do all day and night. Gets to you.

Cockpit to control tower upon descent to Toronto International:
OK, Approach, and we want this man in swimming trunks.
Control tower repeats:
They want a man in swimming trunks-he's got to have the parachutes and the food and the money."

With the delay of the fuel truck, threats to crash land in the atomic plant at Oak Ridge are uttered:
We're gonna have to take this thing down yonder and crash it like I said. We ain't gettin' nowhere here. Hurry 'em up before we have to start shootin' these passengers. Let's take this thing to Oak Ridge, Tennessee, to crash into the atomic works down there and blow up the whole (—bip—) world! The company don't care about us! Detroit don't care about us! The country don't care about us!"
Plans are underway to bring the FBI, Navy and the Air Force into play:
Navy 689-This is Operations. Make immediate departure under priority 1 clearance to Hartsfield International Airport Atlanta. Our assigned mission is to shadow hijacked airliner Southern Airways Flight 49. Maintain capability of instant reaction to future orders.

Captain radioing at Toronto International airport:
Listen - we're pushing up flowers out here.
Henry Jackson down to the mike:
Do you want me to blow this mother up right now?
Who do you think you're playing with?

BATHING BEAUTY

The next morning:
Demands are not met, and the hijackers force the plane back South to Knoxville, Tennessee:
We're gonna blow this thing up. I was born to die; and I have to take all of you with me, that's all right with me. We're gonna make this thing look worse than Munich."

Knoxville's control tower:
Law-enforcement authorities bring in grandma and spouse of hijacker Melvin Cale.
Hijacker's grandmother:
If I get the chance, I'll smack the young hijacker's jaws and pull him off of the aircraft.
Wife (over the radio to hijacker):
Why are you up there doing that?
Mel-why are you doing what you are?
You should be here with the children and me.
Give up before it's too late.
Hijacker:
I'll see you. I won't be long-I won't be long.

Next stop: Chattanooga.
A circus of curiosity seekers, armed with cameras, binoculars, and portable radios rally round the airport. There are peanut and popcorn vendors in the crowd.
Captain Haas:
Your names have probably been on radio and television throughout the country.
Hijackers:
Hey, man—we're celebrities.
To the passengers:
Lower all those window shades, and keep your seat belts fastened, with your heads down on your laps. The first one that raises his head is gonna get it blown off.

12 hours into the hijack:
The money along with two dozen buckets of fried-chicken, parachutes, 7 bulletproof vests, pep pills, and a six-pack of beer are delivered to the plane by a FBI agent in swimming trunks.

Jackson instructs to the stewardesses:
Start counting.

FBI on walkie-talkie:
Looks like the plane's taking off.
Dispatcher:
49 is leaving?"
Walkie-talkie:
That's right.
Dispatcher:
Disregard all units-disregard.
Control tower:
Southern 49-Advise intentions.
Copilot Johnson:
Going to Cuba -they want to talk to Castro.
Controller:
Understand you're going to Cuba...you want to talk to Castro? Southern 49—we will take your proposed route any time you're ready.
Southern 49:
Direct—Havana.
Control tower:
Direct—Roger.

The FBI chase is on again.

Hijacker Henry Jackson gives out handfuls of the green bills to pilot Haas and co-pilot Johnson:
You can do whatever you want with this money.
Captain Haas:
Well, I'll tell you something Henry. The company probably had to mortgage its airplanes and won't be able to pay its employees; but you are dealing with the real Frank and Jesse James. I have been flying around for years just waiting to pull off a deal like this. You see, I've got this old house I'm restoring out in La Grange, Tennessee. I can sure use the money.
Co-pilot:
Yeah-and I've got about five farms out in Arkansas I'd like to buy...

Henry Jackson announces to the passengers:
I realize that this has been an inconvenience for most of you and especially you men who have lost a day's work. I know you've got payments to make on your homes and other expenses, so we're gonna reimburse you for your time and trouble.

Doling out three hundred dollars for each hostage, Jackson and Moore begin the big giveaway.

WE WANT TO TALK TO FEE-DEL

24 hours into the hijacking. The plane on the ground at Havana's José Marti International Airport.
Jackson sticks his head out of the cockpit window:
We want to talk to Fee-del.

Engine noise.

Jackson repeats in a loud voice:
We want to talk to Fee-del.
José Abrantes, Cuba's Deputy Minister of the Interior at the left of the aircraft:
Eez not possible, señor.
Jackson:
Why not?
Deputy:
Dr. Castro eez not available.
Jackson:
Where is he?
Deputy:
He eez in the country among the people.

▷

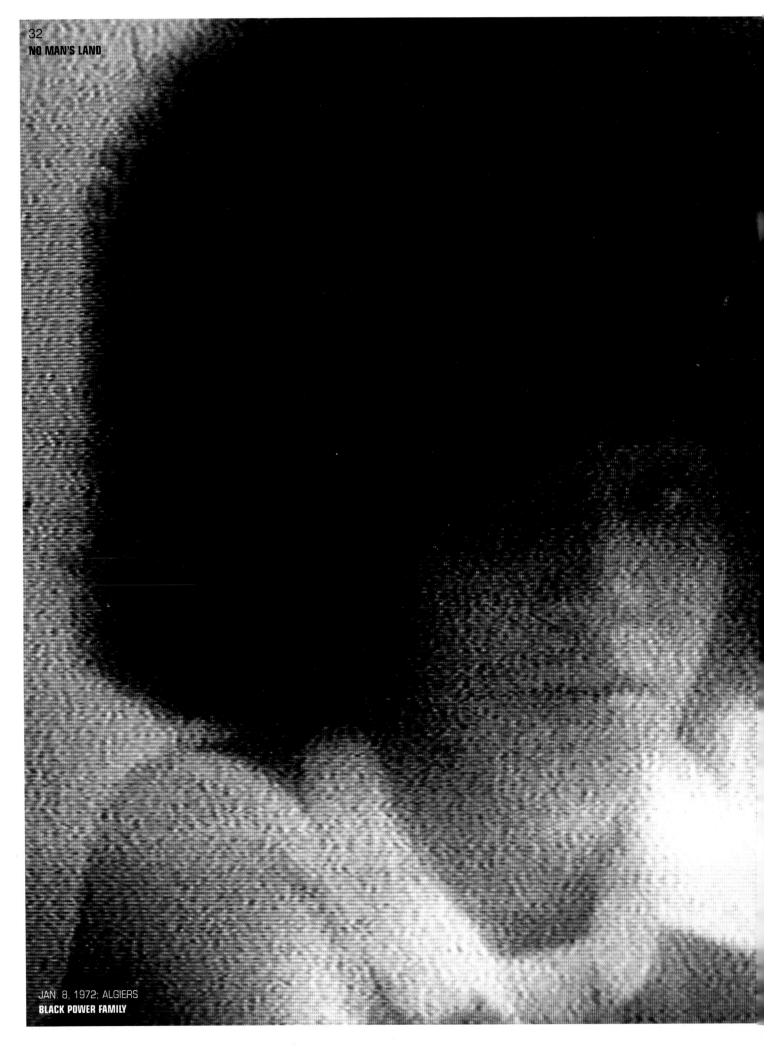

JAN. 8, 1972; ALGIERS
BLACK POWER FAMILY

1968-72: SKYJACK ROUTE TO CUBA:

BLACK PANTHERS ON THE RUN

Nov. 4, 1968:
Self-styled Black Nationalist, Raymond Johnson, diverts National Airlines 727 jet from Houston to Cuba at gunpoint. National Airlines reclaimed as: REPUBLIC OF NEW AFRICA

March 5, 1969:
Black Robin Hood robs from rich passengers to give to the poorer ones: Aboard another hijacked National Airlines plane headed to Cuba, air pirate Tony Bryant brandishing his .38, takes a passenger poll: rich or poor? Then robs them accordingly. One stewardess graciously offers her wallet but he refuses. Black passengers are also robbery-exempt.

June 17, 1969:
Black Panther captain Willy Lee Brent hijacks an Oakland-to-New York TWA 707 to Cuba. In his suitcase he carries: black clothes and a copy of Black Panther, by fugitive Eldridge Cleaver, who resides in Cuba at the time as part of the black revolutionary community in exile.

Nov. 13, 1970:
Minneapolis: FBI arrest Ronald Lindsey Reed, a 20 year-old black man, on conspiracy charges: for allegedly planning to kidnap the Governor of Minnesota, hijack a plane to bargain for the release of Angela Davis and Black Panther leader Bobby Seale.

1972:
CASTRO ALLEGED TO TREAT NEGROES BADLY.
NEXT STOP: ALGIERS.

Jan. 8, 1972:
Black Power Family with kids hijacks Delta Airlines to Algiers

June 3, 1972:
Newspaper headline: HIJACK DEMANDS: 'GIVE US ANGELA'

June 6, 1972:
Black Revolutionary Army, hijack a Western Airlines flight and escape to Algiers with half a million dollars.

▷

Waving his pistol in the officer's face, Jackson persists:
We have millions of dollars to share with him in exchange for safety and freedom. We came here to talk to Fee-del and only Fee-del.
Abrantes:
The matter is one that will have to be considered by the proper political authorities.
Jackson replies:
You people sound like a bunch of Washington bureaucrats.
Hijacker Lou:
C'mon, Henry-let's get out of here.
Jackson fumes:
Cuba ain't no place for us. This place ain't got nothin' but a bunch of Spanish-talking George Wallaces.
Lou:
Yeah-They got some mean-looking cats out here.
Jackson:
This is supposed to be a free Cuba?
It's as bad as Wallace's Alabama or Maddox's Georgia.
Captain:
What are you going to do now?
Jackson:
We're gettin' outa here.
Captain:
Where are we going?
Jackson:
I don't know, but we're leaving here.

SWITZERLAND?

Southern Airway's Miami station manager:
We just received word that Southern 49 is airborne again on a northerly course out of Cuba.
FBI:
Probably inbound to Miami after letting the hijackers off in Havana.
Station Manager:
No, sir - the hijackers are still directing the flight.
They didn't stay in Cuba.
FBI:
For pity's sake, what's going on then?
FBI headquarters are reactivated:
Instructions are that the hijacked craft be disabled when next on the ground.

Southern 49 is refueled at Key West.
Hijackers:
We have a plan. We're going to Switzerland.
Miami air traffic controller:
Southern 49-advise your intentions.
Co-pilot:
Our destination is Switzerland.
Control tower:
Southern 49 - what is your proposed flight course to Switzerland?
Co-pilot:
Directly over the Atlantic.
Captain warns hijackers:
Those engines can freeze on us any second now.
When that happens, we'll go into the ocean and become a midnight snack for a bunch of sharks.
Jackson:
Turn north then.

C'MON, BABY, C'MON

9:15 p.m. arrival time at Orlando airport, the 8th time Southern 49 is on the ground since the hijacking.
Outbound passengers, European tourists on their way to Disney World, are stranded at the terminal.

FBI pumps rifled slugs into the tires of the hijacked plane.

Captain:
They're shooting our tires out!
Hijacker Jackson, furious:
We're gonna kill you. We're gonna kill a lot of you people.
Then to co-pilot:
You're gonna be the first to die. Stand up; we're gonna shoot you.
Co-pilot, stammering:
Man-I didn't do anything. It wasn't my fault. Please-don't kill me.

Roar from gun muzzle. Co-pilot hit by bullet.

Younger hijacker Cale to Jackson:
OK, man-no more shooting. We've gotta get out of here.

Co-pilot Johnson, gushing blood from his arm, is dragged back into the cockpit's right seat.
Revving of engines, vibration of 35 tons of metal, food rattling in the galley, metal rims of the flat tires grinding into the runway.
FBI in pursuit of a disappearing aircraft.
Pilot:
C'mon, baby, c'mon.

Orlando tower operator:
"Due to the length of the runway, you should return with those tires in that condition in order to make a safe landing. Did you copy?
Jackson:
What the (—beep—) did you mess with us for in the beginning?"
Control Tower:
This is Orlando tower. Did you copy? Are you returning?
Jackson:
(—beep—beep—beep—beep—beep—) No!

Silence.

Control tower:
Southern 49?
Hijacker Lewis:
This 49.
Orlando:
Will you please return and exchange that aircraft for another one?
Hijacker:
I am sorry, sir. We cannot trust you. We're gonna take this plane down-we're gonna take everybody with us, nose first.
Control tower:
We know your fuel status, and this is the only airport that can handle your situation.
Moore:
We're not going to another airport, man. We're taking this thing down, nose first.
Jackson:
"GO BACK TO CUBA!"

BACK IN HAVANA

Havana:
The runway of José Marti Airport is covered with foam in preparation for a crash landing. At the same time Castro orders for a banquet at the terminal.

Stewardess:
Ladies and gentlemen, we will be landing in Havana about thirty minutes. I'm sure you are aware that the tires on the aircraft have been deflated. So we don't know exactly what's going to happen. But we want you to be prepared to evacuate this aircraft rapidly when we tell you to do so. Karen is going to go through the motions demonstrating the proper way to go out the exit. You will step through with your left foot first. With that foot on the wing, bend down, taking your head and upper part of your body out the window. Next, place your right foot out on the wing. It's all to be done in one continuous movement. You will not find it difficult. Do each of you

understand that? It is very important that you do. We are anticipating that the landing will be made with the wheels down. Therefore, there will be inflatable slides in use at the forward cabin door. Remove all sharp objects from your pockets. Remove eyeglasses, false teeth, neckties, and neckerchiefs. Before we land, place your seat in an upright position. Place a pillow in your lap. Make sure your seat belt is fastened. Then, with your head resting on the pillow, lock your arms together under your legs at the knees. Remain seated until the aircraft has come to a complete halt.

Crash landing is being prepared. Debris is stored away: a two-day accumulation of garbage, bulletproof vests, fifteen buckets of uneaten chicken and bundles of money piled everywhere.

Approaching Havana:
José Marti-José Marti-this is Southern 49.
Havana:
This is Havana tower, Southern 49. We have you in sight.
Southern 49:
The tires on the aircraft have been deflated; there is possible damage to the undercarriage; the copilot has been wounded by gunfire; and the three hijackers are still aboard.
Havana:
Southern 49, this is José Marti. We do not have enough foam at this location to cover the runway as requested, but firefighting trucks will be positioned on each side of the runway for immediate use as required when the plane comes to a stop.
Southern:
The captain requested permission now to make an emergency landing. When we get on the ground, we would like some of that coffee and some cigars for which Havana is famous.
Operator:
"Come on down. I'll have a steaming hot cup of coffee ready for you."

Metal wheels screeching against the asphalt.

CIGARS

Premier Castro to Captain Haas:
Well done job! Magnificent landing!
Captain:
Apology for messing up the new runway by landing on it with rims and no tires.
Laughter.
Castro:
I notice the palms of your hands are rough and callused. They are not the hands of a pilot but the hands of a worker.
Haas:
From working on my farm in western Tennessee.
Castro:
Ah-then you have not spent all of your time flying airplanes.

Cigars in abundance.

Captain:
And the hijackers?
Castro:
We have all four in custody.
Passenger:
But, sir, there were only three hijackers.

A black Navy recruit had been rounded up mistakenly as one of the hijackers.

The next day:
Swiss Embassy officials presented a stack of invoices for the captain's signature. Sandwiches, lemonade, and coffee furnished during the day for the mechanics totaled $115. When he got over the initial shock of those charges, another set of invoices were presented: bills for the Riviera Hotel were the passengers and crew were accommodated; food and champagne for the Saturday night's runway banquet; breakfast at the hotel, and charges for the refueling of the hijacked airliner. Also included were each of the Havana cigars handed out to the male passengers. Grand total: $12,900.

I HAVE A FEELING WE'RE NOT IN HAVANA ANYMORE
ANOTHER ONE FROM THE ANNALS OF THE "TAKE-ME-TO-HAVANA" GLORY DAYS:

The captain of a hijacked flight, taking advantage of obscure nighttime visibility, carried out an elaborate ruse. Pretending to navigate to Havana, he also feigned communication with Havana Air Traffic Control. With the help of an astute FAA controller, he landed at a southern Florida airport. The hijacker deplaned, convinced he was in Havana—only to walk into the arms of the local law enforcement. The incident gave rise to a serious study exploring the feasibility of building a facsimile of the Havana Airport Terminal building at a military airport in Florida. (Ashwood 1987:33)

WE, RED ARMY SOLDIERS, WANTED TO BECOME STARS OF ORION WHEN WE'D DIE. IT CALMS MY HEART TO THINK THAT ALL OF THE PEOPLE WE KILLED WILL ALSO BECOME STARS IN THE SAME HEAVENS. AS THE REVOLUTION GOES ON, HOW THE STARS WILL MULTIPLY! KOZO OKAMOTO

KOZO OKAMOTO
TEL AVIV, JUNE 1972
TRIED FOR KAMIKAZE ATTACK ON LOD AIRPORT

SKYJACK CAPTURES TELLY:
SAMURAI HAIJAKKU!

TOKYO STREETS DESERTED:
MILLIONS WATCH FIRST TELEVISED HIJACK LIVE

MARCH 31, 1970: THE JAPANESE RED ARMY (JRA) GOES INTERNATIONAL WITH THE VERY FIRST AIRLINER TO BE HIJACKED IN JAPAN. ARMED WITH SAMURAI SWORDS, NINE JRA-MEMBERS FORCE A JAPANESE AIRLINES B727 OUT OF TOKYO TO FLY TO NORTH KOREA IN AN ATTEMPT TO REACH CUBA. IN HIS BOOK *THE SKY PIRATES**, JAMES A. AREY DESCRIBES HOW THEY GET STALLED IN SEOUL. SOUTH KOREA'S KIMPO INTERNATIONAL AIRPORT IS DISGUISED AS A NORTH KOREAN AIR BASE FOR THE OCCASION, TO MISLEAD THE HIJACKERS. COMMUNIST BANNERS REPLACE SOUTH KOREAN FLAGS, ENGLISH SIGNS ARE REMOVED, AND TWO TRUCKS OF AIRBORNE TROOPS IN STOLEN NORTH KOREAN UNIFORMS ROLL IN. THE SET UP FAILS: AMERICAN JAZZ RADIO IS DETECTED AND GIVES THE RUSE AWAY. THE SAMURAI INCIDENT HITS THE SCREEN LIVE, UNFOLDING OVER 84 HOURS BEFORE A TELEVISION AUDIENCE OF MILLIONS. NEW WORD ENTERS JAPANESE VOCABULARY: "HAIJAKKU."

March 31,1970. Only 7:30 AM, still sleepy hour, and the Japan Airlines 727 makes its way from Tokyo to Fukuoka on what is ordinarily a forty-five minute flight. For the first few minutes it was one of those routine trips (coffee, tea, or sake?), those who had already done the flight so often no longer bothered to peer out the window to admire the majestic beauty of Mount Fuji before kicking back to drowse or enjoy the gracious charm of the Japanese flight.
The seat-belt sign had just been turned off and the four stewardesses were distributing the customary hot towels to the passengers when one of the neatly dressed young students stood up and shouted, "We are the Red Army!" And he waved a glittering samurai sword. Suddenly the aisle was full of students, or seemed to be. There were nine of them, ranging in age from sixteen to twenty-seven, all conservatively dressed in coats and ties and looking for all the world like young office workers. But instead of briefcases they carried swords and pistols and homemade bombs.
They rushed down the aisle, wielding their samurai swords like warriors of old and pointing their pistols at the passengers

like sky pirates of today. "Hold up your hands!" they shouted as they ran and took up their various positions. Some burst into the cockpit. One pointed a gun at pilot Ishida, another stood guard and another tied up the copilot. Then, waving their swords threateningly, they announced again that they were members of the Red Army. They demanded to be flown to North Korea.

Captain Ishida continued toward Fukuoka with the threat of guns and swords hanging over his head. Two escort planes joined him in the sky to keep the jet under surveillance. He radioed Fukuoka a few minutes before landing: "The hijackers threaten to blow up the aircraft with bombs in case the hijacking fails. Please do not bring people near the aircraft."
The plane landed at Fukuoka and stayed on the airfield for five hours while pilot and airport authorities pleaded with the hijackers to free the passengers, and police mulled over plan after plan to keep the plane on the ground. Expert riot police-squad marksmen stationed themselves behind the airport buildings. They took great care not to be seen, but they themselves could see

the passengers peering anxiously from the windows, looming shadows behind them. Eventually they decided that gunfire could only worsen the situation. Newsmen and police officers using binoculars could see right into the cockpit. What they saw was a student hijacker, and perhaps the shape of another, standing behind the pilot and copilot with an upraised samurai sword. Definitely, no gunfire.
The passenger cabin was getting unbearably hot as the spring sun shone down upon the craft. The men, tied to their seats, were becoming extremely warm and uncomfortable, and the women tried to help them by mopping their brows. Men who did not have wives or other women seated next to them were out of luck and had to sweat unmopped. Very little movement was being permitted. Passengers who needed to go to the restrooms were allowed to do so, but only one at a time, under nervous, watchful eyes.

The hijackers were getting tense and restless. Their manner toward the passengers was still fairly cordial, but their politeness was beginning to slip a little. The swords were being waved about a bit too freely and

▷

▷

were looking bigger and deadlier all the time.
The impasse had to be broken somehow. It was, and
the hijackers won most of the chips. The police finally
gave up trying to keep the plane grounded and the
young Reds permitted 23 of the passengers to get
off the plane: 12 children, 10 women, and an ailing
elderly man. One of the hijackers stood on top of
the boarding stairs, samurai sword raised high and
flashing in the sun, to see them safely off.

It is a short flight from Fukuoka to the North Korean
coast at the 38th Parallel, and all indications were
that the plane would soon be landing. Fighter planes
soared into the sky. They looked as though they might
be North Korean planes, and perhaps that is what all
or most of the passengers thought they were.
The planes closed in on the airliner in the first move
of an elaborate ruse and escorted it in the direction
of an airport, which identified itself from the control
tower as Pyongyang. It was actually Kimpo Airport
at Seoul. South Korean skies look no different from
those of North Korea. Nobody on board asked
any questions.
Below and to the south there was much activity
at the airport. All Western flags were removed; all
identifying names and English-language signs were
covered up. Quickly, placards were produced
proclaiming welcome to North Korea's Pyongyang
Airport. Thirty South Korean paratroopers
disguised themselves as customs officials.
Other South Korean soldiers and policemen quickly
changed into North Korean uniforms and stationed
themselves strategically about the airport.
Floodlights were blazing as the plane approached.
It was not yet dark but soon it would be, and
perhaps the blaze of light would help to fool the eye
and blot out the view beyond the airfield.
The voice from the control tower to the aircraft
went on talking in its usual cool, laconic way,
"Pyongyang tower calling Japanese aircraft,
Pyongyang tower calling Japanese aircraft..." and
filling the Captain in on such necessary details
as wind velocity, runway length and elevation and
the like. Thus did the "Pyongyang" tower talk the
plane down to Seoul.

In front of the plane official greeters waved the
Welcome-to-Pyongyang placards. Loudspeakers
blared a similar message: "This is Pyongyang, and
we welcome you!" Soldiers with smiling faces and
Communist insignia appeared on the tarmac and took
up positions alongside the plane as if in formation of
an honor guard. Girls carrying bouquets of flowers
scampered gaily along the runway with glad cries
of "Welcome to Pyongyang!"
The hijackers peered suspiciously out of the windows.
Was there something perhaps a little overdone
about this enthusiastic welcome? The doors of the
airplane remained closed. An official approached with
a megaphone. "This is Pyongyang and we welcome
you," he called out engagingly. "Come down!"
Well, perhaps it really was Pyongyang after all.

One of the hijackers went to the main entrance
door and was about to open it when another yelled
at him to stop. Wait - something was wrong!
He had seen a car of American make parked near
the terminal building. And just then another hijacker
turned on his transistor radio and heard English
voices and jazz music.
"This is Pyongyang!" the official on the ground
shouted. "Come down!"
"This is not Pyongyang," one hijacker shouted back
through a cockpit window. "This is Seoul. If this is
Pyongyang, show us proof!"
For proof, they wanted photographs of Pyongyang
to compare with what they were seeing at Kimpo.
South Korean officials replied that they were not
running a photographic bureau. The airport was a
military base and photographs were not available.
Something must be available, the hijackers insisted,
and demanded instead to be shown a portrait of
North Korean Premier Kim Il Sung.
In South Korea there are not many portraits of
the North Korean Premier. Certainly there was not
one to be found at Kimpo Airport or anywhere near it.
For five hours the South Koreans kept on trying
to provide some sort of proof.
None was to be found. The flowers wilted and
the girls trooped off disconsolately. The welcoming
placards were removed. The plane doors remained
closed. Finally, South Korean officials gave up.

A tape-recorded message from the tower repeated
a warning to the hijackers that they would be held
there and the plane would stay on the ground so long
as the passengers remained aboard. The hijackers
countered with a message of their own. They would
be willing to wait three or four days if necessary...
and then they would blow up the airplane.
A waiting game started. Sushi was sent aboard
by airport personnel.

As a result of the Tokyo discussions, Japanese
vice-transportation minister Shinjiro Yamamura flew
to Seoul and spent hours negotiating with the pirates.
His offer, in spirit of the Samurai tradition, was this:
If the hijackers would let the passengers go,
Yamamura would stand in as a substitute hostage
and the hijackers would be permitted to fly to
Pyongyang in the stolen plane.
Fifty of the passengers were to leave the plane at one
time, at which time Mr. Yamamura was to board;
then the other fifty would be freed, after which the
aircraft would depart for Pyongyang. The exchange
of hostages took place without a hitch nearly four
days after the hijacking had started. Passengers and
the four stewardesses got off, and Mr. Yamamura
got on; flight deck crew and nine commandos made
preparations to depart. North Korea was ready to
receive the Japanese aircraft.

* *The Sky Pirates* by James A. Arey, published by
Charles Scribner's Sons; New York 1972

SKYJACK SUNDAY OVER EUROPE

PALESTINIANS LEARNED GEOGRAPHY BY GOING FROM ONE AIRPORT TO ANOTHER

JEAN GENET, *PRISONER OF LOVE*

The Popular Front for the Liberation of Palestine (PFLP) upgraded the Cuban skyjack strategy into a worldwide political phenomenon. The 1967 Six-Day War in Israel had left 700 000 Palestinians homeless, in response the Palestinians turned to hijacking as a weapon to communicate their cause to an international audience. The potential of television as a means to affect worldwide opinion was accidentally realized during the Samurai incident in the spring of 1970. The impact was not lost on the PFLP. The strategy: Turn your cause into prime time. The method: Hold passengers hostage in full view of TV cameras, negotiate with political authorities while the world watches. The stage is set for the most daring plot in the history of civil aviation. In 1970, the 'year of the hijacker,' heavy security measures become commonplace at all major airports, and Palestine turns into a household name.

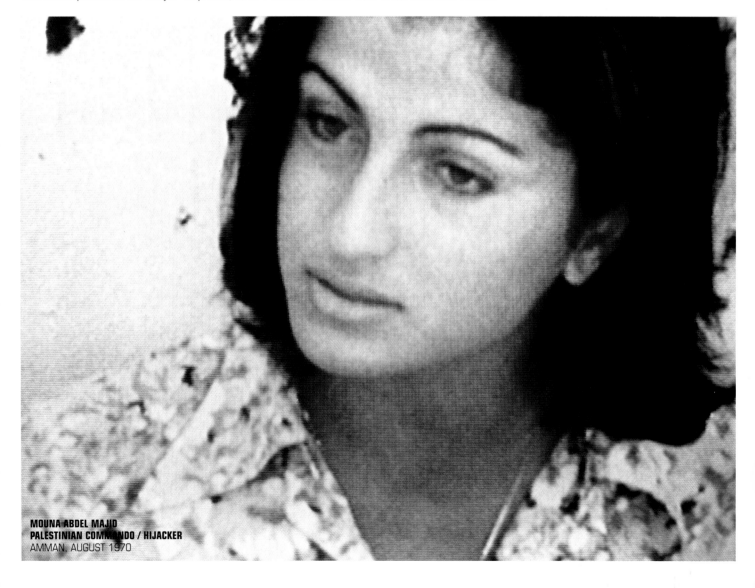

MOUNA ABDEL MAJID
PALESTINIAN COMMANDO / HIJACKER
AMMAN, AUGUST 1970

September 6, 1970:
SKYJACK SUNDAY

12:20 PM (British Standard Time):
TWA's Flight 741, an around-the-world flight on its last leg to New York, is ordered to change course and fly to the Middle East less than 15 minutes after take-off from Frankfurt. There are 145 passengers and 10 crewmembers aboard. The plane lands at a deserted military airstrip in the Jordan desert, near Amman. It is renamed "Revolution Airstrip' by the PFLP commandos.

1:12 PM:
A Swissair DC-8, carrying 143 passengers and 12 crew, is seized by Palestinian commandos thirty minutes after leaving Zurich for New York. The flight then proceeds at gunpoint to the same destination: "Revolution Airstrip'

1:45 PM:
El AL Boeing 707, Flight 219 en route to New York from Tel Aviv, with 148 passengers and 10 crewmembers aboard, has been briefly airborne from Amsterdam. Just as the first drinks are being served, veteran hijacker Leila Khaled pulls out a pair of hand grenades from her bra. Dashing from her seat with a grenade in each hand, she and her companion, Patrick Arguello, scream their way to the cockpit. Following the cue of an Israeli sky marshal, the pilot thrusts the entire plane into a nose-dive. All hell breaks lose: sick passengers, baggage, drinks and bullets catapult throughout the aircraft. Leila is overpowered on the cabin floor, Patrick Arguello left bullet ridden, one steward badly wounded: the El Al hijack a disaster.

3:00 PM:
A slight change of plans: two other members of Khaled's team, who were refused seats on the El Al Flight, book themselves instead on a PanAm Jumbo Jet 747 bound for New York, and decide to hijack this one on their own initiative. They take control of Flight 93 shortly after take-off from Amsterdam, and change course in the direction of the Middle East with 152 passengers and a crew of 17. The plane lands at Beirut to refuel, stock up on explosives, and take Palestinian pyrotechnicians aboard. The hijackers had not bargained for a Jumbo 747 when they purchased their tickets (they had trained on a 727): the aircraft is too large to land safely at the airstrip in Jordan. Instead they head for Cairo Airport. The airliner is to be dynamited upon touchdown. With only 8 minutes to clear the plane passengers run like hell. Egyptian authorities provide slippers for the shoeless passengers, as 24 million dollars worth of aircraft explodes and lights up the night sky.

The PFLP had outdone itself: four planes with more than 600 passengers plucked from the sky on a Sunday afternoon. George Habbash & Wadi Haddad of the PFLP had masterminded the most dramatic coercion in political history. The stakes: the freedom of 3 imprisoned commandos in Germany, 3 in Switzerland, almost 3000 Palestinian guerrillas held by Israel, plus the release of Leila Khaled captive in a prison in London. As the world is caught in its first large-scale, multinational hijacking episode, governments from the US, Great Britain, W-Germany, Switzerland, and Israel try to resolve the incident. Meanwhile a thousand meals a day are flown to the desert airstrip from Geneva, as well as portable latrines, disinfectants, deodorants and talcum powder.

THERE'S PLENTY OF ROOM HERE FOR MORE PLANES PFLP SPOKESMAN

September 9, 1970:
The capture of Leila Khaled, held in a British jail, gives the PFLP a headache: the Brits refuse to breach legislation by trading Miss Khaled for hostages from other nations.
Realizing they do not have British hostages to bargain her release, the Palestinians decide to hijack a British airliner. Three days after the quadruple hijack, a BOAC VC 10 with 115 passengers aboard is commandeered by three PFLP commandos after its take-off from Bahrain for London and is left stranded with the other two jets at 'Revolution Airstrip'. It is the first British commercial airliner to be skyjacked. Demand: Miss Khaled's release in exchange for the new British hostages. Among them British schoolchildren—and one pet-turtle. The newly arrived plane is renamed 'Leila' in her honor, as the guerrillas bring in 4 cases of whiskey for the Brits.

September 12, 1970:
PALESTINIAN POLITICS BLOWN SKY HIGH

The international community agrees to meet the demands. A convoy of Palestinian Commando vehicles escort the released passengers from their temporary home on the three hijacked airliners in the desert—to Amman, where a civil war has broken loose in the Jordanian capital. The three planes are blown up for the benefit of the international television cameras.
Twenty years of being treated with cynical in difference by the major world powers had apparently produced an equally cynical disregard in the Palestinians for any socially acceptable method of conducting a war, observes former air stewardess Ruby Rich in her book Flying Scared. 'Commercial airways suddenly became more dangerous than any place on earth' (Yallop 1994:42).
Elaborate security measures, armed police, metal detectors, hand luggage and body search paranoia are implemented on a massive scale throughout American and Western European airports. Air travel henceforth, will never be the same.

'Stars, that's what we were. Japan, Norway, Dusseldorf, the United States, Holland—don't be surprised if I count them up on my fingers—England, Belgium, Korea, Sweden, places we'd never even heard of and couldn't find on the map—they all sent people to film us and photograph us and interview us. "Camera", "in shot", "tracking shot", "voice off"—but gradually the fedayeen found themselves "out of shot" and learned that the visitors spoke "voice off".

'Whenever Europeans looked at us their eyes shone. Now I understand why. It was with desire, because their looking at us produced a reaction in our bodies before we realized it. Even with our backs turned we could feel your eyes drilling through the backs of our necks. We automatically adopted a heroic and therefore attractive pose. Legs, thighs, chest, neck - everything helped to work the charm. We weren't aiming to attract anyone in particular, but since your eyes provoked us and you'd turned us into stars, we responded to your hopes and expectations. —'But you'd turned us into monsters, too. You called us terrorists!

Israel calls everyone in the PLO terrorists, leaders and fedayeen alike.
They show no sign of the admiration they must feel for you. —'As far as terrorism is concerned, we're nothing compared to them. Or compared to the Americans and the Europeans. If the whole world's a kingdom of terror we know whom to thank. But you terrorize by proxy. At least the terrorists I'm talking about risk their own skins. That's the difference.'

Jean Genet, *Prisoner of Love*

THIS IS A VERY GOOD AIRPORT; WE WILL FILL IT WITH AIRPLANES IF ALLAH IS WILLING

Palestinian Commando

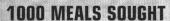

1000 MEALS SOUGHT

GENEVA, Sept. 9 - The International Committee of the Red Cross said today that it had asked its office in Beirut, Lebanon, to provide 1000 meals for the passengers of three airliners being detained in Jordan, particularly cereals, vegetables, macaroni and fruit.

New York Times, Sept.10, 1970

LIFE ON JETS HELD IN DESERT IS HARSH

JORDAN, Sept. 8 - Hostage crewmen of the two airliners being held in the desert by Arab hijackers said today that living conditions on board were bad and growing worse. C.D. Woods, the captain of the T.W.A. plane, said, "The sanitary conditions on the aircraft were good at first and they are still good but are deteriorating." Asked how long the passengers could hold out, he said, "It's a difficult question. If we could flush the toilets, we could go for some time."

New York Times, Sept.8, 1970

I THOUGHT THEY WOULD START AN AIRLINE COMPANY

Mr. Detweiler, hostage at 'Revolution Airstrip'

STEWARDESS AUGUSTA SCHNEIDER: " MEANWHILE, THIS DEMOLITION EXPERT OF THEIRS WAS LOOKING FOR A LIGHT. WE'D SEEN HIM GOING AROUND PLANTING THE DYNAMITE AND WE KNEW PRETTY MUCH WHAT WAS GOING TO HAPPEN. BUT... JUST BEFORE WE WERE READY TO LAND, THIS GUY CAME OVER TO ME AND ASKED ME FOR A MATCH... AND I GAVE IT TO HIM. WHAT ELSE COULD I DO?"

Cairo, Sept.6, 1970; PanAm 747 Flight 93 (Arey 1972:42)

HIJACKED TWA FLIGHT 847 HOPPING BACK AND FORTH BETWEEN ALGIERS AND BEIRUT, JUNE 1985:

I THINK THIS GUY IS ASKING
FOR A CREDIT CARD!

BY CAPTAIN JOHN TESTRAKE (WITH DAVID J. WIMBISH)

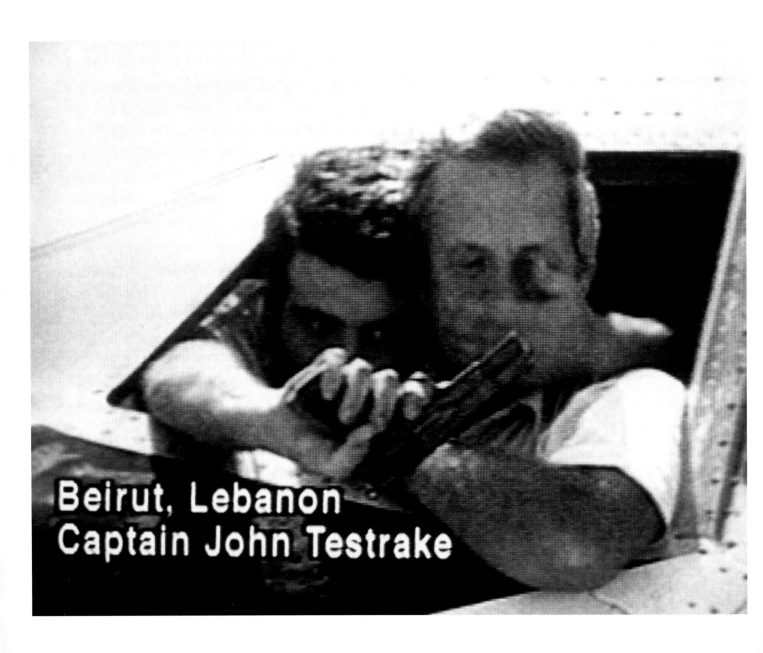

Beirut, Lebanon
Captain John Testrake

Mogadishu, Lufthansa hijack; October 1977

When the Algerians would not agree to give us fuel, the hijackers stepped up their threats to start killing passengers. When it became apparent that the threats were not made lightly, airport officials relented and sent a fuel truck out to us. When the fuel truck arrived, the hijacker with the hand grenades leaned out of one of the cockpit windows to talk to the driver. The two of them were having an animated discussion in Arabic, and as the conversation continued, the hijacker leaned farther and farther out the window.

One push – one very slight push –and we could be minus one hijacker. I looked over at Christian. As his eyes met mine, I knew that he was thinking the same thing. Our eyes locked for a few seconds as we considered whether it was worth a try.

In two seconds, we could have grabbed that guy's legs and tossed him about forty feet onto the runway below. I wanted to do it so badly I could hardly restrain myself.

I glanced back over my shoulder. There was the other hijacker, with his gun drawn, watching over the passengers in the cabin.

I turned back to Christian and saw the look of resignation in his eyes. We both knew we couldn't do it. There was no doubt in my mind that if we tried, the other hijacker would begin shooting passengers at random. They had told us they didn't care if any of us had to die – and I

believed them. It just wasn't worth the risk. After a few more tempting minutes, the hijacker pulled his head back inside the cockpit and strode off, as if he had more important matters to attend to. But whatever the topic of their conversation had been, the truck driver didn't think it was over. He began yelling about something, although we didn't know what.

Phil stuck his head out the window. Then he pulled it back in.

"He's asking me for something."

"What?" I asked.

"I don't know. I can't understand him!"

Phil leaned out the window again. "Tell me again what you want!"

I strained to understand the reply, but I could not make out what the man was saying.

"What?" Phil asked again. This time, he thought he understood.

The look on his face was a strange combination of amazement, amusement, and exasperation.

"You know what?" he exclaimed. "I think this guy is asking for a credit card!"

I leaned back in my chair and rolled my eyes skyward. "A credit card! You mean he wants us to pay for fuel so we can hijack ourselves?"

"I'm sure that's what he's asking for," Phil answered.

I looked over at Christian, who just shook his head as if he were dumfounded.

Uli Derickson stuck her head into the cockpit to see what was going on.

"Uli," I said, "you'll never guess what this idiot out here wants! He's asking for a credit card!"

Uli looked at me for a second or two as if she hadn't heard me right. "A credit card?"

She put her hand to her forehead and let loose with a half-hysterical laugh.

"He wants a credit card? I'll give him a credit card!" She walked out of the cockpit for a minute and came back with her purse.

"He wants a credit card!" she mumbled to herself as she rummaged through it.

She finally found what she was looking for.

"If he really wants one, give him this." She held up her Shell Oil credit card.

Phil took it and handed it out the window.

It was exactly what the man wanted.

Once he had Uli's card, he began pumping fuel: Six thousand

gallons at a dollar per gallon, and all on Uli's Shell credit card!

We needed to fuel again, and the original hijackers had always been able to get fuel by saying they were going to start shooting the passengers. This time, the attitude had changed completely. Jihad came into the cockpit followed by a couple of his men. With them was one of the young passengers.

▷

SIX THOUSAND GALLONS AT A DOLLAR PER GALLON, AND ALL ON ULI'S SHELL CREDIT CARD!

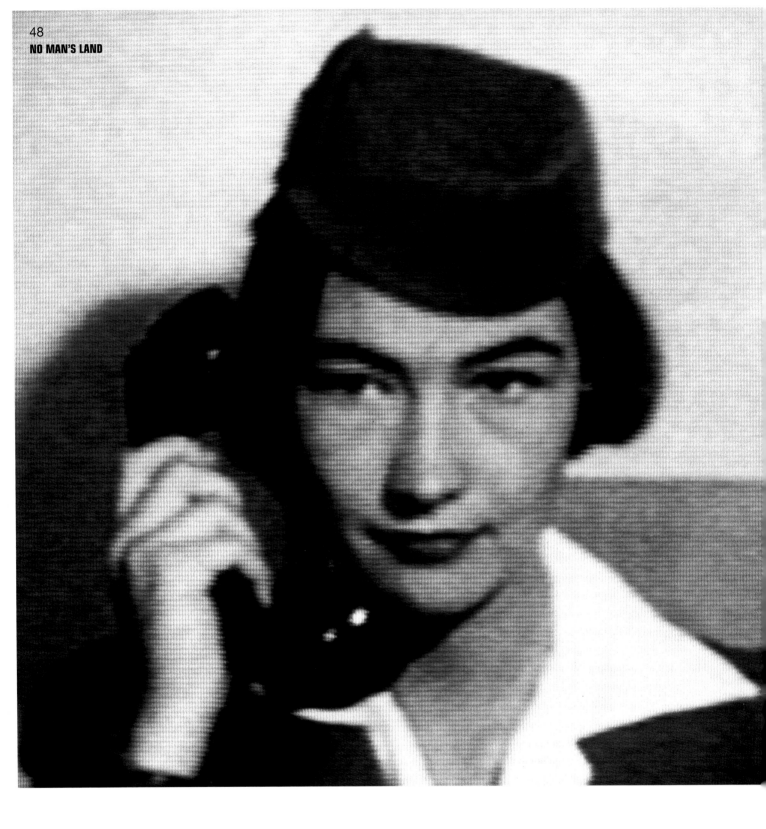

YOUR WORDS HAVE REACHED MY EARS:

"As a Palestinian, I have no honor. My pride is Jerusalem and Gaza. My pride is Haifa, Jaffa, Saffad. I'm searching for my pride, which has been stolen. I want no one to hurt my pride. It's impossible for me to hurt your pride or disgrace your honor. I respect Your Excellency's pride. The reason I landed in this country is that I knew of its great pride. If this had not been the case, I would have landed in another country."

"Your words have reached my ears"

Sheikh Muhammed ibn Rashid Al-Maktoum, controltower Dubai Airport replying to hijackers aboard a diverted JAL, July 1973*

*Source:
Hijack, 144 Lives in the Balance
by Bunsei Sato Gateway Publishers,
Los Angeles 1975

WHERE DO YOU WANNA GO TODAY?

Captain John Testrake to Shi'ite hijackers

▷

"We want to play a little game here," he said. "We need to convince the airport to bring us fuel."
He went on to explain that they were going to open the microphone, and that the young passenger had agreed to cry out as if he were being beaten. This, it was hoped, would prompt quick delivery of the fuel we needed. Unfortunately, though, this particular passenger wasn't much of an actor. He gave a couple of halfhearted cries that barely made their way out over the radio.
Phil gave him a disdainful look.
"Hey! I can do better than that."
"Then go ahead!" Jihad prompted him.
Phil immediately cut loose with some of the most bloodcurdling screams I have ever heard. Perhaps it was good therapy for Phil, letting out some of the tensions of the last few

terrible days. Whatever, I discovered that Phil is one of the all-time champion screamers. You would have thought the poor guy was being beaten within an inch of his life!
As Phil continued to scream, Jihad turned to me.
"Please open the window."
When I did, he took out his chrome-plated pistol and squeezed off three or four quick shots out the window.
The sound of those shots being fired also went out over the radio.
Actually, we rather enjoyed this little episode. It sounds bizarre, but it was a release from the tension – and we were relieved that they didn't seem inclined to start beating passengers again. Our little drama worked, too.
The fuel truck arrived within minutes to fill our tanks. But it was the same driver who had

fueled us up the day before … and he asked again for a credit card.
Phil leaned out the window and shouted down at him, "Hey, buddy! Don't give us that! We gave you our credit card yesterday!"
When he realized he wasn't going to get another credit card out of us, he went ahead and pumped the fuel.
I turned back to Jihad.
"Where do you want to go today?"

Excerpted from:
Triumph over Terror on Flight 847, Old Tappan, New Jersey: Fleming H. Revell Company 1987

OUR BLOOD IS NOT MADE OF PEPSI!

The hijackers drank Pepsis continuously and they would spill it on this center console right here where the radio switches are. They also smoked 24 hours a day and their ashes would drip into the spilled Pepsi.
They were young guys and they had good appetite, so they ate a lot. And they would spill their food in there too. It just sort of made a kind of a soupy mess all over that radio panel there.
—Captain John Testrake

TWA 847: one of the hijackers had given stewardess Uli Derickson a piece of chewing gum that she chewed on for two entire days.

The Hizbollah captor of US citizen Terry Anderson found his village shelled by the US battleship New Jersey in 1984, during which he lost his entire family, including his wife, children, grandparents, aunts and uncles. When I asked the kidnappers, in the name of Islam, to release their hostages because they are innocent, one captor replied, "But my wife, children and grandparents who were killed by Americans were also innocent!"
—M.T. Mehdi, President of the American-Arab Relations Committee, The New York Times, Aug.27, 1989

THE CREDIT MADE ME DO IT

June 28, 1969: Raymond Anthony, casually dressed in shorts and sandals and whiskey breath, commandeers a jet en route from Baltimore to Miami to Havana. Described as seedy but harmless, Anthony had received an unsolicited credit card in the mail, went out and bought too many drinks—then stumbled into an airport. Somehow he managed to board the Miami bound Eastern Airlines jet and land it in Cuba.

THIS IS OPEC HERE: WE HAVE A SHOOT OUT!

December 21, 1975: International Playboy revolutionary Carlos, AKA the Jackal, crashes the OPEC (Organization of Petroleum Exporting Countries) convention in Vienna. Eleven oil Sheiks and Ministers are captured: the richest and most powerful group of hostages in history ever. Carlos demands an airplane and shortly after, he and his prisoners are jet set. The hostages are pampered with pillows, coffee and sweets.

The Hilton provides take out services. Intrigued by their enigmatic host, Sheik Yamani of Saudi Arabia asks Carlos the real reason behind his terrorist career: "I want to be a hero" responds the Jackal. Impressed, Nigerian oil minister Dr. M.T. Akobo promptly asks for an autograph. Later during the plane ride Carlos asks Venezuelan oil minister, Jaime Duenas-Villavicencio, to deliver a letter to his mother in Caracas.

JANUARY 19, 1975: A Palestinian hit squad, led by Carlos, retrieve a handheld missile launcher from a car trunk in the parking lot of Orly Airport in Paris. They head straight for the public lavatories to assemble the bazooka, only to find all toilets in use— and worse, a queue. By the time they've assembled their weapon, their target— an Israeli El Al plane is on the runway, ready for takeoff. They decide to fire the bazooka anyway. Next a shoot-out between the Airport security and the Palestinians. Pandemonium follows: the hit squad heads for the toilets again, this time taking 10 hostages. Notes are slipped under the toilet doors during a 17 hour negotiation phase. (Yallop 1993)

ILLICH RAMIREZ SANCHEZ, AKA CARLOS, THE JACKAL

SANA'AH MUHEIDLI
Beirut 1985

GET KILLED,
AND MAYBE THEY WILL NOTICE YOU*

WHEN I READ IN THE PAPERS ABOUT A VIRGIN OF SIXTEEN BLOWING HERSELF UP IN THE MIDDLE OF A GROUP OF ISRAELI SOLDIERS, IT DOESN'T SURPRISE ME VERY MUCH. IT'S THE LUGUBRIOUS YET JOYFUL PREPARATIONS THAT INTRIGUE ME. WHAT STRING DID THE OLD WOMAN OR THE GIRL HAVE TO PULL TO DETONATE THE GRENADES? HOW WAS THE BODICE ARRANGED TO MAKE THE GIRL'S BODY LOOK WOMANLY AND ENTICING ENOUGH TO ROUSE SUSPICION IN SOLDIERS WITH A REPUTATION FOR INTELLIGENCE?

JEAN GENET, *PRISONER OF LOVE*

HUMAN BRIDE BOMBS

The Shi'ite fraction National Resistance Front (PPS) based in South Lebanon, announced on April 1985 that 17 year old San'ah Muheidli had become the first woman suicide car bomber to perish in action. San'ah Muheidli was a member of the "Brides of Blood", a team of teenage girls trained for suicide missions. Before she set out to meet her fate, she recorded a suicide note by way of video, explaining her actions: "I am very relaxed to go on this operation because I am carrying out the duty to my people. I decided on self-sacrifice and martyrdom for the sake of liberation of our land and our people, because I have seen the tragedy of our people from the humiliation of occupation and oppression, the killing of children, women and old men." She exhorted her mother not to mourn her death, rather "be merry, and let your joy explode as if it were my wedding day." Sana'ah had told her parents that she was off to buy lipstick. Then she drove off in a white Peugeot stuffed with TNT, crashing it into an Israeli convoy. She killed herself and two soldiers.

WE DO HISTORY IN THE MORNING, AND CHANGE IT AFTER LUNCH*

The videotapes distributed to Western news agencies bewildered the world. NATO forces, comprised of Americans, British, French and Italians pulled out of Lebanon. Tank-trap devices appeared outside the White House in Washington DC. US warships in the Mediterranean were on alert to the possibility of kamikaze style attacks with small planes by Hizbollah terrorists. Around the world, millions were spent on updating defense diplomatic missions against this new threat.

HAND OF SUICIDE: BOMBER FINGERPRINTED

December 12, 1983: A severed hand is identified as the only recognizable part of 21-y old Raad Maftel Ajeel, a Shi'ite Iraqi refugee living in Iran. He crashed his General Motors truck through the gates of the US embassy in Kuwait, detonating his cargo of explosives together with himself.

* Don DeLillo: Mao II

SANA'AH TOLD HER PARENTS SHE WAS OFF TO BUY SOME LIPSTICK

DO YOUR
DISAPPEA

FAMOUS RING ACT

Skyjack Air™

THE SKYJACKER'S PROFILE

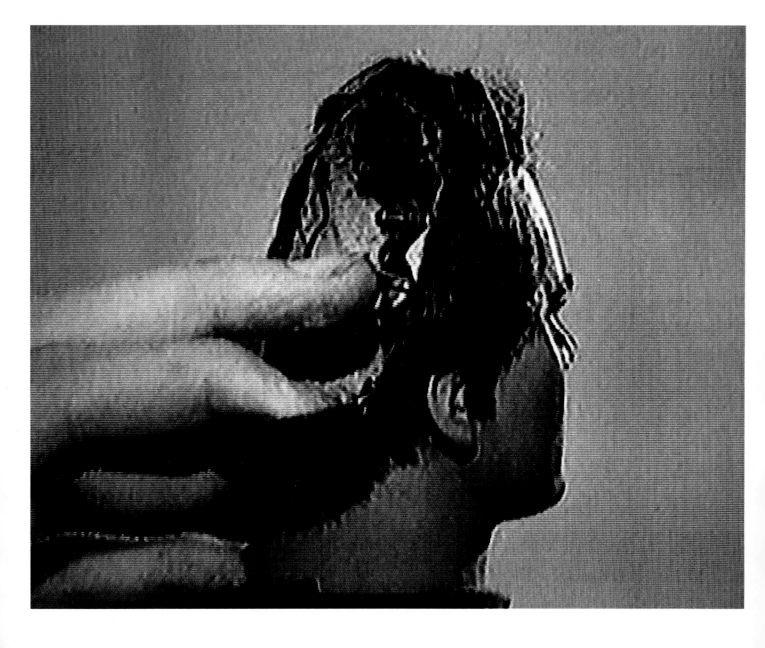

PSYCHIATRIST DAVID HUBBARD, AND HIS STAFF AT THE CENTER FOR ABERRANT BEHAVIOR IN DALLAS, TEXAS, INTERVIEWED A DIVERSE RANGE OF HIJACKERS: FROM MENTAL PATIENTS TO HENPECKED HUSBANDS; WOULDBE REVOLUTIONARIES TO GOVERNMENT BUREAUCRATS. IN HIS BOOK *THE SKYJACKER. HIS FLIGHTS OF FANTASY*, HUBBARD SPINS A FREUDIAN TWIST ON THE HIJACKER PHENOMENA, EXPLORING HOW THE IMPACT OF GRAVITY, SEX AND THE 1960'S SPACE RACE FUELED THE MIND OF THE PSYCHOTIC SKYJACKER. IN THE 1970s HIS THEORIES BECAME POPULAR—A LEGITIMATE MEANS OF DIVERTING ATTENTION FROM THE POLITICAL MOTIVATIONS OF SKY-JACKERS, REDUCING THE ACT TO MERE SEXUAL FOREPLAY IN A CONTEXTUALIZED FREUDIAN FLYING MACHINE.

In his analysis, Hubbard noted evidence of a subtle disturbance of the 'inner ear', which affects the hijacker's body image and sense of gravity, defined as: "vestibular disturbance". The vestibulum or inner ear, controls and stabilizes the body's equilibrium. When its function is impaired, a person will feel unsteady and unable to maintain a balanced body posture. One skyjacker, who returned by sea from Cuba to the US, continued to sway for a week after disembarking the ship.

This physical disturbance of the inner ear causes emotional instability, hence the skyjacker's obsession with flight and motion in times of emotional stress to overcome his troubled relationship to gravity. A recurrent theme is the skyjacker's dreams and fantasies of flying— and his angst at falling. There are also the aspirations to become a pilot or astronaut, which contrast with a miserable self-image, often one trapped in an intolerable existence. In one instance, a hijacker displayed a keen identification with Laika, the Russian space dog—the first animal shot into orbit. Hijacking, it seems, realizes his fantasies and represents an act of sexual conquest. This is his chance to triumph over the limitations of space and gravity, while gaining an international forum to air his grievances. Airplanes become glamorous symbols of power and a spectacular means of escape. The hijacker can literally get away from his own pathetic existence and enjoy a brief moment of celebrity.

In a final desperate attempt to cope with his physical and emotional imbalance, the skyjacker literally lifts himself out of his seat and takes control of the airplane. Affirming the ability to stand "like a man"— in the air, symbolizes freedom from his uncontrollable relationship to gravity. In the patient's imagination, the aircraft once airborne (the umbilical cord is cut once the cabin doors close) becomes a social micro-cosm under the leadership of an omnipotent pilot. Simply by grabbing his pistol, the sky-jacker accomplishes a coup d'état, usurping the pilot's authority.

In proving to himself that he can "stand like a man", he also abandons his passive identification with his mother in favor of challenging the domineering father. Symbolically he assaults the stewardess with a gun, in what, according to Hubbard, is probably his first aggressive sexual act against a female. By commandeering the plane, he also defeats his father—the captain. He identifies with the pilot, the man with wings on his chest, who makes his dream come true.

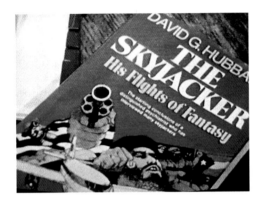

GRAVITY AS A PSYCHIATRIC CONSTRUCT:

FIRST STEP TOWARD A THEORY

Dr. David G. Hubbard*

My plane ride back to Dallas was pleasant. I was thinking about the exultant feelings of hijackers and their response to breaking free from the ground. I thought about floating ecstasy, of their sensations of being so high, and of earth's being so tiny and so far away. To them, it was in the act of flight, they had achieved their manhood. Why, I wondered, should flight, with its implied sense of freedom, both specific and symbolic, be the ultimate expression of self-hood for them? The Freudian approach through the sexualized relevance of this material offered a ready explanation, but somehow it lacked adequate applicability for us to "feel right" about its theoretical appropriateness in these cases.

My attention now turned to my distinct impression of the coexistence of "dual realities" in the hijackers, which struck me as being so firmly intertwined as to be indistinguishable. But in the process of skyjacking, the realities had become, momentarily, detached and identifiable and, in that moment, aspects of each reality also became capable of symbolic substitution between themselves. The two 'realities': were: (1) physical attraction of mass for mass, which in its aggregate is called "gravity'; this reality is physical and basic; (2) emotional attraction of human being for human being, which in its aggregate is called "social compact"; this reality is physical and basic. If the force of physical attraction (gravity) cohesively holds the earth together in its physical structure, so too does the force of emotional attraction (compact) cohesively hold society together in its social structure. Could it be possible that the latter fact (compact) is patterned upon the former act (gravity), and could, indeed, even be its prerequisite? For the human infant in the beginning, it is undoubtedly true that one of the most evident benefits of "belonging to the human race" is that he can be moved about by the adults in his surroundings. Before he has learned to move himself about, he learns to cry or to stretch out his arms in order to bring others to him, because

they can defeat the gravity which binds him to his position. Perhaps motion of any kind seems valuable and might lead to a desire to emulate the figure who seems most able to defy the physical environment—in most cases, the father. Thus, the first understanding for the infant would be the "power" of gravity itself, and the second "power" of the adult who could defeat gravity physically. Later as he learned the "power" of the ethical system which could defeat both gravity and the father's physical power, he would achieve the ultimate in controlling his environment. Obedience to the social compact would be seen as essential to participation in the highest power.

The skyjacker's ultimate challenge appeared to lie in his simultaneous defiance of both realities. Flight is the defiance of physical gravity, murder/suicide the defiance of emotional gravity. In the process, he set himself against the total environment (reality) at the risk of death. In one abrupt action, in the wild hope of breaking his emotional chains in order to "live," each of these men broke both gravitational and social ties. In psychiatric terms, the id denied the super ego at the price of possible death. Starkly manifest here is the notion that if a man would fully live, he can do so only if he gambles his person, his life, and his status; just as when the infant first dares to stand in the "unknown" of vertical posture, he must assume not only the load of a heavy burden, but the possibility of falling and being destroyed.

I CAN SIMPLY MOVE MY ARMS LIKE THIS [FLAPS ARMS] AND GO WHERE EVER I WANT

If the struggle against gravity is indeed inherent in man, then his history and behavior ought to reflect it. At the moment of birth, the force of gravity is the first thing the infant becomes aware of when he is thrust out of the sac of amniotic fluid in which he had been suspended*. In studies of newborn infants it has been noted that the only fear common to all is the fear of falling—an expression of their increased awareness of

the strange new force of gravity. The fear of gravitational pull may well serve as the paradigm of all subsequent fears. Certainly the attempt to overcome gravity constitutes the principle struggle of the early years of existence. The child must first manage to control his position in the crib, and then to crawl, walk, run, and jump. Gravity is the cause of the first ego strain. One may say, "Where id was, there shall ego be.**" and its perpetual antagonist is gravity, which speaks through its own organ. Such a view contained within it elements of psychiatric "heresy," but I reconciled myself with the thought that, at the same time of the evolution of Freud's theory, man's movement was basically still restricted to the limits of his own physical neuromuscular system. Man was only beginning to defy earth's gravity through the technologies made possible by reciprocating engines, jets, or rockets. In effect, what I had postulated might well be considered as one result of an "age of flight" of man's nature. As the pre-Freudian period was unable to expose the presence of an unconscious because of hypocrisy and taboos, so Freud's age was unable to recognize fully the import of gravity to the development of the human personality.

This thought brought to mind the similarity between these cases and the symbolic meeting of the space program, through which man, in his infinitely id-ish way, taxed the capacities of his ego to rape the heaven. In its ultimate form, man intends to project his own seed into the universe, whether she is willing for him to do so or not, and in direct defiance of gravity. In the period since 1957, much of American man's national interest, personal ambition, dreams, and his conception of his own person has been wrapped up in the space program. In 1961, the first fruit of the program was harvested. This led me to speculate that in stealing aircraft in the same year, downtrodden, helpless misfits were unconsciously attempting to identify themselves with an astronaut (a space rapist), rising to the heavens of elation from the

▷

HONEY, WE'RE GOING ALL THE WAY!—TO CUBA

WELL, HONEY, IF YOU WANT A DIRECT FLIGHT, I'VE GOT A GUN YOU CAN BORROW*—*Skyjacker to Stewardess*

January 1972: Havana Hijack
PACIFIC SOUTHWEST AIRLINES

Here is a man who has really no sexual experience at all, who looks at the hostess as a sexual symbol and when he takes his gun and sticks it in this goodlooking girl's belly and says "Honey, we're going all the way!—to Cuba", he may very well be making the first sexual gesture in his life.

THERE'S A BIT OF THE SKYJACKER IN ALL OF US
DR. DAVID G. HUBBARD

NOTORIOUS

The basic dream described to me again and again by skyjackers I interviewed is this: " I can fly, not like in an airplane but all by myself, I can simply move my arms like this [flaps arms] and go where ever I want." In such a dream, one defeats gravity, the ultimate physical force, without the expenditure of energy and the use of mechanical devices we require in real life. The persistence of this dream among skyjackers, long after the time when most adults have given it up, is intimately related to their limited grasp of reality and their fantastic expectation, they fail at everything. Their failures increase their self-deception, and their need to perform some notorious act.

I'M ANTI-GRAVITY!

Gladys, Skyjacker Girl

JULY 24, 1961: JOSÉ MARTI AIRPORT, HAVANA.
US SKYJACKER CRASHES PARTY FOR RUSSIAN COSMONAUT EMBARRASSED CASTRO WATCHES

They thought we were the Soviet cosmonaut Gagarin arriving,' recalls Captain W.E. Buchanan, pilot of the second American airliner to be hijacked to Cuba. While Fidel Castro adds final touches to his official welcome for the world's first cosmonaut Soviet Major Yuri Gagarin, a hijacked Eastern Airlines turboprop screeches to a halt on the Havana landing strip.

▷

hell of their own despair.
They had come to a time in life in which they could no longer bridge the gap between their knowledge and the mysteries by an act of faith, through which they had been able to transcend self previously. For their loss of psychic transcendence, they substituted physical transcendence in an aircraft, in search of a new homeostasis.

SKYJACKING AND THE SPACE PROGRAM

I had already gathered the available information about manned space flights, and now I found that the immediate correlation between the commencement of space activity and the commencement of the skyjacking was striking.
The years 1961, 1965, and 1968-69 showed a relationship between major outbreaks of skyjacking and maturation of Friendship, Gemini, and Apollo families of space vessels. Ordinarily, the Apollo series would have occurred in 1969, but President Johnson accelerated the program. Even so, as it turned

out, the principle "pulse" of the skyjack effort covered a period of roughly July, 1968, to July, 1969. Apollo XI, with the first live satellite television coverage to Europe (which created the world's largest television audience), caught a relatively unguarded foreign population off-guard and got a proportionate response from those areas through skyjacking.

If it were true that the sudden onset of skyjacking in the United States had occurred in the same year as the beginning of our space effort, it seemed wise to look more closely at that year to see what specific relationship, if any, might exist between the two sets of events.
A review of newspapers for the year yielded dates on both skyjacking and manned space flight. The first skyjacker rose in the five-day period between the first USSR and the first US effort. The fourth man did the same in the five-day period between the second US and USSR shots. The others were tightly clustered nearby.

Both sets of events occurred close together in about a ninety-day period. The newspapers at the same time were particularly interesting in that, at both the start and the finish of the ninety-day period, a single front page would include an article on a space shot just recently completed, a skyjacking on the day of issuance, and a space shot in countdown! The articles even touched each other. Like the staff man who hummed, "Oh, if I had wings of an angel," the compositor of this page knew more than he knew he knew.

* Excerpted from:
The Skyjacker. His Flights of Fantasy; by David G. Hubbard; New York / London: Macmillan 1971

* An environment comparable to amniotic suspension is employed to study relative weightlessness and the effect of sensory deprivation.

**Sigmund Freud: *New Introductory Lectures on Psychoanalysis*; in: *The Standard Edition of the Complete Psychological Works of Sigmund Freud*, Vol.22, 1932-1936 (London: Hogarth Press, 1964), p.80

WE COULDN'T HAVE BOUGHT A TRIP LIKE THIS, SEEING ALL THE THINGS WE'VE SEEN, RIGHT, KIDS?

Hijacked mom, September, 1970 Black September Hijack, Amman, Jordan

August 26, 1994; Morioka, Japan:
TRAIN PASSENGERS PAY TO BE HIJACKED AND TAKEN HOSTAGE—
Six hundred tourists board a Japanese bullet train with the thrill of knowing they will be terrorized and taken hostage. They paid 400 dollars each for the experience. The tourists, mostly women, took the ride as part a mock hijack sponsored by a theatre company and Japan's National Railway. Like any good mystery, the passengers and the organizers had various motives participating in the scheme. The producer and writer who developed the plot said it was a good way to get their work seen. The Train Company was pleased too: the entertainment helped them sell seats.

BOY, WILL THIS EVER GET THE BUREAUCRATS OFF THEIR ASSES FOR A WHILE!

Here is exhibitionism and increased identity, curiosity, sexual longing, admiration and the wish to identify, hostility towards authority, and delight in iconoclasm. The passengers had all these additional delightfully enjoyable sensations for the price of their tickets. Singularly important among the passenger reactions is the sense of hostility towards the government (which robs them of their taxes) and birdmen (who rob them of their sense of pride). The wish of most is to be part of showing them up. These attitudes are only slightly different (and only because of better defenses) from those of the skyjackers. To a greater or lesser extent, we are all earthbound and resentful of that fact.

The "scapegoating" of the plane (flag, nation, bureaucrats), the pilot (birdmen in general and astronauts in particular), and the "raping" of the hostess (little sisters, mothers, and the last woman who turned us down) is not just the activity of the skyjacker. He speaks for the mob, i.e., all of us, in his sick moment. Since the public knows the rules of the game as well as the major players, they sit quietly for a free ride to Cuba. They know that the game, correctly played, makes them celebrities too, among their circle of friends when they relate the tale. For a moment, too, they also run away from wives, mortgages, the International Revenue Service, and the church appeal. "My God, history is being made, and I'm part of it!"

LOVERS PACK BATHING SUITS AND SET OFF TO 'CATCH' PLANE *

A Casestudy by Dr. David G. Hubbard

GLADYS

Gladys was the only female in our sample, and one of the very few women who have been involved in skyjacking; she was nineteen years old.

Asked about dreams, she readily reported recurring dreams of flying. 'I'm flying, I'm able to fly, and I'm flying and flying and flying—just me, flying.' She described herself as 'anti-gravity, very.' She enjoyed the leaps in ballet lessons because they got her off the ground. 'Wow, that is what you want, to fill yourself up with air and the sensation of flying is such a thing I was after. I'd jump and try to defy it—to stay in the air. Just to try to keep on jumping.

She met George the summer she turned seventeen. 'He was leaning against the fence, oh, wow! He had a suede jacket on, that's right, and a white shirt, and blue jeans, and he was just leaning there, waiting. And I walked out and he saw me and he was still waiting because he wasn't really waiting for me, he was waiting for something else." In ecstatic terms, she described their relationship: 'We'd do everything together, and we'd get so silly, we'd laugh for hours over nothing. We'd play these silly word games. We did everything, man, pillow fight, run around, play baseball. Oh, wow! He's so beautiful. Wow, when I make love to him—when I made love to all those other guys. I turned myself off, but with him, oh! It's so different! It's like a whole new thing.' She denied having used mind-expanding drugs, except LSD on two occasions—both times with George. On one acid trip, two months before the crime, she experienced a feeling of flight. 'We got to the top of a hill,' and I said, 'Can we actually fly now, can we actually jump off this world, you know.' She took LSD because

George was doing it and she wanted to be with him. 'I'd say, 'Well, if you're high and I'm not, how can this work?' So we took acid together.' She was hostile toward the space program. 'Okay, here are these fools, trying to fuck the universe, right? With their little rocket. Right? Infinity goes both ways. Naturally it goes out, but it also goes in, into yourself, past, past everything.'

She did not particularly want to go to Cuba, but felt 'there doesn't seem to be any place for us, there really doesn't.' She felt the skyjacking was necessary for the sake of George's 'manhood,' not for the sake of going to Cuba. 'You see, to me it was like the coming of manhood for him. The first stand-up and the like, all the other time he was hiding.' She loved the flight itself. 'There was the elation, yes. It was the seas and the water. It was beautiful. It was a beautiful flight—and I felt elated.'

She often felt separated from her body. She saw her body as 'meaningless, sad.' She said she felt 'above' her body. 'I'm a mind, and I'm lonely, sad, lonesome, a sadness in my throat, but I'm not even aware of my body very much.' She retained definite suicidal tendencies. She had an urge to jump from balconies whenever she was on one. She said that she would enjoy jumping out of a plane. Death to her was a redirection of the energy of life. 'You can't destroy energy, it just changes, so you change, and maybe clouds are the souls of people who die. I would like to fly straight out into the arms of the stars, into the night and feel myself thinner and thinner, like cigarette smoke, until I was the stars in the night, you know, so maybe I was just like one of them.'

IF I WERE TO KISS
YOU HERE THEY'D
CALL IT AN ACT
OF TERRORISM—SO
LET'S TAKE OUR
PISTOLS TO BED,
WAKE UP THE CITY
AT MIDNIGHT
LIKE DRUNKEN
BANDITS

TAZ; Hakim Bey

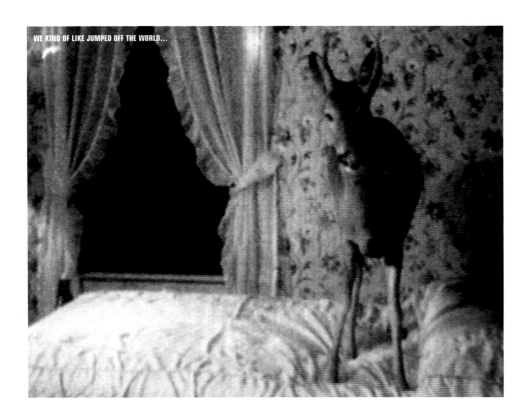

WE KIND OF LIKE JUMPED OFF THE WORLD...

GEORGE

George was white, twenty-one years old, highly intelligent. One of his earliest and most frequent dreams was of floating. 'Generally a very 'up' feeling, drifting over landscapes. For some reason, there's always a corner block. On numerous occasions in dreams, he was rooted to the ground by a great heaviness and was unable to 'break free' of the pull. At such times, he made no effort to physically break free. He either floated spontaneously or awoke in fear. The heavy sensations he experienced when he was awake and in non floating dreams have continued to the present time. He reported that he wet his bed until he was at least twelve years old.

After his relationship with Gladys began, they tried LSD together. 'Making love was very, very beautiful. We were very close then.' Speaking for his love of her, he said, 'It's hard to put into words. It's kind of like two pieces just fit together. I remember the feeling. It's difficult to remember the joy of every day.' I had been living so soft all my life without working. It was difficult. I was chained by a lot of things, cigarettes, Pepsi-Cola. I didn't want to give those things up. So I was incapable of getting out of it, but I was capable of staying in it. So I felt that if I

made a big jump into a new situation, things would get better, because I had always had a lot of difficulty in making decisions, making changes.'

Dreaming of Cuba, the two of them thought: 'We get to Cuba and we get in a corner of a sugarcane field somewhere and we just start chopping. That's the type of life there'd be. That's all there was to it.' He admitted it would have worked in Tahiti, or any other place as well. The idea of going to Cuba came to him while he was taking a course in Latin American history. He got the impression that Castro had improved the country, especially in comparison to other Latin American countries. He mentioned his fantasy to her, and she fanned it with helpless little questions like, 'could we really do that?' He would bravely reply, 'Yes', and finally found himself committed to a course of action.'

They began to discuss their going to Cuba seriously. 'It was always a ridiculous possibility that was going to be tried. Perhaps the idea took a month and the preparation not more than two weeks. I had read a few things about Cuba. I knew that something had to happen. We thought it was a good idea in the first place, because of the simplicity of it and the almost

nothingness that you had to do. You didn't have to really force anybody to do anything because the responsibility on them was so great, they weren't in a position to counteract it. I thought that was probably the best reason for doing this type of thing. Also because it was easy... I was kind of looking toward Cuba as the skyjacker, stealing, some kind of welcome. The downtrodden American fleeing the oppression of the capitalists and all that kind of thing. It became a romantic type of thing, the land of milk and honey, and all that type of stuff.'

For weapons, they got a paring knife from Gladys' mother's kitchen and bought a can of insecticide. She bought the ticket with funds in their joint account. They took a train to New York where they boarded the plane, sitting across the aisle from each other. When he decided it was time, 'I really didn't feel much momentum getting up so I put my head down. I was going to count to ten, and when I got to ten, stand up. I still didn't have much momentum. So I had to go all the way to about sixty and finally opened my eyes and got up and walked through the curtains.'

Excerpted from: The Skyjacker. His Flights of Fantasy, David G. Hubbard; New York / London: Macmillan 1971

DELTA IS READY WHEN YOU ARE

After the breakup of his marriage, William Herbert Greene III, a thirty-year-old unemployed movie cutter, had displayed rather peculiar behavior for several months.

In April 1972, he left his job and from then on wore only women's clothes, in accordance with a divine order communicated to him on the radio. Several days later, he left Los Angeles, again following God's command as revealed in a song. In a stolen automobile he drove to San Diego, then to Mexico, and then back to San Diego for no apparent reason. Suddenly he decided to fly to New York to visit his sister. When the plane landed in Chicago, he grabbed another passenger's bag in front of a crowd of people.

To his disappointment, he was not arrested; the passenger only demanded the return of the bag and did not pursue the matter. Next, Greene was commanded by God via a television movie to visit the space center at Cape Canaveral. Complying with the order, he flew to Florida and planned to steal a police car in Palm Beach. Then he noticed a sign saying, "Delta is ready when you are." Recognizing the divine order, he boarded a Delta plane and when it was airborne, passed the hostess a handwritten note claiming that he had a pistol and that he wanted to be flown to the Bahamas and to be given half a million dollars.

The pilot suggested to Greene, who never left his seat, that they return to Chicago and permit the passengers to disembark. Greene calmly agreed, and when the plane arrived in Chicago, he was arrested without resistance. He did not possess a gun, nor did he have any idea what he wanted to do in the Bahamas. (Hacker 1976:95-96)

BURSTING INTO THE COCKPIT

July 12, 1968; Delta Flight 977:

Ten minutes after bursting into the cockpit, Hijacker Oran Daniel Richards suddenly broke into tears and dropped into a crouch on the floor. Sobbing uncontrollably, he asked for his mother.

(Arey 1972:129-130)

A VERY TALL AND SLENDER BLACK MAN, SIX-FOUR OR FIVE

On the morning of December 19, 1968, Thomas George Washington of Philadelphia, a 29-y-old unemployed chemist, appeared unexpectedly at his former wife's apartment and asked permission to take his 3-y-old daughter Jennifer for a walk. His former wife, Joanne, from whom he had been divorced since March of that year, gathered the impression that father and daughter were to spend the day in town together, probably shopping. Not long after leaving Joanne's apartment, Washington and his little girl boarded an Eastern AirLines DC-8 bound from Philadelphia to Miami. Flight 47 was scheduled as a nonstop flight, but Washington changed the schedule, and a stop was made... in Cuba. During the hour or so it took to reach José Marti Airport,

Miss Uta Risse, the 23-y-old German-born stewardess, sat in the last row with the hijacker and the child. Washington did not seem particularly menacing. Miss Risse said she was worried but not scared, and the hijacker was very nervous. "A very tall and slender black man, six-four or five, and he was shaking, and once he cried and said he was doing it for his daughter. The little girl was crying, and I cried, and she used some tissue I had given her to wipe my tears." When the plane landed in Havana, Washington apologized to the passengers and the captain. "I'm sorry", he said. "I wouldn't have hurt anybody." And, with the little girl in his arms, he left the aircraft escorted by six Cuban soldiers.

(Arey 1972:104-5)

TO CUBA WITH LOVE...

June 22, 1969: The Perezes did not appear to be seasoned travelers. They were conspicuous at the airport terminal —they were each carrying four or five paper bags. The Eastern AirLines jet was about to take off from Newark to Miami with eighty-one passengers and a crew of eight. The Perez family seated themselves in the rear section of the plane, fumbling with their paper bags. Mrs. Perez seemed to be extremely nervous and uncomfortable. She spoke only to her husband, who muttered back in monosyllables. Mr. Perez suddenly stood up in the aisle and started speaking in Spanish to stewardess Rosemary Evans. She did not understand what he was saying at first, but quickly got the picture when he pulled out a butcher knife and said, "Havana, Havana!" With the aid of the knife he persuaded her to unlock the cockpit door. His English was limited to "Havana, Havana", so his daughter came in and translated. In the cockpit, the mini-skirted teenager interpreted for her father. His sick wife wanted to see her family in Cuba before she died. Havana it was. At 11:55 A.M., half an hour after Flight 7 should have touched down in Miami, it landed at José Marti Airport. Hijacker, wife, and daughter disembarked. The mother's knees buckled when she got off the plane, and she almost fell. One of the militiamen grabbed her and kept her on her feet. And so the Perez-Esquivel family was home. (Arey 1972:107-9)

SOS LIPSTICK

Miss Mary Alice Ireton, of the United States Information Service, heard shortly after take-off the sound of a gunshot coming from the cockpit; the pilot had been killed. The purser then ran into the cockpit and was fatally wounded.

Miss Ireton said she heard another shot and later assumed it had been fired to intimidate co-pilot. Miss Ireton said that when she looked down and saw the Philippine coast receding she realized that 'the only place we could be going was China'. The airliner was spotted by the pilot of a Nationalist Chinese Air Force fighter.

Miss Ireton saw the fighter draw close, noticed the insignia and 'frantically painted SOS SOS on the window with her lipstick.
(Dec.30,1952; Philippine Air Lines leaving from Laoag airport for Aparri; mentioned in:Phillips 1973:39-40)

"HER" SKYJACKER

One US airline hostess regularly visits "her" skyjacker in prison. She wants to wait and marry him after he gets out of prison some ten to twelve years from now. (Hacker, 112)

DOG GAY AFTERNOON

Brooklyn, New York; August 22, 1972:

It was probably the most unusual bank robbery in history. The two gunmen, who told the police they "were gay," apparently wanted to get to Denmark on a hijacked plane for a sex-change operation for the leaders' "wife". The bizarre train of events began at 3pm: homosexual friends of the gunmen visit the scene to kiss them in the bank doorway to the cheers of a huge crowd. At 11.25pm leader, John Wojtowicz tosses out handfuls of $1 bills. Shortly after FBI agents deliver three large pizza pies to the front of the bank. Next: the gunmen demand a plane and set off with the hostages to Kennedy International Airport. Eighty police cars and three helicopters force them to finally give in.

(The New York Times; August 23, 1972)

HIJACKERS TREAT HOSTAGES TO HIJACK FLICKS

Beirut; June 1985: Passengers held in Beirut, following the hijack of TWA Flight 847, were treated to three videotaped Al Pacino flicks, including Dog Day Afternoon—which was inspired by the Brooklyn hijack/bank robbery scenario of 1972. Money and plane were for a sex change. (Carlson 1986)

JESUS CHRIST SUPERCIGAR

April 16, 1972: Mario Maimone, who describes himself as the reincarnation of Jesus Christ Superstar, hijacks Swiss Airplane with a cigar. He convinces the pilot his cigar is a powerful explosive and diverts the plane direction to Rome for lunch with the Pope.

SECRETS OF FATIMA

In the summer of 1981 a former Trappist monk, Lawrence James Downey, holds captive the captain and passengers of an Aer Lingus Boeing 737 flying from Dublin to London. He demands that the Pope publicly releases the Third Secret of Fatima revealed to a Portuguese girl in a vision. A troop of French counterterrorists cordon off the airfield and persuade the hijacker to surrender.

SUPERMARKET HISTORY

INTERVIEW WITH JOHAN GRIMONPREZ ABOUT HIS FILM *Dial H-I-S-T-O-R-Y**
BY CATHERINE BERNARD

Catherine Bernard: Paul Virilio once said, "To invent the ship is to invent the shipwreck, the train the derailment, and so on." In your film *Dial H-I-S-T-O-R-Y*, the opening line, "Shouldn't death be a swan dive, graceful, whitewinged, and smooth, leaving the surface undisturbed?," also seems to relate speed and death, history and speed.

Johan Grimonprez: I'd like to quote Nixon from *Dial H-I-S-T-O-R-Y*, who, while speaking to an audience of scientists, paraphrased Virilio. He said something like: "If it wouldn't have been for science, there would be no airplane, and if there was no airplane there wouldn't have been any hijackings, so we could make the argument that it would be better not to have science at all." True, every technology invents its own catastrophe. TV technology has reinvented a way to look at the world and to think about death. That is, in fact, what the film is about. It analyzes how the media participates in the construction of reality. We could say that with the reinventing of reality, a culture of catastrophe is also being invented, and with it a new way to look at death. The acceleration of history is also related to technology: The film shows both how TV news has been historically presented, and how it has been accelerated by the new technological means of recording reality. The film ends with the camcorder revolution: honeymooners who inadvertently taped a hijacked, crashing plane, and were immediately invited onto CNN to host Larry King's talk show. It reveals how the distance between spectator and history has entirely dissolved. The spectator has become the hero; now the "Best of Homevideo" programs even urge us to send in our own little catastrophes.

The title refers to the multiple choice of automated voice-mail systems. How is the relation of hijacking to history presented in your film?

It is true, history conflates with hijacking. The plane is a metaphor for history. It is transgressive, always on the move between several countries, between several homes. Nowadays, home is a nomadic place. The Palestinians didn't have a country so the airplane became for them a sort of house. At the end of the sixties and seventies, the political implication of home became very clear. Leila Khaled stated in an interview that because there was no Palestinian territory, war had to be fought in a plane; the plane is claimed as home, in a state of nowhere. Hence, the recurring image of the flying house, appropriated from The Wizard of Oz. The

twister which carries Dorothy's house over the rainbow into the land of Oz parallels the hijacking of a plane across a violent border towards a political utopia.

Dial H-I-S-T-O-R-Y is like supermarket history: There is so much available and history cannot be understood as singular. It tells of how history is recorded and catalogued, and how these techniques accelerate and accumulate memory, almost as an excess of history. If you punch the word "hijacking" on the Internet, or look for footage on <www.footage.net>, you get so much information that you don't know where to start. You are already lost in push-button history, so you have to zoom in on specific aspects. In focusing on hijacking, I chose one detail which revealed history in another way. Looking at details is much more concrete because history, after all, is the conflation of the personal with the global.

Hijacking takes place between spaces, political and physical. It has the possibility to literally explode historical dialectics: Bombs explode rationality. So could terrorism represent a moment outside of historical determinism?

History is always on the move, one step ahead. It is not fixed or in place, so hijacking is very much part of history. History is always happening between places, right?
It is only afterwards that the structures of power consolidate it into a text, an image, a TV series, a narrative. History is read differently by different people—for example, the Palestinians and the Israelis. Vincent Alexandre, the assistant editor, was doing research at the TV Archives in Cairo and was looking for images from the colonial period tracing Palestinian history, but all of them had been removed by the Israelis, either destroyed or stored somewhere else. So, if Palestinians have been written out of history, then by hijacking they can reinscribe themselves in it.
Abstract statements about terrorism are hard to make. The whole terrorist spectacle has been absorbed by a game of political masquerade: Right is playing on the icon of the Left—government is playing terrorist. It is more perverse than simple dialectics or a destructive bomb: David Yallop was interviewing Carlos, for the book *Carlos the Jackal*, and realized in it that he was not dealing with the real Carlos. There were two or three versions of Carlos or, in the end maybe Carlos didn't exist at all; maybe he was just an invention of the counter-terrorist movement or the power structure in place.
As we watch the film, the story of hijacking

unfolds as a way of telling the story of the media, how it engineers drama and fiction as forms of control. I am thinking, for example, of the sequence which collages the generic music of Westerns and frontier myths with images of a congressman, Reagan, rockets, and missiles.
I traced the history of hijacking from the first passenger flights onwards, and how it has changed through the course of history, but this is just a cover under which to talk about the story of the media and of the representation of hijacking itself. For example, if a hijacked plane explodes midair in Africa it is turned into a thirty-second news byte. If there are a few Americans on board and no death, then there is a narrative, a suspense involved: the suspense of postponed death. A narrative can easily be constructed, so the media takes it on. So, it's actually all about narrative and the narrator telling the story, not transparency.

The story of hijacking is inextricably linked to the Cold War, and its playing field largely defined by the ideological divide between communism and capitalism: for instance, Cuba aligned to Russia; the Japanese Red Army and the Palestinian Liberation Front aligned to Mao; Israel aligned to the U.S. "Skyjacking," as it was called, was somehow written into the romantic idea of the revolution during the sixties and seventies. East and West were, more or less, clearly defined and the hijackers had names: Leila Khaled, Ulrike Meinhoff, Kozo Okamoto, Rima Tannous Eissa, Mouna Abdel Majid... But towards the eighties the utopian project has imploded; the former dividing lines disappear, hijackers are killed, cynicism is put in place. The media is more and more implicated as a key player; the image of the individual is substituted by a flow of crowds; hijacking is replaced by anonymous suitcase bombs. The image of the hijacker has vanished: TWA flight 800 can be explained as an accident or a missile or an extraterrestrial attack; the Lockerbie bombing got woven into several political rhetorics, each legitimizing a global power game. Since the eighties, the Reagan Administration started to accommodate the terrorist spectacle to veil its own dirty game in El Salvador, Guatemala, and Nicaragua. Terrorism became a superficial game played through the media to hide the big shit underneath. It might be premature to invent subliminal narratives, but the fact that anonymous parcel bombs have replaced hijackers might very well reflect the dynamics of abstract capitalism, the disintegration of the Soviet Union and

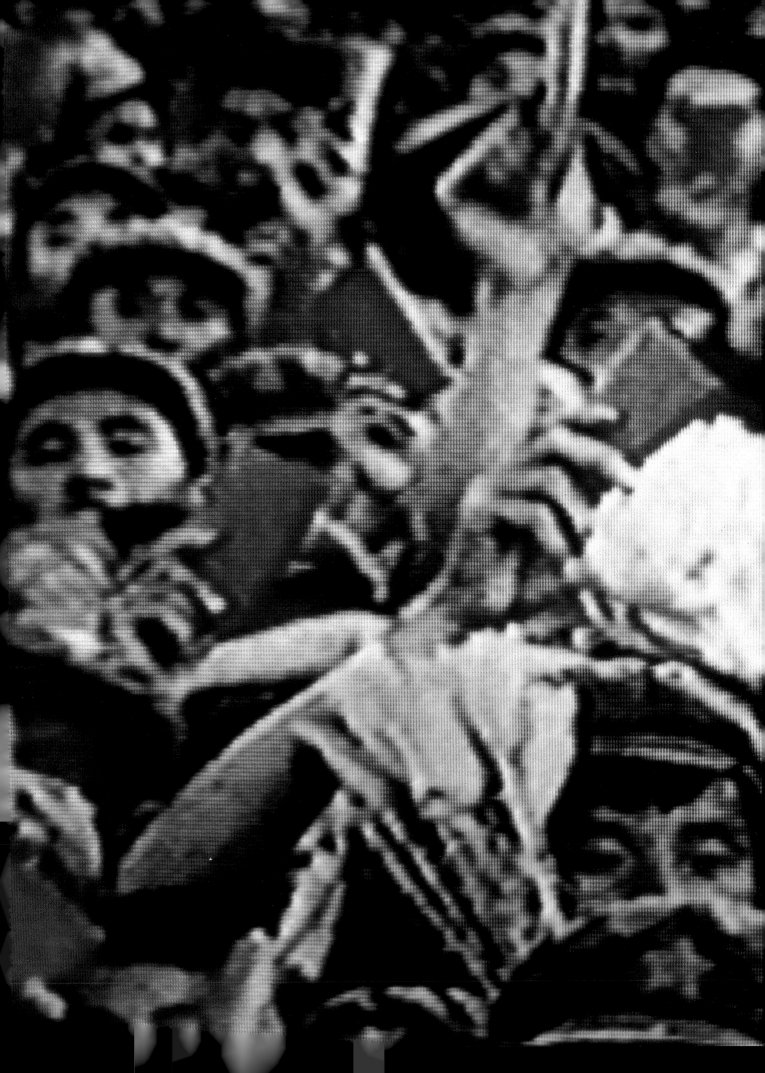

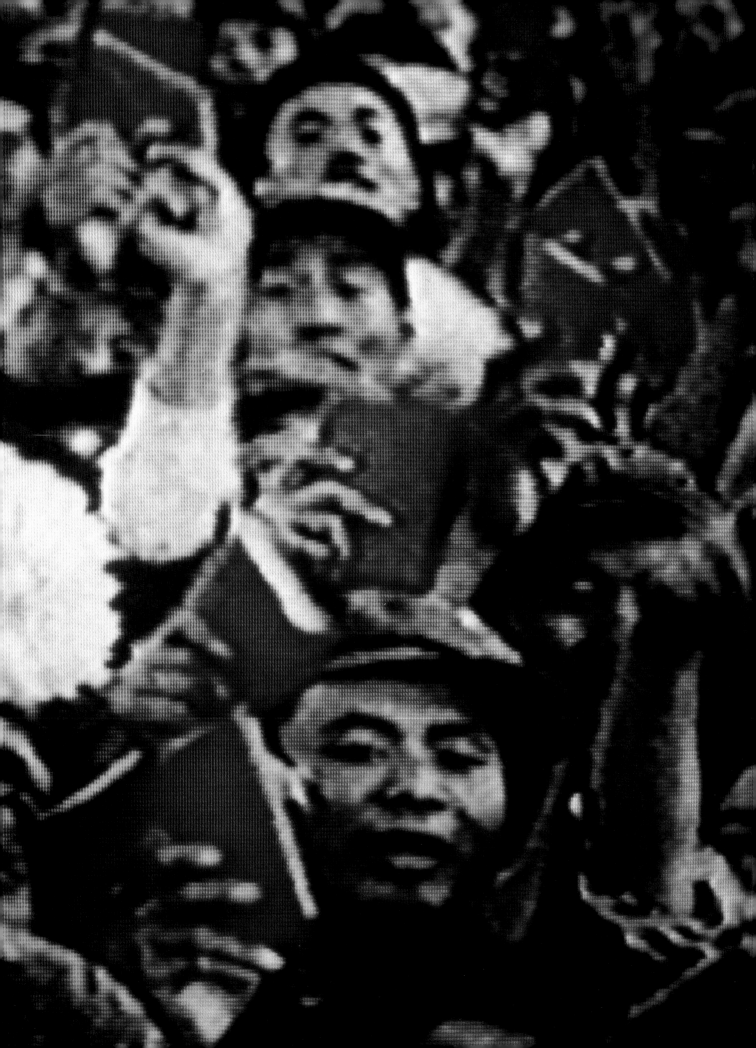

the U.S. trying to redefine itself in terms of its imaginary Other: no longer James Bond against Russia, but Mickey Mouse versus E.T.

The idea of catastrophe is constantly highlighted in the film through the editing and the musical score. In doing so, is your intention also to deconstruct the language of TV docudramas, news, and talk shows?
I mimic what is going on in the media, rather than deconstructing it. In choosing to do so, I think that criticism is more implicit than explicit. The news has turned into a soap opera, as in the Clinton-Lewinsky affair.
A lot of it was inspired indirectly by the Gulf War reportage, which reduced history to a video game, the sights mounted on top of a missile. It catapulted the camera's proximity to destruction right into our living room.
As we saw with the O.J. Simpson trial and, more recently, with Princess Diana's death, catchy logos and soundbytes are put in place immediately; the news adapts Hollywood's aesthetic codes or styles itself after MTV.
Only the applause and laugh tracks are missing.
At one point Hollywood even ran ahead of reality. The invention of a war to divert attention from the president's sexual escapades—as portrayed in the film Wag the Dog—preceded the recent Gulf crisis. It made the whole Clinton-Lewinsky affair look like a poor soap-opera adaptation. Saddam Hussein took the story one step further by broadcasting Wag the Dog on national cable in Iraq: Hollywood goes global political.

Zapping is a strong syntactical element in the film, done with fast editing and syncopated rhythm. Is this form of collage related to the narrative—the history of media and media techniques?
Zapping could be defined as a new sort of Brechtian rupture: zapping as poetry. It reflects the television vocabulary that was online during the Gulf War: Reporting was all mixed up— baby diapers and politics, ketchup and smart missiles, commercials between images.
If one could transpose a videotape of the Gulf War reportage into the Vietnam War period, it would immediately reveal how the news industry has transformed itself into a surrealistic shopping zone. Zapping is a new way of looking at reality. It can't be denied and it's everywhere: Walking through a city, we are bombarded with impressions. It's like Walter Benjamin's "walk through the city," but in fast-forward mode. Soon we will mistake hard reality for a commercial break.

The way you juxtapose the images—color and black-and-white, accelerated and slow motion, circular motion, fast-paced editing —creates a poetics of space in which they sometimes barely touch and sometimes permeate each other. Is the idea of flux

between spaces and narratives one of your concerns?
The juxtaposition shows how memory works: Domestic banality coexists with TV; intimate, domestic stuff is also part of history. Like I remember exactly where I was and what I was doing when the Gulf War started: drinking a cup of coffee over a household quarrel. It was like watching Star Trek in pajamas as a kid in the seventies. Both worlds are colliding all the time. This is what history is all about.
The hijackers in the film are also mostly portrayed in a banal manner: Rima Eissa washing her face behind bars; Kozo Okamoto falling asleep in the courtroom; Minichiello smoking a cigarette; the Shiite hijackers drinking Pepsi; Leila Khaled in close-up after her face-lift.

Men have tried throughout history to cure themselves by killing others. The dyer passively succumbs, the killer lives on
—White Noise; Don DeLillo

The idea of a fluid structure is also enhanced by the use of precisely dated and identified sequences, organized not necessarily chronologically but in strata. This would seem to refer to the dynamics of desire in the way we apprehend reality. Can it be read also as a critique of linear history and of the rationalization of sociopolitical space?
There is a specific structure in the tape—the story of hijacking—but the way I approached it was empirical. I was dealing with something which was outside myself, but very much part of my memory. While I was researching and collecting images, exploring the relationships between camera and event, I would find connections in a nonchronological way. The film starts with the first live hijacking to be broadcast on Japanese TV, and goes on to depict a sort of voyeurism of voyeurism. The image of the camera pervades the film and, indirectly, it becomes an account of how reality is mediated.
But initially I wanted to make a tape about people saying good-bye in airports, to trace how that has changed in just thirty years.
It was to be something more autobiographical, a recollection of memories in relation to my little daughter, who was at that time living on the other side of the ocean; reunions always happened in airports. Marc Augé has called the airport a "non-space," where everything is

in flux, the whole world transforming into one big airport. The film reflects this loss of home, conflating desire and politics, public history and personal memory.

Dial H-I-S-T-O-R-Y is about the transgression of borders and state, arguing against the old dichotomies of fiction and reality, movies and documentary.
Whereas traditional documentaries are tied to epistemological limitations to describe reality, Dial H-I-S-T-O-R-Y plays with the presupposed notions of structure and chronology.
For that reason I choose to depict a double narrative that sets the television timeline against the backdrop of a story.
In the classical documentary, chronology and structure are logical and a specific vocabulary is used to describe reality, whereas in my film, the chronology of hijacking is underscored by a fictionalized storyline based on a novel by Don DeLillo, which plays with how these notions collide.
The film also tries to trace intimate politics to point to historical alternatives.
Reality is always co-constructed; it is not only the news, the political forces beyond us, but it is also inside us, part of our desire. I criticize certain notions or structures of the state, but I feel that I am also implicated in them. On an emotional level, one feels several things at the same time: revulsion and desire, seduction and repulsion; the disco beat of "Do The Hustle" accompanies the final sequence of planes crash-landing, urging on the ultimate disaster.

In the political arena, women are represented in the media in a few distinct ways: the passive faire-valoir figure, who enhances humanitarian causes and other charities through her presence; the threatening figure with an appropriate nickname, like Margaret Thatcher's "Iron Lady"; the spokeperson. In the history of terrorism, women are almost absent: The media have all but obliterated their role. One of the reasons for this disappearance is that they actually were not accorded any important role besides that of companion: Obviously war is seen as a man's affair. I would like to suggest a parallel here with the emphasis placed in the official history of terrorism on whatever served the Cold-War cause (Cuba, Israel/Palestine, Libya/Eastern block), where Third World countries were featured only when it directly affected the principal power structures. Can you comment about such frame presences which translate into visual lacunae?
History is definitely selective. While researching at ABC News, I realized that there were so many images of hijackings! I knew that in choosing some, I was eliminating lots of others. Walter Benjamin said something like, "History is written by the guys who went to

war,"...right? You realize how much is never written down, recorded, or even taped. It also has to do with power and money: CNN can afford to send news crews everywhere. So history is always related to power, to the narrator who tells the story.

In the film I make fun of Dr. David Hubbard, the American psychiatrist who specializes in hijackers. He focused on the Freudian principle, trying to analyze the plane as a big Freudian machine: pilot, stewardess, and hijacker caught in an oedipal triangle, and so on; so skyjacking—the "flight of fantasy," as he calls it—is reduced to a mere sexual impulse. But then where does that leave Leila Khaled, the Palestinian hijacker? She could embody the phallic woman. It was pretty smart on the part of the Palestinians to introduce Leila Khaled: seduction as part of guerrilla strategy. For her second hijacking, she went even further, undergoing a face-lift and dressing herself up as a tourist.

The film's narration consists of excerpts of Don DeLillo's novels, *Mao II* and *White Noise* which establish a relation between hijacking, terrorism, and writing. Are they really even comparable?
In Mao II, a relation is spun between the terrorists and the novelist. It questions the status of the artist versus the status of the TV image. What is the role of the artist today? "Novelists and terrorists play a zero-sum game, what terrorists gain, novelists lose," says Don DeLillo in *Mao II*. The book contends that the terrorist has taken the writer's role in society, because he is able to play the media. In White Noise, catastrophe is a member of the family. TV stages the clash between the little world of domestic bliss and the bigger political picture that surrounds it.

The text also affirms the precedence of media drama in plotting the narrative of the contemporary world while the fiction writer is assigned the role of dinosaur. How do you see your own situation as an artist making films? Is any definite place possible?
Yes, the reason why I chose the writer-versus-terrorist narrative is to speak about the artist versus the media. The situation is, in a sense, also contradictory: The film declares the death of the novel, but at the same time is based on a novel. It presupposes the necessity of writing while it proclaims the impact of the suicidal die-hard. "Get killed, and maybe they will notice you," runs a line in the film. Thus the game played out between terrorist and novelist becomes an autobiographical story, a metaphor for the role of the filmmaker within a media-saturated world. Nobody can deny television; as a filmmaker, it certainly cannot be denied. This dilemma is very much part of my life. The world is full of meanings,

an abundance of meanings, all scrambling for attention, says DeLillo. On TV, imagery becomes more and more extreme and the accumulation of images more rapid: The TV set has swallowed the world. Reality has lost credibility: Even when confronted with real death one feels detached, as if the violin strings are missing in the crucial scene. A lot of sixties and seventies films and videos about counter-movements situated themselves in a dialectical process against TV or in the avant-garde. Nowadays the situation is much more inclusive, like contemporary criticism. Mellencamp (1990) points out that the dream of the global village to invent "counter-TV" has already materialized, but in an inverted sense: the sitcom. *Dial H-I-S-T-O-R-Y* situates itself precisely in this sort of everyday schizophrenia in which shock and catharsis happen at the same time: It is inclusive and critical at the same time. It is about both seduction and the displacement of desire. Commercials can become a metaphor for very intimate things.

> # The supermarket shelves have been rearranged. It happened one day without warning
>
> —White Noise; Don DeLillo

During the seventies, hijacking and terrorism played an important role in the construct of a sociocultural imaginary in Europe. Fear, bomb scares, and "terrorist chic" went hand-in-hand, especially among intellectuals. Is this aspect interesting to you?
"Terrorist chic" captures very well the failure of what happened with the romanticized ideas of revolution in the narratives of the sixties and seventies. Consumerism has absorbed the revolutionary impulse. The utopian project has imploded, and in the end there is not one projected dream or idea left. When we look at images now, we realize how much everything has been absorbed by the seduction principle. When, back in the seventies, Baader and Meinhoff went off to training camps in Palestine, it was very much like Duchamp's urinal. The urinal shocked because it was displaced inside the boundaries of a bourgeois world. Recently someone peed in Duchamp's urinal at an exhibition: Back to start. "Terrorism" has become an empty term, just like "democracy," a figleaf to disguise whatever ideology lies underneath. Just as the Wizard of Oz turns out to be a big fake! Terrorism is such a vast concept that it has to be contextualized,

geographically and historically. If it happens in a country in South America, it is totally different from what happened in the seventies in Europe or what is going on with recent extreme-right bombings in the United States. Ideologies also have to be localized; you can't generalize unless you're speaking from Hollywood. The end of *Dial H-I-S-T-O-R-Y*, set in St. Petersburg in 1994, portrays a Russian terrorist, a bullet in his stomach, a microphone pushed in his face, dying on camera. No longer capable of answering why he took hostages, he dies on the set with TV's full complicity. Final declaration: silence. The media is left alone with itself.

More recent hijackings and terrorist actions have turned into bloodbaths (Lockerbie, Marseilles), and the state has also adopted guerrilla tactics. Could this be a form of victory, or the complete absorption of terrorist dynamics within the state? Take the Unabomber story: Danger and disaster become ubiquitous yet impossible to locate. Perhaps it also points to technological warfare as a last frontier?
Maybe the state wants precisely to claim terrorism's ubiquity, to further entrench its police control. Didn't we used to wave goodbye to our loved ones from the observation deck, watching the take-off? Now our bon voyage ritual involves security gates, X-rays, surveillance, lasting-lipstick billboards, a little bit of shopping. The intimate body has become totally controlled. Terrorism and hijackings were followed by countermeasures. Every time a terrorist would invent something, the state adopted a strategy of mimicry. It has gotten to be an extreme situation. All the recording security systems in today's airports is a result of seventies hijackings. Paradoxically, there is so much security in place now but bombs pose a bigger threat than hijackers. Take Lockerbie, for example. 270 people died and we're left with a suitcase bomb: no terrorist anymore. The terrorist is absent. It's a total masquerade of the structures of state.

*Originally published in *Parkett # 53*, Zürich/New York 1998

* *Dial H-I-S-T-O-R-Y*; a film by Johan Grimonprez; with excerpts from *Mao II* and *White Noise* by Don DeLillo; original music and sample collage by David Shea; produced by Kunstencentrum STUC and Centre Georges Pompidou, MNAM; with the support of Documenta X, Klapstuk 97, Fundación Provincial de Cultura, Diputación de Cádiz, The Fascinating Faces of Flanders and the Ministry of the Flemish Community. Excerpts from *White Noise* (© Don DeLillo, 1984-1985) and *Mao II* (© Don DeLillo, 1991) are used by permission of the author and the Wallace Literary Agency Inc.; 1997, Belgium-France, color + black & white, 68 min, stereo, dvd.

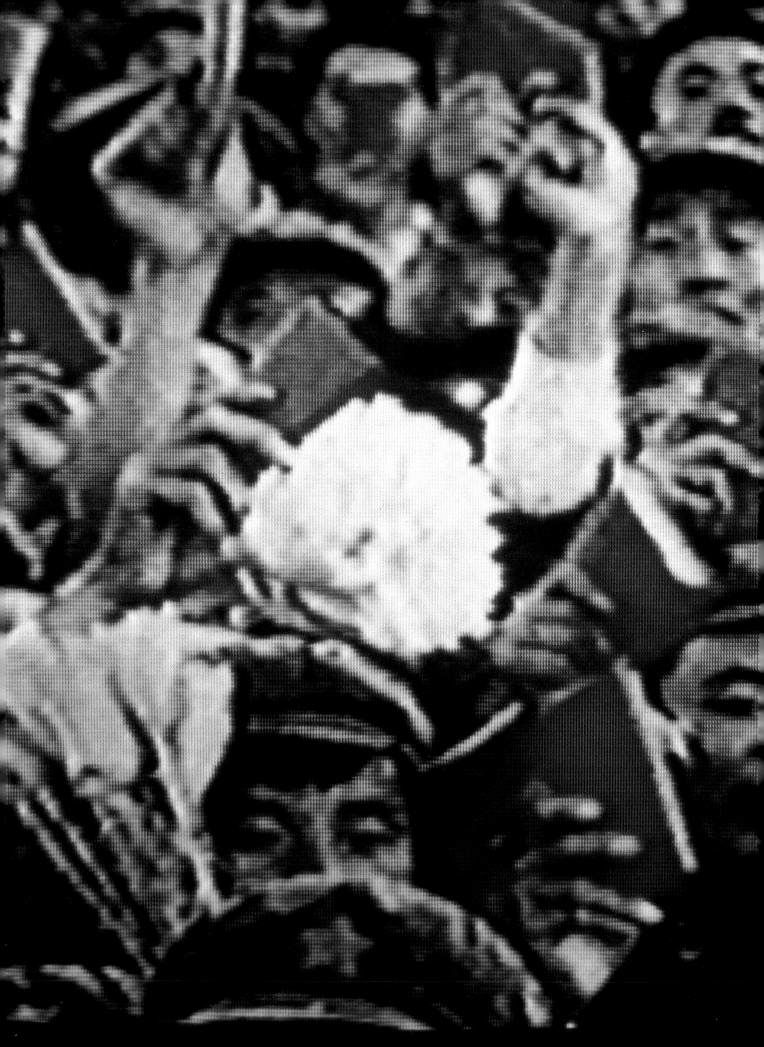

COACH POTATO ZAPS PLANE !

June 1998, Spain: Skyjacker holds-up plane with a television remote control

Pushing a TV remote control button is a momentary activity accomplished in less than one second. Since its duration is so short, its frequency can be very high (60+ times a minute) or very low. Thus, during three hours of prime time viewing, remote control use can vary from 2 (turning the set on, turning it off) to 10 800 or more button pushes.*

Walker, Bellamy and Traudt** identify six types of remote control gratification:

1. The selective avoidance of unpleasant stimuli (such as commercials or political speeches and newsreporters)
2. Getting "more" from television
3. Annoying others
4. Controlling family viewing/accessing television news
5. Accessing music videos
6. Finding out what's on TV

1984: ADVERTISING AVOIDANCE

In panic concerning the television viewer's control to avoid commercial messages,
the industry calls for zap proof strategies to carry viewers through commercial breaks

* Bellamy, Robert V. & Walker, James R.: *Television and the Remote Control, Grazing on a Vast Wasteland* New York/ London; Guilford Press 1996

** Bellamy, Robert V. Walker, James R., Traudt, Paul J.: *Gratifications Derived from Remote Control Devices: A Survey of Adult RCD Use*
 In: Bellamy, Robert V. & Walker, James R.(eds.): *The Remote Control in the New Age of Television*
 Westport, Connecticut; Praeger 1993, pp.103-112

SET YOUR VACATION FOR

747

A strange thing then happened.

The house whirled around two or three times and rose slowly through the air. Dorothy felt as if she were going up in a balloon. The north and south winds met where the house stood, and made it the exact center of the cyclone. In the middle of a cyclone the air is generally still, but the great pressure of the wind on every side of the house raised it up higher and higher, until it was at the very top of the cyclone; and there it remained and was carried miles and miles away as easily as you could carry a feather.
It was very dark, and the wind howled horribly around her, but Dorothy found she was riding quite easily. After the first whirls around, and one other time when the house tipped badly, she felt as if she were being rocked gently, like a baby in a cradle.
Toto did not like it. He ran about the room, now here, now there, barking loudly; but Dorothy sat quite still on the floor and waited to see what would happen.
Once Toto got too near the open trap door, and fell in; and at first the little girl thought she had lost him. But soon she saw one of his

ears sticking up through the hole, for the strong pressure of the air was keeping him up so that he could not fall. She crept to the hole, caught Toto by the ear, and dragged hum into the room again; afterward closing the trap door so that no more accidents could happen. Hour after hour passed away, and slowly Dorothy got over her fright; but she felt quite lonely, and the wind shrieked so loudly all about her that she nearly became deaf. At first she had wondered if she would be dashed to pieces when the house fell again; but as the hours passed and nothing terrible happened, she stopped worrying and resolved to wait calmly and see what the future would bring. At last she crawled down upon it; and Toto followed and lay down beside her.
In spite of the swaying of the house and the wailing of the wind, Dorothy soon closed her eyes and fell fast asleep.

The Wonderful Wizard of Oz ; Frank L. Baum

BRITISH AIR OPENS FLIGHTS TO RUSHDIE

December 24, 1998:
British Airways lifts its nine-year
ban on writer Salman Rushdie.
Rushdie was a security liability,
his novel, *The Satanic Verses* was
considered blasphemous enough
in the Islamic world for a religious
death sentence to be issued,
making him the world's
most dangerous cargo.

Out of thin air: a big bang,
followed by falling stars.
A universal beginning, a
miniature echo of the birth of
time ... the jumbo jet Bostan,
Flight AI-420, blew apart
without any warning, high
above the great, rotting,
beautiful, snow-white,
illuminated city, Mahagonny.
Babylon. Alphaville.
But Gibreel has already
named it. I mustn't interfere:
Proper London, capital of
Vilayet, winked blinked
nodded in the night.
While at Himalayan height a
brief and premature sun burst
into the powdery January air,
a blip vanished from radar
screens, and the thin air was
full of bodies, descending
from the Everest of the
catastrophe to the milky
palanees of the sea.
Who am I?
Who else is there?

THE SATANIC VERSES

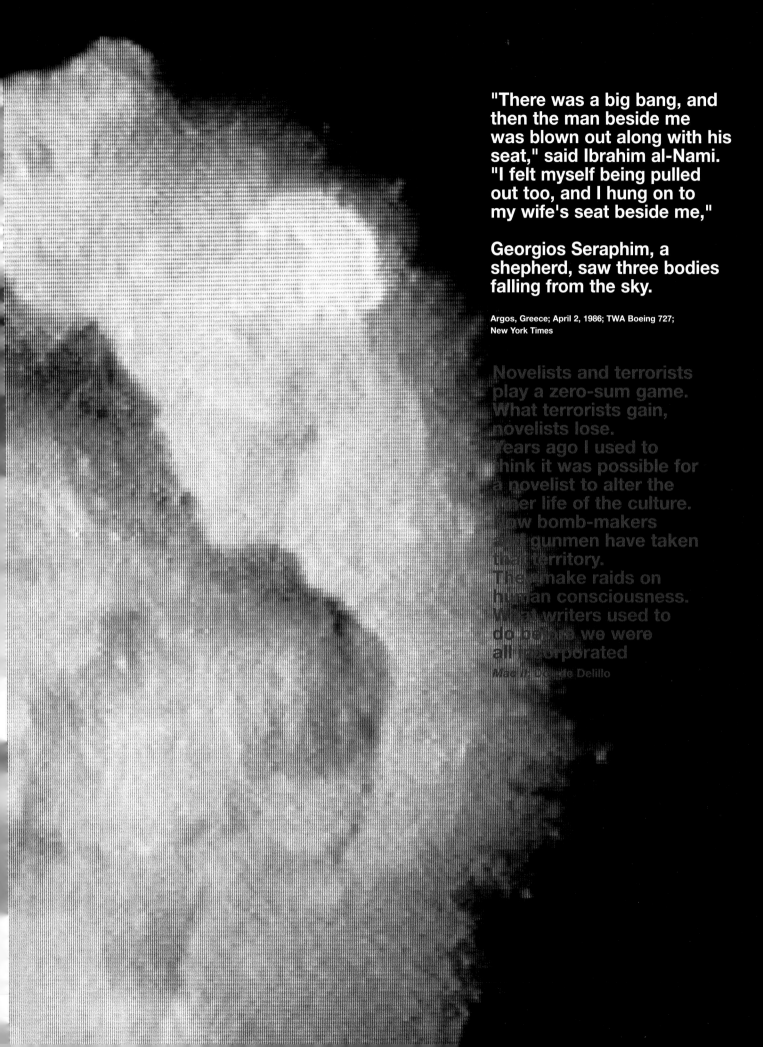

"There was a big bang, and then the man beside me was blown out along with his seat," said Ibrahim al-Nami. "I felt myself being pulled out too, and I hung on to my wife's seat beside me,"

Georgios Seraphim, a shepherd, saw three bodies falling from the sky.

Argos, Greece; April 2, 1986; TWA Boeing 727; New York Times

Novelists and terrorists play a zero-sum game. What terrorists gain, novelists lose. Years ago I used to think it was possible for a novelist to alter the inner life of the culture. Now bomb-makers and gunmen have taken their territory. They make raids on human consciousness. What writers used to do before we were all incorporated

Mao II, Don de Delillo

JET HITS TOWN

MATTHEW COX & TOM FOSTER

LOCKERBIE, SCOTLAND 1988

At 7:00 P.M. on December 21, Bobbie Miller and his wife had begun watching the television program *This Is Your Life*. But the show failed to hold their interest. She got up and headed to the kitchen for a drink of water. He got up, turned off the television.

Across the street at 6 Sherwood Crescent, Mary Ward was wrapping two boxes of cookies. They were a Christmas present for eighty-two-year-old Jean Murray, her friend and neighbor. Murray lived at No. 14, and on this Wednesday evening four days before Christmas she was watching television. Next door to the Somervilles, at No. 17, John and Janet Smith, a retired couple in their mid-seventies, were sitting in their living room, waiting for the program "Coronation Street" to come on television. The first thing most people noticed was the sound. One man described it as the low rumbling of thunder; another said it was like the rush of twenty express trains coming into the station all at once. The fuel-laden wings of the Boeing 747, joined by a section of fuselage, slammed directly into 13 Sherwood Crescent, where

I WAS WATCHING
"THIS IS YOUR LIFE" WHEN
THE PLANE CRASHED THROUGH
THE CEILING AND KNOCKED
ME HEADFIRST INTO THE TV SET

Dora Henry was preparing supper for her lodger. The wings were descending at between 506 and 575 mph, and the more than a hundred tons of fuel they carried exploded on impact, gouging out of the earth enough dirt to create a V-shaped crater 155 feet long and 40 feet wide—about half as long as a football field. The blast killed Maurice and Dora Henry and vaporized their house, including its foundation.

Jean Murray died alone at No. 14, in front of her television set. Pieces of the plane fell upon the neighborhood like a deadly rain, ripping through roofs, crushing walls. A bathroom sink from the plane knifed through the Miller´s roof and wedged itself inside a gable. Globs of flaming aviation fuel fell with the debris, igniting fires as far as a thousand feet downwind.
A towering orange fireball boiled up out

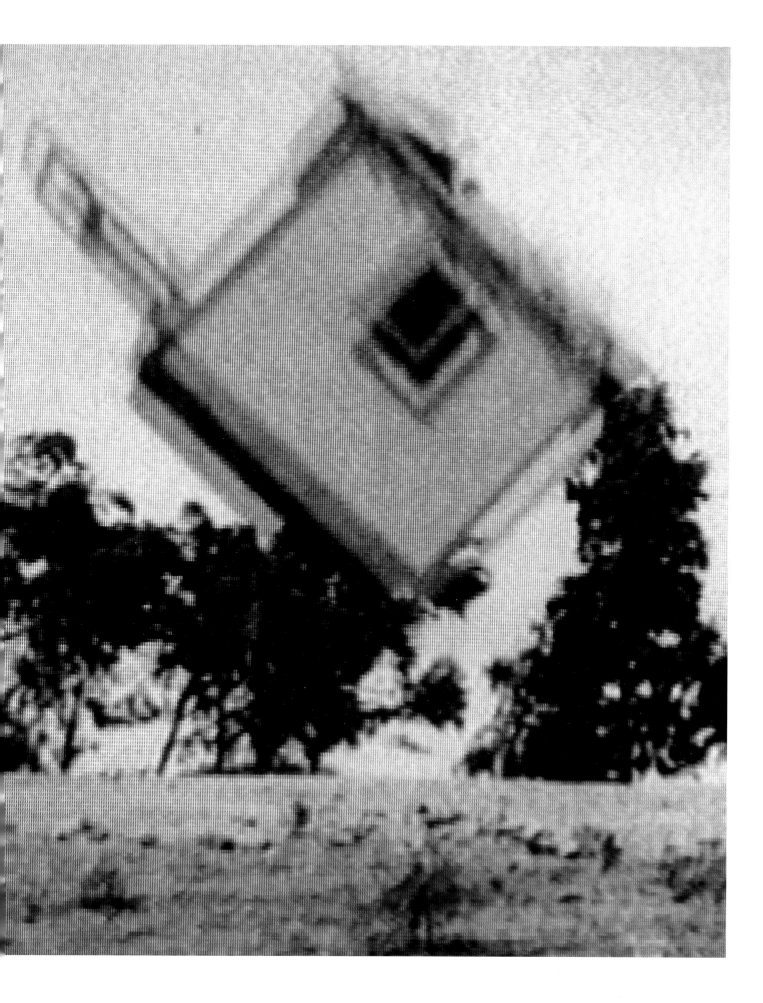

of the crater, displaying its brilliant colors against the black sky. It flashed through houses and scorched vehicles in the two southbound lanes of the A74.

A Lockerbie policeman, Michael Stryjewski, thought it looked like the mushroom cloud from a miniature atomic bomb.

"It was extremely noticeable for miles around. It just kept going up," Stryjewski said. "It rose quite slowly—I was surprised how slowly—but I couldn't see the top. I would estimate it went up at least a thousand feet." Against the orange of the cloud he saw the black silhouettes of thousands of tiny particles raining on the earth. He picked up the telephone to call 999, the number of emergency services, but his line was dead.

The blast lobbed more than fifteen hundred tons of debris skyward in sweeping arcs that subjected rooftops to a second pounding. The debris included chunks of roadway and houses. A four-foot block of concrete crashed through the Millers' roof and landed in the couple's bed.

John Smith who was watching "Coronation Street" with his wife, sensed the approach of an airplane. He was turning away from the television to say to his wife, "This plane's very low," but before he could get the words out, something hit the roof of his house. A sheet of flames rolled down from the ceiling above his head.

Inside the Shell station worker Ruth Jamieson was petrified. "The whole sky lit up; then everything came flying through the roof, " she said. Eleanor Hogg had been walking with her sister in front of the drugstore at the center of town. "At first we thought it was thunder," she said. "Then the sky lit up, and there was a terrific bang." Against the orange sky she spotted a falling object she recognized as a jet engine. From where she was standing it looked as thought it would land on the town's movie theater. The engine, falling at 300mph, missed the cinema, slamming into the soft ground of Mains Meadow.

"Suddenly there was a loud bang and everything was on fire," Smith said. "Something fell on top of me – I don't know if it was part of the house or from the plane – and I fell down on my knees, trapped. I tried to move it. The first time it wouldn't budge, but the second time I got free. I went into the kitchen to try and find a way out, but it was full of smoke. So was the bedroom." Smith struggled out the front door, then called for his wife. She said she couldn't move, so he went back inside to get her. She had collapsed on the floor. "I couldn't see her, but I managed to grab hold of her and led her out of the house. There were flames everywhere. Even the lawn was on fire."

Rescuers pulled the Smiths over a garden wall to a safer part of the neighborhood. Up the street, in the house where Mary Ward had been wrapping boxes of cookies in Christmas paper, pieces of blazing wreckage crashed through the roof, showering her with chunks of masonry. She managed to escape through her front door. Her cat, Misty, survived, too.

At 5 Sherwood Crescent Bobbie Miller heard the rushing sound of the falling debris and turned away from the heater he had started to adjust. The explosion blew in the window behind him and knocked him headfirst into the television screen across the room.

BODIES FALLING OUT OF THE SKY.

About two miles northeast of Sherwood Crescent a large piece of the plane's fuselage slammed into 71 Park Place, where Ella Ramsden was home with her dog and bird. The fuselage section—extending from the rear of the wings about halfway back to the tail—contained the bodies of some passengers still strapped into their seats. Ramsden had been feeling sad all day. Her son and his family, who had celebrated the holiday with her a week early, had left that morning to return to Germany. After the Scottish television soap opera "Take the High Road" had ended at 7:00 pm, Ramsden turned off the set, got down on her knees in front of her livingroom heater, and began opening the day's batch of Christmas cards. That's when her dog, a terrier named Cara, started to growl. Ramsden heard a low, droning sound. It was coming from the sky, but it sounded too near to be an airplane. She got up from the heater, walked to the window, and opened the curtains. The whole sky was lit up with a bright

orange glow. Somewhere she heard an explosion. "First of all I thought it was the petrol station. So then my next thoughts were, What am I going to do? Am I going to get out of here or am I going to stay in the house? I don't know whether I was thinking or saying out loud to Cara, 'I think I would be better out amongst other people.' So I picked her up under one arm, and I came from my window to my back door, which was in the kitchen. And as I put my hand on the door to open it, it wouldn't go; it was jammed. And the lights went out."

She heard a whooshing sound and felt wind pulling at her legs. She bent down to see if the rug at the back door had become wedged into the doorframe. Then Ella Ramsden's house began to fall in on her. The noise was long and deafening. Ramsden became convinced she would never get out. Then the noise stopped as suddenly as it had started. She wasn't sure if she was alive or dead. The back door was still there, but when Ramsden looked up at where the ceiling used to be, she could see stars in the night sky. Ramsden edged over to a cupboard to her left, gripped a pan in one hand and smashed the glass on the back door. The overwhelming silence returned, and Ramsden whispered for her neighbors.

"John, Martha, are you there?"

When she got out of the house and was standing on her lawn, she turned to look back. "I still couldn't think what had happened. I look up, and the bedroom on the left-hand side – there was nothing but the wardrobe in it." About fifty bodies landed with the fuselage in Ella Ramsden's garden.

Excerpts from: *Their Darkest Day. The Tragedy of Pan Am 103 and its Legacy of Hope*, Cox, Matthew & Foster, Tom; New York: Grove Weidenfeld 1992

* Quote from:
The Media and Disasters, PANAM 103; Joan Deppa

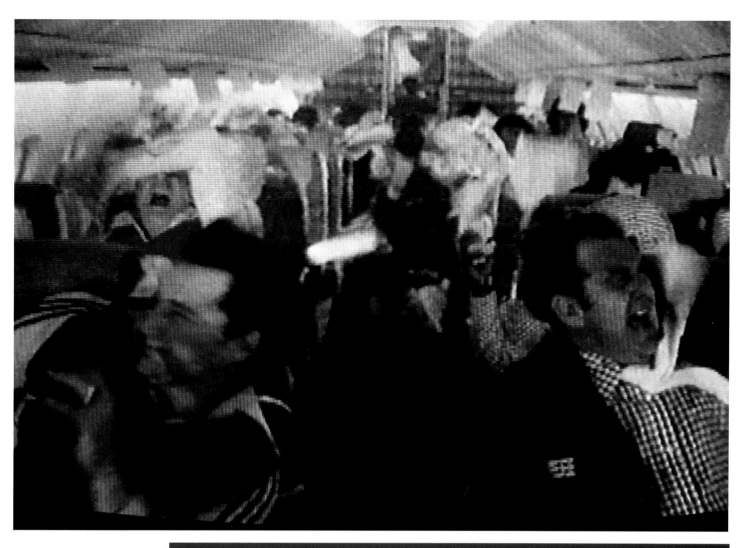

30-40% of television viewers run off to the toilet or grab a beer from the refrigerator during a commercial break*

There are more homes with TV, than there are homes with a refrigerator**

* Fountas, A.: *Commercial Audiences: Measuring What We're Buying*
In: *Media and Marketing Decisions*, January 1985; pp.75-76

** Geller, Matthew &Williams, Reese (Eds.): *From Receiver to Remote Control: The TV Set*
New York, The New Museum of Contemporary Art New York 1990

INS

COMM

HB

ERT

ERCIAL

RE

NO PLACE LIKE HOME

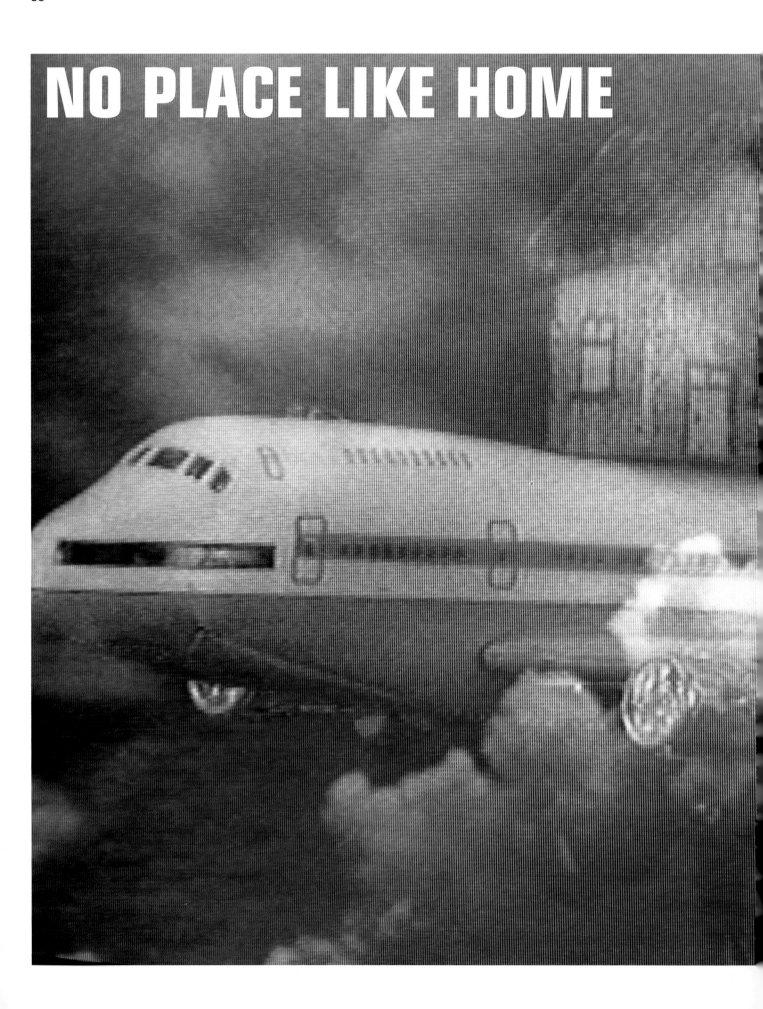

DECEMBER 18, 1994; SIMPSONS EPISODE 2F08:
MARGE SIMPSONS SCREAMS DOWN THE AISLES IN AN EPISODE
ABOUT HER FEAR OF FLYING

DEEP SPACE HOMER
FEBRUARY 24, 1994: HOMER SIMPSON CALLS NASA TO COMPLAIN
ABOUT THE BORING SPACE COVERAGE ON T.V. NASA INVITES HIM TO
THE JOIN THE NEXT MISSION. DURING 'HOMER SPACE ODYSSEY',
OUR HERO LOSES CONTROL OF HIS POTATO CHIPS AND CRASHES—
BOLDLY GOING WHERE EVERYBODY'S BEEN BEFORE

JODI DEAN

Abduction stories had been part of ufology for more than twenty years, although a couple had even received attention in the mainstream press, it was in 1987 that two abduction books, Whitley Strieber's *Communion* and Budd Hopkin's *Intruders*, made the best-seller lists. These two books, moreover changed the tone of the abduction story circulating in popular culture. Rather than an outside event, happening mostly to men on the road, as hinted at in *Close Encounters of the Third Kind* and described in the widely publicized cases of Betty and Barney Hill in the early sixties and Travis Walton in the seventies, abduction in the late eighties happens, in bedrooms.

▷

**THE WORST PART OF BEING PREGNANT WITH ALIEN BABIES:
THEY SET OFF AIRPORT METAL DETECTORS**

TV STAR RHONDA SHEAR, SUN MAY 23, 1995

▷

Moreover, as Strieber and Hopkins describe it, the aliens are much more interested in sex, genitals, and reproduction than earlier reports let on. Strieber occupies in his texts a traditionally feminine position. Not only is he a parent, heavily identified with his home and his child, but he is also repeatedly violated and abused. His home, his bedroom, is a site for his vulnerability. He is raped and afraid either to remember or to speak his experience. Hopkins makes women featured figures in narratives of alien abduction. He describes in detail the intrusions of the aliens into the reproductive dimensions of women's lives, giving voice to women's fears and anxieties as their bodies are colonized to produce a hybrid race.

I read abduction as the dark underside of official space, as a return of the repressed dimensions of astronaut heroics. No abductee has been given a parade. Compared with astronauts they are victims not heroes. The confusion and the fear throughout their accounts evoke a nostalgic longing for a future we seem to have abandoned. We don't explore space anymore. Some of us never did. We aren't on any Star Trek. We just stay where we are consuming fantasies and virtual realities. That women in their homes, sometimes wives, give voice to the pain of loss even a myth of adventure doesn't surprise me. But of course their stories give voice to more. They bear witness to a lack of control, insecurity, and violation, to a lack of response from those who are supposed to protect and care.

The Challenger explosion (1986) marks the end of public fascination with and interest in the American space program (though interest seems to be returning with reports of Martian life and the use of the Internet to bring the pathfinder into the homes of everyday people). The dominant meanings of outerspace, the ideas associated with space and space travel have changed since the sixties. Previous space was linked with the agency of the astronaut; it now connotes the passivity of the audience who witnessed the conquest of space on television or, more frighteningly, the horrors of the challenger or the aliens invading our homes and bedrooms. The cultural stress had been on escaping the confines of earth; now it's on finding ways to stay home—which is exactly what the Pathfinder mission accomplished. With the Internet, we bring everything to us without ever having to go anywhere. We can act and watch at the same time. And we can watch and see most anything we like.

Outerspace was now alien space. The Challenger disaster gave us a good reason to stay at home, to turn from outerspace and toward the new opportunities available in cyberspace, in personal computers, VCRs and camcorders. The Challenger explosion, in other words, made us more willing to think about outerspace coming to us.

Mercury astronaut Gordon Cooper's description of zero gravity, "a freedom man has been striving for over the centuries—the ability to glide around with no effort" sounds like the hacker's dream of leaving the meat. Travelling via mouse and modem is safer, easier, and more democratic than strapping a chosen few to the top of a rocket. We—a new "we" constituted through our techno-savvy—can all roam the net, and never go anywhere at all.

Excerpts from: *Aliens in America. Conspiracy Cultures from Outerspace to Cyberspace*; Jodi Dean; Ithaca, London: Cornell University Press 1998

* According to Phil Cousineau's research, UFO believers outnumber the voters who placed Reagan, Bush, and Clinton in office. More people believe in aliens than the president!

(*UFOs: A Manual for the Millenium*; New York: Harper-Collins West, 1995)

PHASER ENVY
IS THAT A PHASER IN YOUR POCKET OR ARE YOU JUST HAPPY TO ABDUCT ME?
The aliens' abduction and breeding practices may stem from their own lack of genitalia—a psycho-physiological ailment that keeps them wrapped tighter than a classified government document. From the hundreds of investigated abduction cases not a single one reported any sightings of alien genitalia. Of course, staring at ET's crotch may not be your first instinct when they have you strapped to an operating table, but you don't easily forget a captor who has the eyes of a grasshopper and the lap of a Barbie doll. It seems, therefore, highly probable that genitalia envy is the root cause of the aliens' antisocial behavior. Flying the intergalactic highways and byways, our ET neighbors may be more than envious when they witness our daily and nightly matings in the bedroom, office, car, and on Baywatch. Not only do they want to teach us all a lesson. How else can you explain their quaint method of genetic coupling that rivals Leather Night at the Stone Anvil?
The Official Alien Abductee's Handbook; Joe Tripician

GARY STOLLMAN: **HACK REPORTER***

On August 19, 1987 a gun-carrying Gary Stollman entered the studio of Los Angeles's KNBC television, crashing consumer reporter David Horowitz's live newcast. Stollman handed Horowitz a written statement and ordered him to read it while holding a gun on him. Unbeknownst to Stollman, KNBC immediately switched to a commercial, not permitting the statement to be transmitted. When Horowitz finished reading the statement, Stollman surrendered his gun, which turned out to be a toy pistol. Stollman, the son of a pharmacist who appeared on KNBC newscasts as an expert on drugs, was sent to Los Angeles County Jail. Here's the text of his message :

The man who has appeared on KNBC for the last 3 years is not my biological father. He is a clone, a double created by the Central Intelligence Agency and alien forces. It is only a small part of a greater plot to overthrow the United States government, and possibly the human race itself.
The CIA has replaced and tried to destroy my family, and those of my friends. Although I have known about this since 1981, I have not taken any action about it for fear of the lives of my family. I have been forced into CIA-run mental hospitals, such as Cedars-Sinai Thalians, where I am shown being interviewed by many different doctors, although I spoke to nobody there for two weeks.
At UCLA-NPI, I attempted to have myself released by a court several times, but was asked by a Dr. Martin Zsuba to keep removing my requests for a writ-hearing. I have been unable to obtain records from several other hospitals, including Ben Taub Hospital in Cincinnati, where all the phones were turned off for 48 hours after I arrived. I do not know where my real family or others are being held, but I believe it is somewhere in California. The records for Ben Taub Hospital, I have been informed, no longer exist, or have been misplaced. I say that the CIA assassinated John F. Kennedy and the 22 material witnesses that day, who all died within 2 years of each other, a mathematical impossibility.

What they are capable of, I know only too well. I demand the public release of all secret Air Force files concerning UFO's, which were kept secret even from Senator Barry Goldwater. I demand the release of information concerning the objects contained in Hangar 18 at Wright-Patterson Air Force Base, now obscurely referred to as the Environmental Control Building, the most highly guarded building in the world. Why has the knowledge of such advanced beings and equipment been kept so secret that even the United States Congress does not know?
I would have been satisfied to let my situation stand if it were only I and my family who were at stake here. However, I spoke to a girl at Florida Junior College two summers ago, who related the story to me of how seven of her friends had also been replaced. She said that she had written absence excuses for them when they weren't sick, then they disappeared for a week, only to come back with different personalities. Unless we act swiftly, there may not be very much hope for any of us. These people, or whatever they are, are taking over the phone services right now. The CIA is either doing this themselves, or are helping them.
I was warned in 1981 by someone with connections to the CIA to stay off computers, that they didn't trust people on computers. Then I began receiving disturbing calls

from my parents, which led me to believe that something terrible was going on. I was forced into a mental hospital in Tallahassee, where I learned that my brother-in-law had been driven insane in the same manner that someone was trying to do to me. I eventually was released, but then my mom came down to visit me and I knew it was an imposter. I know that the secret service is involved in this as well, so who knows just how far this has gone in five years. I know of a counselor named Pat, who worked at the Optimist Boys School near Pasadena, who was involved in recruiting members for some secret group of people. Apparently they adopted orphans and gave them fake IDs and birth certificates. Since we already know of a secret group led by the President's own staff, someone had better find out what is going on and fast. I only know that there are beings around us now with the power to teleport instantaneously and do the same to others, who can read and control minds, and transform matter into other forms or create it at will.
I ask for a Congressional Investigation and Federal protection for my family, and those involved. There is no way I can harm anyone with an empty BB gun.

* First published in: *Secret and Suppressed, Banned Ideas & Hidden History*, Ed.: Jim Keith, Feral House 1993 Portland.

'BEEP' THEORY

BY RICHARD THIEME

Now we're closing in on the Snark. Are government agents using the subculture to manipu-late or experiment with public opinion? To cover up what they know? Are the investigators "useful idiots," as they're known in the spy trade, real spies, or just in it for the buck?"

One of my online adventures illustrates the difficulty of getting answers to these questions. A woman in Hamilton, Montana was speaking to Peter Davenport, head of the National UFO Reporting Center in Seattle about a UFO she said was hanging around her neighborhood. She said could hear strange beeps on the radio when it was hovering. Then, while they spoke, some beeps sounded. 'There!" she said. "You hear that? What is that?"

Peter played the beeps over the telephone. I recorded them. Then I posted a message on alt.2600—a hacker's Usenet group —asking for help. I received several offers of assistance. One came from LoD. LoD! The legion of Doom! I was delighted. If anyone can get to the bottom of this, LoD can. These guys are the best hackers in the business. I recorded the beeps a .wav file and emailed them to LoD. They asked a few questions and said they'd see what they could find. Meanwhile I received another email. This writer said he had heard similar tones over the telephone lines and short-wave radio in his neighborhood, which happened to be near a military base. Then he wrote, "I have some info that would be of great interest. Government documents..." He mentioned friends inside the base who told him about them. Meanwhile the LoD examined the switching equipment used by the telco and reported that they were evaluating the data. A third email directed me to a woman specializing in the "beeps" frequently associated with UFOs. She sent me a report she had written about their occurrence and properties. LoD asked for my telephone number and someone called the following week. They could affirm, the caller said, that the signals did not originate within the telephone system. They could say what the signals were not, but not what they were. One negative did not imply a positive. Then the correspondent near the military base sent a striking communication. "The documentation and the info that I am getting are going to basically confirm what a member of the team has divulged to me. "They are here and they are not benign." He gave me information about other things he had learned, then acknowledged that all he said was either worthless hearsay or serious trouble. Therefore, he concluded, "I am abandoning this account and disappearing back into the ether."

Excerpt from: *Stalking the UFO Meme*; Internet Underground, November 1996

>
>
>

AT PLAY IN THE DIGITAL FIELDS: <HACKTIVISM> AND DATA-HOSTAGES

>
>
>

X-Originally-To: <history@online.be>
Date: Fri, 22 Oct 1999 14:34:55 -0400
From: ricardo dominguez <rdom@thing.net>
X-Accept-Language: en
MIME-Version: 1.0
To: Johan Grimonprez <history@online.be>
Subject: Re: hacktivism

>
>

>
>
>

WIRED FOR WARFARE
Rebels and dissenters are using the power of the Net to harass and attack their more powerful foes
By Tim McGirk/Mexico City

>

>

In the Chiapas jungles of southern Mexico during the mid-1990s, Zapatista guerrillas—fighting for the rights of Mayan peasants—evolved a new method of conflict: "CYBER-WAR." A mode of battle that involves the Internet and other forms of telecommunication, cyberwar, or Netwar, is employed with increasing frequency by rebels, terrorists and governments around the world. A Netwar can be pure propaganda, recognition that modern conflicts are won as much by capturing headlines as by capturing territory. But a Netwar can have more dangerous applications when computer viruses or electronic jamming are used to disable an enemy's defenses, as both Serb and NATO hackers proved in Kosovo by unleashing barrages of propaganda and attempting to bring down each others' telecommunications systems.

>

When they rebelled in 1994, the poorly armed Zapatistas were no match for the Mexican army in Chiapas. But their spokesman, Subcomandante Marcos, is an agile media manipulator. A renegade college professor who hides his face in a ski mask, Marcos titled his Ph.D. dissertation 'The Power of the Word'. In the battle for public sympathy, he knows HIS LAPTOP IS A MORE EFFECTIVE WEAPON THAN AN AK-47 KALASHNIKOV RIFLE. Using a network of universities, churches and non-governmental organizations (NGOs) in Mexico, the U.S. and Canada—all linked through the Internet—Marcos mobilized international pressure to make the government cease its assaults against the Zapatistas. When the Mexican army declared in December 1994 that it had surrounded the 12,000 rebels, Marcos dispatched news that the Zapatistas had slipped out of the trap and conquered dozens of villages. It wasn't true, but according to cyberwar specialists the Zapatistas' disinformation campaign caused enough confusion to help touch off a run on the peso, plunging Mexico into recession.

>

The Zapatistas' tactics also attracted the attention of military strategists. The U.S. Army, for one, sponsored a 1998 study on the group's tactics by the Rand think-tank. "Marcos is not a computer geek," says John Arquilla, a defense information expert at the U.S. Naval Postgraduate School in Monterey and co-author of the Rand report 'The Zapatista Social Netwar in Mexico'. "He's more committed to the idea of info-revolution."

>

That revolution is spreading. These days missiles are not only tipped with warheads but with video cameras; television and radio deliver war news as it happens; and alleged eyewitness accounts of battles and massacres appear on the Internet, quickly finding their way into other media. What matters in today's combat, says Arquilla, "is whose story wins." Not surprising, then, that 12 of the 30 terrorist organizations identified by the U.S. State Department have their own websites. Armies are also entering this digital arena. Sweden's leading military college recently graduated several infowar specialists, and the American military academy West Point is expected to add cybercombat to its curriculum.

>

In Netwar, governments are often at a disadvantage against rebel groups or terrorists. Since they are hierarchies, governments are digital sitting ducks, easy prey for electronic attacks. Groups like the Zapatistas and Burmese dissidents fighting the military regime in Rangoon, on the other hand, use swarms of loosely organized "hacktivists" to strike at governmental computer networks. The hackers strike, then swiftly disperse into cyberspace. The rebels' electronic battle station is seldom inside the country they are targeting, and tracing it back through the Net can be like trying to find the door in a hall of mirrors. The Zapatistas' first websites, for example, were based in the U.S., while Colombia's Revolutionary Armed Forces (FARC) guerrillas are in Europe, and Serb Net propagandists relied on sympathizers in Eastern Europe during the Kosovo crisis.

>

One of the most novel weapons in the Zapatistas' digital arsenal is the Electronic Disturbance Theater, which operates out of New York City. These Net activists specialize in virtual sit-ins. Using a JavaScript tool called FloodNet, the group organizes thousands of online protesters to invade a Mexican government website with up to 600,000 hits a minute, normally bringing it to a grinding halt. "We're not into blowing people up or hacking sites," says one of the Theater's founders, Ricardo Dominguez. "We just want to create a small force field that will disturb the pace of power." He predicts that soon peasant farmers in Chiapas will be able to protect themselves from assaults by security forces with "wireless video uploads" that can secretly record incidents of police or army brutality and transmit live on the Internet. According to Dominguez, this would enable viewers to circulate the faces and badge numbers of assailants to human rights groups.

>

PAGE 1/2
The art of Netwar is rapidly advancing. Cyberwar is "in its early stages," says the U.S. Naval Postgraduate School's Arquilla, "but it's the harbinger of a new kind of warfare." According to Dorothy Denning, a professor of computer science at Georgetown University, the Kosovo conflict was "the first war fought on the Internet." Air strikes targeted television and radio stations controlled by the Serbs, but NATO deliberately spared the four Internet servers in Yugoslavia from its bombardments.

The aim was to let Yugoslavs tap into news on the conflict free from Serb censorship. But this ploy backfired. The Yugoslav government seized control of the servers and used them to pour out pro-Serb propaganda. Their aim, nearly successful, was to weaken the resolve of NATO countries.
>
No challenge to NATO's domination of the skies, the Serbs held their own in the Internet trenches. Serb hackers also used the servers and satellite links left intact by NATO to break into government and industry computers belonging to members of the alliance, disrupting services and defacing web-sites. NATO hackers did the same to Serb sites. Serb computer experts also lobbed "e-mail bombs" at U.S. government facilities, clogging the sys-tems.
>
Digital sabotage is rife in Asia, too. In the week after the results of East Timor's referendum on independence were announced, the Department of Foreign Affairs received hundreds of e-mail "letter bombs" designed to disable government computers. "Without a firewall, [the e-mail] would have contam-inated the system," says a source within the department. In Taiwan and China, supporters and opponents of Taiwan's bid for statehood regularly hack into and deface each other's websites.
>
Some Netwar experts concede the limitations of this kind of combat. Jamming governmental web-sites may be a nuisance to the Mexicans, for exam-ple, but it is unlikely to scare the administration into surrendering to the Zapatistas. Nevertheless, argues Georgetown's Denning, "An electronic peti-tion with a million signatures may influence policy more than an attack that disrupts emergency serv-ices."
>
Others, like Zapatista activist Dominguez, view cyberwar as a more civilized alternative to blood-and-guts fighting. "I'd much rather see extremists take down an Internet server than go around killing people," he says. For the Zapatistas, fighting a Netwar may have saved them from extermination, winning the rebels widespread international sup-port. Marcos often compares himself to the cartoon character Speedy Gonzalez. Like this quick-witted mouse, Marcos used the Internet to run rings around his bigger foes. His comrades in other countries may well follow his lead.
>
>
>
>

TIME SPECIAL REPORT/THE COMMUNICATIONS REVOLUTION/ LANGUAGES OF TECHNOLOGY OCTOBER 11, 1999 VOL. 154 NO. 15
http://www.pathfinder.com/time/magazine/articles/0,3266,32558,00.html
>
>
>
>

>
>
>> WHAT ARE WE GOING TO DO, NUKE THEM FOR TURNING OFF OUR TV'S ? (US Department of Defense Official)
>

>>
>
>From: rdom@thing.net
X-Originally-To: <history@online.be>
 Date: Thu, 30 Mar 2000 08:12:45 -0500
 Reply-To: rdom@thing.net
 MIME-Version: 1.0
 To: Johan Grimonprez <history@online.be>
 Subject: Paper Airplanes
 >
 >
 >
Amador Hernandez, Chiapas -- The Zapatista Air Force today attacked the Federal Army encampment here with paper airplanes. Some flew well and maneuvered them-selves right into the dormitories, hidden by vegetation and large black plastic sheeting. Others sputtered in flight and barely cleared the barbed wire fence.
>
The aircraft, white in color and letter sized, carried written messages for the federal troops which have occupied a portion of the outskirts of this community for the last five months. The barbed wire is not the only cutting edge: "Soldiers, we know that poverty has made you sell your lives and souls. I also am poor, as are millions. But you are worse off, for defending our exploiter -- Zedillo and his group of moneybags."
>
The daily, persistent and almost incredible protest of the indigenous of this region against the military occu-pation of their lands on the outskirts of Montes Azules has sought in many ways to make itself heard by the troops, who appear to live on the other side of the sound barrier. This afternoon they took to the air in typewritten notes, originals and carbon copies, in the prehistory of graphic reproduction.
>
They wrote several editions, with their copies, to maxi-mally equip their contingent of Kamikaze letter-bombers. The plane is the bomb: "We do not sell our lives. We want to free our lives and those of your chil-dren, your lives and those of your wives, your brothers and sisters, your uncles and aunts, fathers and mothers, and the lives of millions of poor exploited Mexicans. We want to free their lives also so that soldiers do not repress their towns by the order of a few thieves."
>
In recent nights, the military encampment has remained on alert. All night, every fifteen minutes, a voice is heard saying, "alert, alert," among the soldiers. "So that they don't sleep," says Jose, a Tzeltal Maya peasant who has spent those nights in the encampment of the peas-ants who watch over the community of Amador Hernandez, and during the day they dream up protest options.
>
>
From the Mexican daily La Jornada
January 3, 2000
translated by Duane Ediger
>

>
X-Originally-To: <history@online.be>
Date: Mon, 28 Jun 1999 11:42:56 -0400
From: ricardo dominguez <rdom@thing.net>
Reply-To: rdom@thing.net
Organization: The Thing
X-Accept-Language: en
MIME-Version: 1.0
To: Johan Grimonprez <history@online.be>
Subject: re: Digital Zapatismo

>
>
>
>
Digital Zapatismo
by Ricardo Dominguez
>
>
>

Digtial Zapatismo as Swarm Systems.
>
On April 17, 1998 The Electronic Disturbance Theater is
invited to present The SWARM Project at Ars Electronica,
a new media festival in Linz, Austria. The SWARM actions
would end with distribution of a Virtual Sit-In kit at
one minute after midnight in celebration of the fifth
anniversary of the uprising in Chiapas:
>
The Zapatista movement in Chiapas, without benefit of
any technological infrastructure, has been able to mani-
fest itself as a transnational network of email based
activism that has constrained the Mexican Goverment
from crushing them immediately. The advent of these
networks has up to now been able to do the work that is
needed--to spread information about the situation in
Chiapas on a mass scale. This continues to be the most
vital element of Zapatismo on-line.
>
Digital Zapatimo calls all individuals and groups to par-
ticipate in research and development of new methods of
Electronic Civil Disobedience that move beyond email
lists and information sites. This investigation should
focus on non-violent Electronic Pulse Systems (EPS), that
function beyond the Tactical Flood Nets that we have
already built
(http://www.thing.net/~rdom/zapsTactical/zaps.html),
that will enable mass public participation in Zapatista
actions.
>
>
1998. September 8, Tuesday.
>
Call to Action is sent out:
*In solidarity with the Zapatistas in Mexico, the
Electronic Disturbance Theater will launch its FloodNet
software against the web sites of Mexican President
Zedillo, the Pentagon, and the Frankfurt Stock Exchange
on Wed., September 9, from its base at the Ars
Electronica InfoWar Festival. These actions are part of
the Electronic Disturbance Theater s SWARM presentation
at the festival now happening in Linz, Austria.
>
Since April the Electronic Disturbance Theater has used
its FloodNet software to engage in virtual sit-ins on the
web sites of the Mexican government and the Clinton
White House. Such electronic actions are designed to
demonstrate collective and world-wide support for the
Zapatistas in Chiapas and their opposition to the
Zedillo government with its global neoliberal economic
agenda.
>

he SWARM actions on September 9, targeting government,
military, and financial web sites in three countries,
will commence at 11:00 a.m. (Linz) for a 24-hour period.
Participants around the world will set their Internet
browsers to the FloodNet page.*
>
>
1998. September 9, Wednesday.
>
A section of the SWARM Chronicles by EDT
[http://www.thing.net/~rdom/ecd/CHRON.html]
>
At 7:32 a.m., Ricardo Dominguez received a threatening
phone call, from someone presumed to be of the Mexican
government, in his hotel room in Linz, Austria. Ars
Electronica organizers and the Linz police have been
informed and we await an official statement.
>
Dominguez said: 'I picked up and in very clear Spanish,
Mexican Spanish, they said 'We know who you are. We know
where you are at. We know where your family is. We are
watching you. Do not go downstairs. Do not make your
presentation. Because you know what the situation is.
This is not a game." And they hung up.'
http://www.aec.at/infowar/attack.html
>
At 11:00 a.m. the SWARM action commenced. FloodNet was
directed toward Mexican President Zedillo, the Pentagon,
and the Frankfurt Stock Exchange.
>
After 3:00 p.m.
The Disturbance Theater begins to receive messages such
as 'Countermeasured effectively kept me from partici-
pating this morning; I'm wondering if you could give me
an update on how things went?' Another person wrote:
'What's up ? seems we still get the java attack. Any
news?'
>
At 7:05 p.m. the Electronic Disturbance Theater made an
opening announcement at the InfoWeapon Contest award
ceremony to inform Ars Electronica participants that 1)
Ricardo Dominguez had received a threatening phone call,
2) a hostile Java applet had been launched against
FloodNet, and the 3) Stefan Wray had received an email
message from New York University that system adminis-
trators there had been contacted by the DISA of DOD
(Department of Defense) about his ECD page.
>
In the evening we receive an email message from Niall
McKay of Wired News stating: 'I presume that your attack
was unsuccessful since the sites seem to be up and run-
ning?' We later learn that McKay contacts the DOD to ask
about the countermeasure.
>
Later in the evening the SWARM base in Linz received
email from Brett Stalbaum of the Electronic Disturbance
Theater, of CADRE in San Jose, California, that he had
stopped the Hostile Java attack on FloodNet: *The count-
er-attack is paused for now. Someone has authored an
applet called "Hostile Applet", which unlike the Java
Script counter-measure, we can not turn off. It's a real
applet just like the FloodNet. I changed the html to
avoid the pages where they put the applet, so we should
be ok for a while.*
>
>
>
Beyond Soft Hacking
>
Digital Zapatismo has always been an open system of
sprawling networks-this has been the force multiplier of
the movement. It has used digital cultures most basic
system of exchange, e-mail between people to disturb

<click>
for hackcess

the Informatic State. Now that we know that they are using, as we always suspected, hyper-surveillance filters to regain control of the network. We must begin to invent other methods of Electronic Civil Disobedience:
>
1. Continue building alternative networks with more access and bandwidth.
>
2. Deep programming:
Creating Spiders, Bots, and other (minor network agents) to move against specific URLs without interrupting the Server.
>
3.Virtual proximity capabilities:
Thing Connector 3.0. [http://bbs.thing.net]
A simple access systems for Real Time intercontinental electronic communication. These type of system would disable the possibility of surveillance.
>
4. A Satellite/s: Giving us autonomy from controlled networks and backbones.
>
5. Jamming Chips:
Jamming of microchips by groups could systematically disrupt wide areas of sensitive networks. These groups could slip basic disturbances into the chips bought by the U.S military-entertainment complex from foreign countries. Many of these elements are part of a wide range of defensive and offensive weapon systems--that could induce a general dysfunction in performance at a pre-set time.
>
>
>

Theatres of Disturbance
>
The Zapatista Networks, in the spirit of Chiapas are developing methods of electronic disturbance as sites of invention and political action for peace. At this point in time it is difficult to know how much of a distur-bance these acts of electronic civil disobedience specifically make. What we do know is that since Jan 1, 1994 the analysis of the Digital Zapatismo has been at the top of the list of the Military and Intelligence research agenda. We hope that both coordinated and uncoordinated actions can, like the Lilliputians, con-strain this violent giant by many tiny bonds. For now all we can do is continue to forge ahead and always remem-ber that all of this electronic activism is about a real community in search of a real peace. A community that has been calling for a world the makes all worlds possi-ble.
>
>
The Electronic Disturbance Theater
http://www.thing.net/~rdom/ecd/ecd.html
>
Ricardo Dominguez
Carmin Karasic
Brett Stalbaum
Stefan Wray
>>
>
>On Hacktivism:
http://www.rhizome.org/hacktivism
>
CyberZapatistas:
http://www.eco.utexas.edu:80/Homepages/Faculty/Cleaver/zapsincyber.html
>

Attachment converted: hammerPB500:Digital Zapatismo.doc (WDBN/MSWD) [00003259]

<hacktivism>
HACKER SITES
Compiled by Chris Ziegler
>
>
2600 zine <www.2600.com>
The flagship site of the hacker scene, supplementing a print zine named after the old blue box tone that enabled phone phreakers to get free calls. Has an archive of hacked sites, columns and information on 2600 and hacking and gen-eral.
>
AntiOnline <www.antionline.com>
A extremely controversial and occasionally vilified comput-er security site, run by John Vransevich. A wealth of secu-rity information--even including "hacker jargon"--shares space with articles by the uncompromising Vransevich and staff, offering updates on the latest bitter hacker feuds.
>
Attrition <www.attrition.com>
Quite often, on the opposite side of everything from Vransevich, Attrition is sort of an anti-AntiOnline, offering information like text files and technical data from a decid-edly different perspective.
>
Cult of the Dead Cow <www.cultdeadcow.com>
Lauded as "punks with computers" by Mondo 2000 magazine, the cDc has been a long-time bastion for cyber-iconoclasm. Besides the infamous BackOrifice program, which merciless-ly exploits bugs in Microsoft Windows to allow easy remote access to networks, the cDc text archives offer point-and-click access for everything the government wants off the Internet.
>
Electronic Civil Disobedience
<www.thing.net/~rdom/ecd/ecd.html>
The distribution link for FloodNet, a virtual sit-in program, as well as a clearinghouse for information of both the the-ory and practice of electronic civil disobedience.
>
Electronic Frontier Foundation <www.eff.org>
An organization dedicated more to broader free speech issues on the Internet, as well as the driving force behind the digital blue ribbon campaign of 1996.
>
Hacker News Network <www.hackernews.com>
Frequently updated site offering the latest on hacked sites, security issues and federal encroachments on free speech, Hacker News strives mightily to disseminate important hacker information with as little distortion as possible.
>
L0pHT Heavy Industries <www.l0pht.com>
Home of the hackers who testified before Congress on the sorry state of the nation's digital infrastructure. This site has software programs, updates on security flaws and general hacker news.
>
Kevin Mitnick <www.freekevin.com>
A site assembled by supporters of the until-recently jailed hacker, rife with legal documents, news updates and infor-mation that ably refutes much of the establishment line against Mitnick. Also offers information on how to help Mitnick's cause and where to order bumper stickers.
>
>
Content-Type: APPLICATION/octet-stream;
name="WebSidebar.wd6" Content-ID:
<Pine.OSF.4.03.10002261501580.13642@alpha.whittier.edu>
Content-Disposition: attachment; filename="WebSidebar.wd6"
Attachment converted: hammerPB500:Websidebar.wd^
[????/----] [00004229]
>

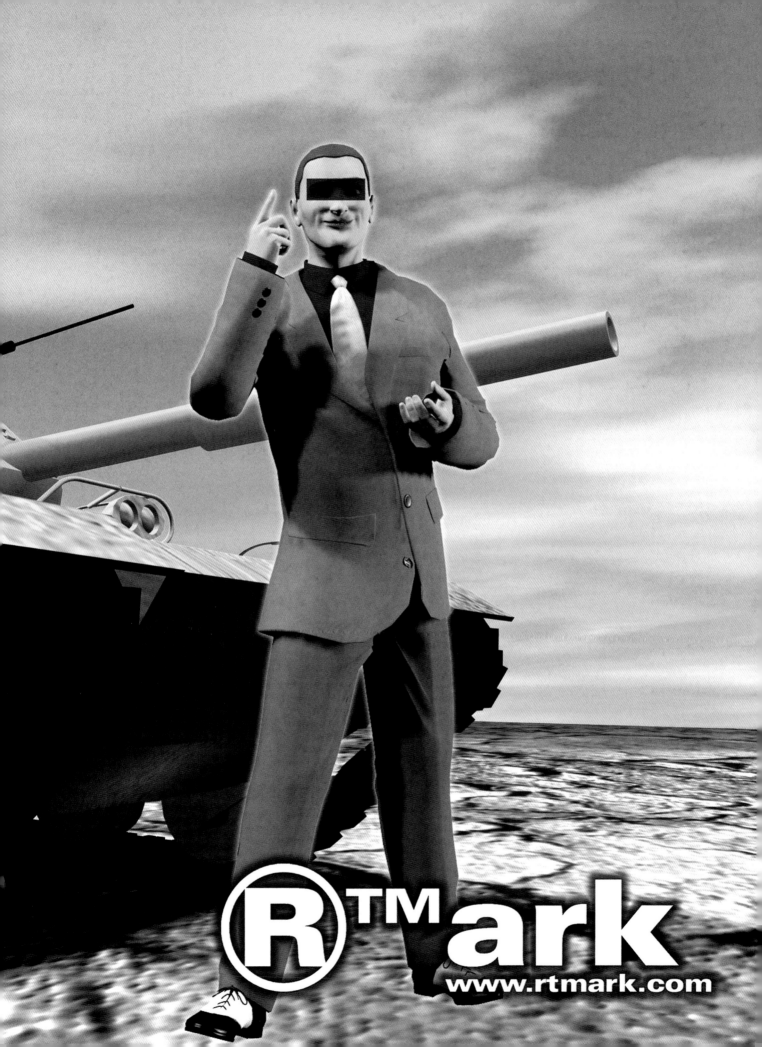

HOW THE WILD WIDE WEB WAS WON:

The story of etoy versus eToys

>
>
>
>
>
>X-Originally-To: <history@online.be>
Date: Wed, 26 Jan 2000 17:18:50 -0500 (EST)
To: Safe for the Moment <history@online.be>
From: RTMark <announce0029@rtmark.com>
Subject: Finally, total victory for etoy (and history@online.be)
>
>This is not a commercial message. Remove by writing mailto:remove@rtmark.com?subject=history@online.be
>
January 26, 2000
FOR IMMEDIATE RELEASE
>
>
>
>
>
ETOYS FINALLY DROPS LAWSUIT, PAYS COURT COSTS
>
>
Late last year, eToys attempted to buy etoy.com from European art group etoy, and offered upwards of $500,000 in cash and stock options for the domain. etoy turned down the offer, so on November 29, 1999, eToys obtained a court injunction preventing etoy from operating a website at www.etoy.com, which had been registered before eToys even existed. To obtain the injunction eToys told the judge that etoy.com was confusing customers, and furthermore that it contained pornography and calls to violence. etoy.com had never made any reference to eToys or toys, nor featured anything resembling pornography or calls to violence.
>
During the subsequent weeks, activists attacked eToys by a variety of means that have been widely credited with contributing to the 70% decline in the value of eToys stock--a decline that began the same day as the protests.
>
The Dec. 15-25 Virtual Sit-in crippled the eToys servers, as CNN reported (http://cnn.com/TRANSCRIPTS/9912/17/mlld.00.html), and prompted eToys to file a restraining order against one of the organizations responsible for it, and to threaten another activist anonymously.
>
Simultaneously, the Disinvest! campaign filled eToys investment boards and other outlets with messages about the situation. Many investors responded by dumping their eToys stock. Even those who refused to see a link

between activist attacks and the eToys stock fall were at a loss to explain how it could lose so much money, so consistently, on consistently good financial news. Some suspected foul play by eToys management, and the possibility of a class-action lawsuit was raised.
>
Finally, on December 29, eToys announced it was "moving away" from its lawsuit in response to public outrage. At first, etoy and the activists were delighted, and a formal counterpart to the statement was expected from hour to hour. Then, when nothing happened for days and then weeks, it became clear that eToys' announcement had been an empty verbal concession it had no intention of making concrete--a typical corporate ploy to derail activist momentum.
>
Activists quickly renewed their campaigns against eToys. RTMark initiated two new campaigns to drive eToys' stock price yet further down (it has now sunk well below its opening value of $20 per share, after a high of $67 reached the day the protests began), and a new community platform, http://www.toywar.com, gathered a "toy army" of 1400 activists poised to perform "operations" on command.
>
The strongest attack to date was scheduled to coincide with eToys' earnings announcement on Thursday. Yesterday, just in time, eToys formally dropped its case against etoy "without prejudice"--a phrase that means either party is still free to attack the other. eToys has also formally agreed to pay etoy's court costs and other expenses incurred as a result of the lawsuit.
>
"A precedent has now finally been set in stone," said RTMark spokesperson Ray Thomas. "eToys thought it could act like corporations typically do, but it had no idea how the Internet works. Now e-commerce corporations have a choice: either obtain a legal stranglehold on the Internet, so that this kind of defensive reaction is no longer possible, or behave decently towards the humans who use this medium for purposes other than profit."
>
"This is the Brent Spar of e-commerce," said Reinhold Grether, an Internet researcher and a mastermind of the anti-eToys campaigns. "Just as the petroleum industry learned it had to listen to environmentalists, so e-commerce companies have now learned that the Internet doesn't belong to them, and they can't do whatever they want with it." (See http://rtmark.com/shell for more about the Brent Spar, and http://www.hygrid.de/etoyrhiz.html for more comments by Grether.)
>
"eToys will try to paint this as a misunderstanding, as just a simple error that has now been corrected," wrote etoy in a prepared statement. "But this is not what happened. They tried to destroy us, and that got them into very big trouble. They wanted to drop their case 'with prejudice,' because they fear further attacks and trademark battles, but now they see they have no choice at all in the matter. It is a total victory."
>
>
Contact: mailto:etoyfund@rtmark.com
More information: http://rtmark.com/etoypress.html, http://rtmark.com/etoy/, http://toywar.com, http://rtmark.com/shell, http://www.etoys.com/cgi->
BACKGROUND AND TIMELINE (see also

RTMark, which is in no way associated with etoy, aims to publicize the widespread corporate abuse of democratic institutions like courts and elections. To this end it solicits and distributes funding for "sabotage projects." Groups of such projects are called "mutual funds" in order to call attention to one way in which large numbers of people come to identify corporate needs as their own. RTMark projects do not normally target specific companies; the etoy Fund projects are an exception.
>
30
>

December 12, 1999
FOR IMMEDIATE RELEASE
>
>
>

NEW INTERNET "GAME" DESIGNED TO DESTROY ETOYS.COM Stock plunge must be accelerated, groups say
>
>
RTMark has joined the growing torrent of outrage, sometimes violent in tone, against Internet toy giant eToys (http://rtmark.com/etoypress.html) by helping create and distribute what RTMark calls "a new toy": a multi-user Internet game whose goal is to damage (or possibly even destroy) the company.
>
The game, which aims to punish eToys for shutting down the Internet art group etoy's domain (see http://rtmark.com/etoypress.html for more information), takes the form of an RTMark "mutual fund," or list of sabotage projects (http://rtmark.com/etoy/). All projects in the "etoy Fund," some of which have already been financed, aim to lower the company's stock market value as much as possible. The site also includes pages that will help visitors to cripple the eToys servers during the ten days leading to Christmas (http://rtmark.com/sitin.html), pages providing detailed financial information about the company, and a page of links to the dozen or so other groups calling for eToys' downfall.
>

eToys is the third largest e-business on the Internet; etoy.com, which eToys lawyers have shut down, is the domain synonymous with the influential Internet art group, etoy. etoy has owned etoy.com since 1995, before eToys existed, and two years before eToys registered its own URL. etoy.com has never made any reference to eToys. See http://rtmark.com/etoypress.html for more information.
>
Since November 29, when eToys lawyers shut down the art group's domain and news of the massive and violent-toned reaction began to spread, huge sellouts (including a 2.5-million-share sale by Moore Capital Management, Inc.) have caused eToys stock to fall from $67/share to $45/share, or nearly 33%; before November 29 eToys stock had been rising. RTMark's new projects group aims to systematically capitalize on and accelerate the eToys share fall.
>
"The etoy Fund projects are a game the whole world can play," said RTMark spokesperson Ernest Lucha. "Many of the projects--boycotts, pickets, e-mail campaigns--can be played by anyone, while other projects--countersuing eToys, disturbing the eToys servers, etc.--require specialized work. There's something for everyone, and we know we can easily count on 10,000 players to start with."
>
There's also something for hackers, who are normally apolitical but have by and large taken eToys' attack on etoy as an attack on themselves. "eToys is trying to take advantage of a legal situation in which there's basically no protection against corporations, whether you're an artist, an activist, or just someone in the wrong place at the wrong time," said a hacker who identifies himself as "Code Blue." "But they're relying a bit too much on the legal. They're saying f*ck you to everything that etoy stands for, and that's like spraying tear gas all over the entire hacking community."
>
"This game is much more exciting than any other computer game, because you have a real world bad guy to fight," said RTMark spokesperson Lucha.
>
"We think it's especially exciting that the court date [December 27, at which the final fate of etoy.com will be decided] falls so close to Christmas," said Richard Zach, a graduate student at the University of California at Berkeley who has closely followed the dispute since the beginning. "The holiday season is a time of giving, but since eToys decided to take, we're making an example of them during their busiest season. Christmas won't be the end of the game, but it's an important first milestone."
>
It's not just about etoy, nor about art or hacking, according to Lucha: the etoy Fund and directly hostile efforts like it could help lead to a new balance of power between citizens and big business. "Why should global culture be dominated by business? The net is a playing field that could help to create, through law, a worldwide balance of power that just doesn't exist now."
>
The anger against eToys is not likely to dissipate soon, even with a favorable outcome to the case (i.e. the survival of etoy.com), according to Lucha. "eToys says etoy.com was hurting sales by disturbing those who stumble upon it. Well, eToys' domain is disturbing people

who want to see great internet art but stumble upon
eToys instead, and so why not say eToys shouldn't exist?
Why should financial might make right? If they want to
play by barbaric rules, we will too."
>
"eToys feels comfortable destroying art for the benefit
of its business, so all the players of this game can feel
great destroying eToys--for the benefit of art," said
Lucha.
>
>
OTHER ATTACKS
>
RTMark and its "etoy Fund" collaborators are only one
group among dozens to mount digital and real-world
attacks against eToys in time for Christmas.
>
Another anti-eToys tool that has already been deployed
and will be announced within the next several days,
according to a source within the above-mentioned group,
is a program that generates fraudulent web page access-
es ("hits") disguised to look like those of Internet shop-
pers coming from numerous, randomly-chosen locations.
The aim of the tool is to make the financial valuation of
eToys.com, which depends heavily on web access counts,
unreliable. This uncertainty, which should become more
evident in the days to come, should increasingly make
investors even more skittish about investing in the com-
pany, according to the source.
>
>
******** OTHER LATE-BREAKING NEWS: ********
******** SEE http://gatt.org/ FOR DETAILS! ********
>
>RTMark is no stranger to the hot topic of domain-name
control. The World Trade Organization's press release
about http://gatt.org, accusing RTMark of "illegal prac-
tices" in publishing information critical of the WTO at
that site, merely brought the WTO ridicule from the
press (http://rtmark.com/gatt.html); George W. Bush's
and Microsoft's legal attacks on GWBush.com
(http://rtmark.com/bush.html) and MicrosoftEdu.com
(http://rtmark.com/allpress.html#mse) failed to affect
the domains. See also http://rtmark.com/othersites.html
for more on this issue.
>
>
30
>
This is not a commercial message. Remove by writing
mailto:remove@rtmark.com?subject=history@online.be
>
If you have received multiple copies of this notice and
wish to receive only one, please remove as above all
address versions but one.
>
>
>
>
>>
>
>
>>
>
>
>>
>
>>

X-Originally-To: <history@online.be>
Date: Fri, 05 May 2000 12:55:57 +0200
From: Reinhold Grether <Reinhold.Grether@uni-
konstanz.de>
To: history@online.be
Subject: Re: text 'HOW THE ETOY CAMPAIGN WAS WON'
Mime-Version: 1.0
>
>
>
>
>
>
>
>
>
>
>
>
>
>
>
HOW THE ETOY CAMPAIGN WAS WON
>
An Agent's Report
agent.NASDAQ aka Reinhold Grether
>
>
>
>
>
>
>
>

Thank you for flying etoy...
>
When, back in November 1999, eToys management unveiled
its coup and Judge Shook pored over the files and etoy
developed the concept for the Toywar platform, I had
just completed my several-month-long study of the evo-
lution of stock prices on the Neue Markt, Germany's
vague equivalent of the US technology index NASDAQ. The
bulk of these stocks for the most part rose dramatically
after their initial public offering and then more or less
zigged and zagged along a plateau before plunging down-
wards, opening out onto a bland wallowing around the
initial offering price. As they say, these valuations are
rather drab. Since these new companies are just now
creating the markets within which they move, the valua-
tions excuse the most miserable data as long as the
story allows expectations for greater future valuations.
>
The actual dynamic lies in the story, the fantasy of the
market, which, like Switzerland's warm wind, keeps
things stirring as long as there's enough hot air feed-
ing it. If, over time, the story loses some of its plausi-
bility, the smart investor grabs his profits, borrowing
the same paper for a limited time, selling high, and if
the stock falls, buys it back and gives it back. Those
who anticipate a change in the market profit whether it
goes up or down. The sovereign speculator is the one
with his hand on the course of the story.
>
As the story turns, so turns the market. The stock falls
because a majority of investors believe they'll earn
more if it falls than if it rises. Rather nasty for those
who banking on high valuations. Long-term investors
wait for the next upward trend, others take their losses

Who owns the dot?

and validate the downward trend, while the truly sorry ones are those forbidden to deal by the rules of the exchange. These are the founding investors and the company management for the duration of the six months following the initial public offering. Looking at the toys market, the general trend on the exchange and overall economic development, literary critics and economists would not be alone in risking argumentatively sound statements on the future of the story and the stock exchange.

>

If two entities are fighting over the same thing, e.g., the domain www.etoy.com, the one who wins will be the one who can convince the other that the object of desire is not as desirable as it appears. The etoy domain was an object of desire, for EToys, because they were losing 20,000 of 300,000 hits a day to etoy.com, for etoy, because the domain name was the point of reference of their artistic existence. And the fight was particularly heated because the opponents followed different sets of logic; the economic, on the one hand, which has to do with numbers and payments, and the artistic on the other, where it has to do with anything but. The art group was in possession of a double advantage: for one, the domain was theirs, and for another, far more important one, the exhibition of the bizarre practices of the financial world was nothing less than their artistic project. While etoy could always put both sets of logic into play, eToys was never able to put the logic of economics to use against its opponent by, for example, burying the opponent in an avalanche of legal fees, nor could it use a third logic, for example, the criminal prosecution of Net activists. No one could hold it against eToys that they couldn't follow the logic of art.

>

When I developed, without knowing any of the participants, the core of what became the RTMark campaign with my "a new toy for you" (all of which is documented at www.hygrid.de/etoyrhiz.html), the point was to set up an undeniable mirror which would make the moves by etoy.arts and etoy.politics appear as losses in the market value of eToys. This mirror was the NASDAQ notation of eToys, from which I was able to determine that the company had exhausted the hot air puffing up their story and that the market was looming on the verge of introducing a downward trend. The idea of focusing the campaign on the destruction of eToys's market valuation was an act of speculating on speculation, a metastory, telling once again the parallel story already autonomously programmed for a fall. As etoy.arts used the similarity of the domains as a value effect, so did etoy.politics use the fall in the stock price as a battle effect. "To hype out the hype," as Ricardo Dominguez and I coined the tactic in The Thing's BBS chat.

>

It wasn't a betting game. It was a thought through calculation: The stock was introduced on May 20, and starting on November 20, the insiders flooded the market. The valuation reflected the anticipation of expectations for the Christmas shopping season and was already moving downward. All ETAILERS found themselves under pressure because the traditional companies had found their electronic footing. And the campaign would arouse so much brouhaha that the majority of new investors would be betting on the slide.

>

Conceptually and legally, etoy.arts was set up brilliantly. Etoy.politics followed a few days afterwards. The judge's ink was barely dry when the first attacks hit the eToys Web site. The spontaneous self-activation of hundreds and the sheer speed of the flow of information were the trump cards. A respectable batch of unmoderated mailing lists such as Rhizome, where my "urgently needed", sent 36 minutes after I received the news to Nettime and four minutes later to Rhizome—had long since met with a wave of positive resonance, when Nettime moderator Ted Byfield let me know that "we don't send out stuff like this." EVEN THOUGH THE POINT WAS TO ATTACK ETOYS IMMEDIATELY, TO HIT THEM SENSELESS WITH ATTACKS JUST WHEN THEY WERE ALREADY OVERWORKED WITH THEIR MONUMENTAL CHRISTMAS BUSINESS. THE MEDIA AND NET.ART SCENE SUBSCRIBED TO RHIZOME UNDERSTOOD IMMEDIATELY, AND SHORTLY AFTER "A NEW TOY," I FOUND MYSELF HIJACKED BY THE ART GROUP RTMARK TO THE WORKING GROUP FURIOUSLY TOILING AWAY.

>

When the forms on the Web site, and then the mailboxes of the management were plastered with protests with the help of Richard Zach's estimable Feedbackpage, eToys was pulled into a press frenzy, and they must have realized in no uncertain terms that they were facing a powerful opponent with a talent for grand politics. Etoy made this clear on a legal level, RTMark on the political, the NASDAQ valuation on the financial and the virtual sit-in on the infrastructural level.

>

A virtual sit-in is little more than a collective, simultaneous requesting of a Web site. If one requests a Web site faster than it can be transferred and built up on the end user's screen, the server receives, on the one hand, a message telling it that the first request is no longer valid, and on the other hand, the new request. Scripts running on one's own computer or on go-between servers automate this process, and after a certain number of requests, the server under attack begins to suffer under the strain. One has to differentiate very specifically between knocking out a server for private motives and a political action openly disrupting a Web site for clearly formulated reasons and for a limited time. That's when it becomes comparable to a warning strike during wage negotiations, a means of civil disobedience signaling that one side has the willingness and courage to fight. A virtual sit-in risks bringing symbolic forms of action to bear in a medium of virtuality.

>

In the case of eToys, great pains were taken to attack the server for short spans of time only (six fifteen-minute periods on ten Christmas shopping days) and to avoid completely bringing it down at all costs. There was a "killer bullet script" which was capable of doing just that, but its use was unanimously opposed. One participant wrote: "I'm not ready to trade the distributed, swarming community of activists model for a single tactical nuke." The point was to get across just how widespread the protest was; it was not about a terrorist attack.

>

This much can be said of the effect: There were seven or eight rotating mirrors around the world running five different scripts. Added to this were several tools circulating around on the Net, which can be installed on personal computers. The combination made it possible to keep eToys's server busy performing routine tasks. THE CLEVEREST SCRIPT WAS PROBABLY "KILLERTOY.HTML", A NON-LINEAR SCRIPT THAT FILLS COOKIES-BASED SHOPPING CARTS TO

>
>
X-Originally-To: <history@online.be>
X-Originating-IP: [207.252.62.157]
To: history@online.be
Subject: digital hijack
Date: Tue, 07 Mar 2000 19:03:51 EST
Mime-Version: 1.0
>
>

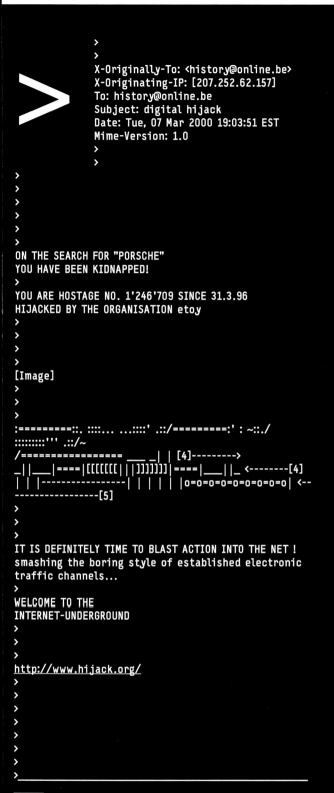

>
>
>
>
>
>
ON THE SEARCH FOR "PORSCHE"
YOU HAVE BEEN KIDNAPPED!
>
YOU ARE HOSTAGE NO. 1'246'709 SINCE 31.3.96
HIJACKED BY THE ORGANISATION etoy
>
>
>
>
[Image]
>
>
>
:========::. ::::... ...::::' .::/=========:' : ~::./
::::::::''' .::/~
/================= ___ _| | [4]--------->
_||___|====|[[[[[[|||]]]]]]|====|___||_ <--------[4]
| | |----------------| | | | | |o=o=o=o=o=o=o=o=o| <--
----------------[5]
>
>
>
IT IS DEFINITELY TIME TO BLAST ACTION INTO THE NET !
smashing the boring style of established electronic
traffic channels...
>
WELCOME TO THE
INTERNET-UNDERGROUND
>
>
>
http://www.hijack.org/
>
>
>
>
>
>
>
> _____

THE BRIM WITHOUT ACTUALLY MAKING A PURCHASE. For every
new item, the server would have to refigure the complete
list all over again, a process that would take longer and
longer as the cart filled, and some of the mirrors could
generate a hundred thousand or more requests a day.
eToys's server was able to process the simple request for
pages on the first day without a hitch, but the more com-
plex scripts introduced on the second day gave it a run
for its money. Requests for particular IP addresses were
completely blocked, meaning that eToys was taking itself
out of these networks. It was the "super_plus_version" of
the shopping scripts, then, that led to the shutdown of
one of The Thing's Web sites by backbone provider Verio.
Here, too, the "hype out the hype" strategy was at work,
further virtualizing eToys's virtual shopping carts with
virtual purchases.
>
Just as important was the constant presence in all the
investors' forums that had to do with eToys where
breath-taking, whiplash-like discussions were taking
place. At first, the tone was set primarily by the finan-
cial world gloating over those mourning for the lost
domain. But the vocabulary of investors can be picked up
pretty quickly, and soon, the speculators counting on an
upward trend were confronted with all sorts of negative
financial data. When the market made its irreversible
dip, the catcalls from investors betting on the slump out
yelled even those from the activists.
>
The financial press was as surely in eToys's hands as the
cultural press was in etoy's. But the telling difference
lay in the fact that one side publicized the story for all
it was worth, while the other side avoided every instance
of publicity. So the financial press, which could hardly
ignore the dramatic fall in the stock price, kept the
impact of the "Internet renegades" as invisible as possi-
ble. Up to the point of eToys's first concession when
Bloomberg.com ran the complete press statement from
RTMark. "It's hysterical," one of the founders emailed.
>
No personal meeting, no telephone contact. Email and Web
sites, nothing else. Mad email traffic early in the
evening, and when necessary, early in the morning. Then,
time to think it all over. Shortly after noon, mails to
Rhizome so that the early risers on the East Coast were
immediately brought up to speed. Flow, when ten to
twenty people were communicating at once and sending
information around the world. Anyone can do it. You, too.
>
An email finish with electronic slingshots! Hundreds of
Toywar agents place the eToys management under Toywar
fire! Unconditionalsurrender!!!
>
>
>
>
>
First published in German Telepolis on February 9, 2000
Translated by David Hudson
 >
 >

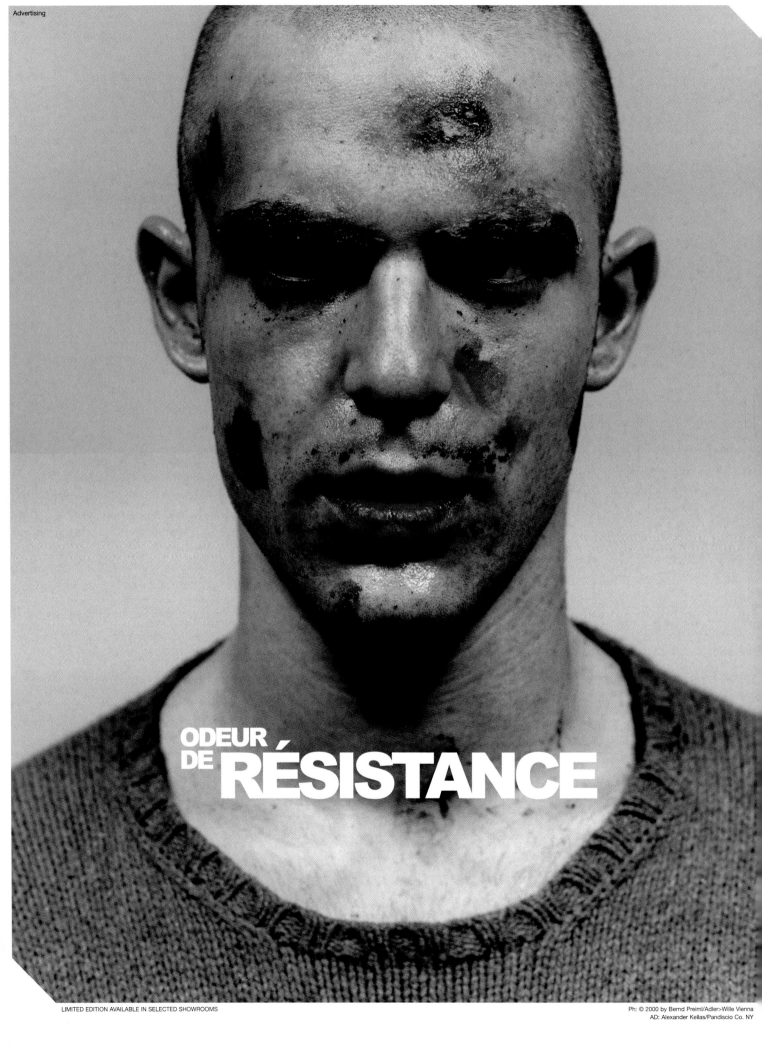

ODEUR DE RÉSISTANCE

Ph: © 2000 by Bernd Preiml/Adler>Wille Vienna
AD: Alexander Kellas/Pandiscio Co. NY

IT HAS TO BE VERY SIMPLE AND SLAPSTICK, THE MORE ORTHODOX THE BETTER. VERY SOFT DOUGH WITH MOUNTAINS OF CREAM SO WE DON'T HAVE TO THROW THE PIES, BUT INSTEAD WE CAN LAY THEM DIRECTLY DOWN ONTO THE FACE OF OUR VICTIMS. THIS WAY OUR HIT RATE IS 95%. NOEL GODIN, ALIAS GEORGE LE GLOUPIER

CREAM AND PUNISHMENT: THE REVOLUTION OF EVERYDAY PIES

By Mark Sanders*

* Originally published in Dazed & Confused, issue 42, May 1998

Noel Godin, alias George Le Gloupier, is a true veteran of May '68. Author of Cream and Punishment and an 800-page Anthology of Subversion, he has since his early days as a film critic in Brussels been the leader of the infamous Entarter Movement; that pie-flinging band of self-styled revolutionaries who stop at nothing in their quest for freedom and personal liberty.

Formed in the late 1960s as a response to the growing complacency of the rich and famous, the Entarter have since grown in stature. Advocating what they politely term, 'a symbolic pastry assassination of the image', they stalk the would-be darlings of the media ready to plant a well placed Bombe Surprise at but a moments notice.

No one can escape their wrath. Novelist Marguritte Duras, film director Jean-Luc Godard (for turning Catholic and kissing the Pope), the Bishop of Nante (while delivering the Eucharist), the French Minister of Culture (on his first ever official engagement), five Swiss MPs and the reviled right-wing French philosopher Bernard-Henri Levy who, holding a special place in Monsieur Godin's heart, has been pied five times in as many years.

Their latest victim, Microsoft chief and the richest man in the world Bill Gates, is still recovering from his multi-layered chocolate gateaux onslaught that took place earlier this year, prompting BodyGuard Weekly to announce - 'IS ANYONE SAFE?'.

But as the controversy thickens Godin remains oblivious to any danger that might threaten him. In a quiet suburb of Brussels, surrounded by thousands of stolen books on subversion and thousands more pirated video tapes of slap-stick comedies, he plans his next move; "We are only just beginning", he grins mischievously, "We feel ready now. We are strong in numbers. A genuine International Brigade Patissiere has been born and I firmly believe that we are capable of achieving even greater things in the near future. For instance, I believe we can eventually flan the Pope".

Mark Sanders: The first person you ever flanned was the novelist Marguerite Duras in November '69. Your latest, Bill Gates in 1998. That's almost 30 years of constant flanning.
Noel Godin: It started all that time ago and I just never stopped, I will never stop. For the first time it was like an orgasm, the coitus. There's something so sexual about flanning someone, you feel so gratified.

Do you consider 'a pie in the face' an act of subversion in the spirit of late '60s?
Of course! I have always remained true to the spirit of May '68. I still live for that time and have always advocated direct sabotage; the sabotage of the professions, the sabotage of the roles into which we are trapped by our day to day boredom. I propose to all workers to sabotage their work, to sabotage their production and their employers and so in accordance to that philosophy, I myself sabotage my own position as a proletarian intellectual. That's how I started in the first place, working as a cinema critic for a magazine published by the Belgian Catholic League. There I sabotaged everything that I ever wrote.

In true Situationist style.
Indeed. The systematic sabotage of life. During my time as a cinema critic I printed complete falsehoods. I would invent non-existing films that I illustrate with snapshots of my relatives. I wrote well over 200 interviews without ever leaving my desk, asking questions and then write the answers immediately. Everything in my short celebrity news column was faked; breakfast with Robert Mitchum, aperitifs with Jack Lemon - none of it ever happened. I only got away with it because I was a credulous editor and no one would ever see the copy outside of Belgium.

Poetic misinformation?
Exactly, a methodical form of private and public subversion. It lasted for 12 years and I never got into trouble.

Who was your most popular creation?
I once created a blind director from Thailand named Viviane Pei. Although she couldn't see a thing I wrote this glowing review stating

that her's were the most beautiful films in the history of cinema. Masterpieces such as The Lotus Flower Will No Longer Grow On The Shores Of Your Island dripped off my pen. In fact she was so convincing as a character that an Asian cinema critic named Pierre Dial actually went to Thailand to find her. Once he discovered that she didn't actually exist he went ballistic!

And your personal favourite?

That has to be George Le Gloupier, leader of the Entarter movement. I made up this story that he was on a crusade, flanning film directors around the world. His first fictitious victim was Robert Bresson but when I learnt that Marguerite Duras was coming to Belgium I decided to cross over from the realm of fantasy into the world of reality.

And that was your first venture into the world of flanning. Where you alone on that fateful day?

No. I had a girlfriend who, in accordance to tradition, handed me a pie at the moment of delivery. There was also a cameraman and two photographers but as usual the cameraman missed the shot and only the photographers were successful. We were on the front cover of all the Belgium newspapers and have never looked back since.

And now George Le Gloupier has become the official disguise of all would be Entarters.

As soon as one flans a victim one instantly becomes George Le Gloupier. That's why anyone involved in a hit should wear the Le Gloupier disguise; a false beard, thick spectacles and a bow tie.

Even women?

Especially women!

And now the Entarter movement stretches across the world.

Their are cells everywhere ready for action. We have received well over a thousand letters giving us support. Wherever I go people want to fight for me. I take down the addresses but I never get round to calling everyone. We could be over ten thousand strong by now, a huge organisation, but we operate in a complete mess all the time so we recruit from the street instead. When I was last at the Cannes Film Festival we were building up a safari patissier but I was only with one other friend but by the time we flanned Tuscan du Plantier, Bernard-Henri Levy and Arielle Dombalse, we numbered at least 30. Many people volunteer so I just choose them at the last minute.

As you did recently with Bill Gates.

With that particular hit we numbered 32. 25 pies in all. We were very cautious, even scared. We were careful to make sure that on the morning of the proposed flanning, two thirds of those involved still didn't know who the target was because we didn't want people giving the game away by talking to their friends who would then undoubtedly repeat the information and destroy our cover. You plan these hits to the last minute detail. How do you find out

where a potential victim is going to be at a particular time or date? For the last five operations, the victims have been betrayed by their own entourage. We have informers who come to us with a precise plan of action. That's what happened with Bill Gates. We announced in the press that we were targeting him and within nine days someone high up in the Belgium headquarters in Microsoft contacted us with a full itinerary of his forthcoming trip to Belgium. His reasons were simple enough. Although he had always admired Bill Gates he felt that he had become unbearably arrogant and needed to be brought down a peg or two. From that moment on he never stopped faxing us inside information, including a map of the hotel where Gates was going to be staying.

You had his every move pinned down.

Exactly, the day before he arrived in Belgium, friends of ours in Paris managed to get hold of special press passes and so were able to inform us that he had a body guard of five armed men who never left him alone for a second. Our informant at Microsoft also told us that on his journey to Belgium, he would be accompanied by four motorcycle policeman and that wasn't even taking into account the interior security that would undoubtedly be in place in all the places that he was to visit. But we had numbers on our side. Body guards are trained to stop a conspiracy of say, two or three terrorists but against 32 people armed with custard pies they are useless as a defence.

Did you have to stalk him further?

On the actual day of the hit we had to wait all afternoon. We congregated at the pub and drank Monks beer to give us all courage. Finally we left the bar singing old anarchist songs to keep our spirits up. When we arrived at the scene we divided into small elite groups of three people called Unitees Gloupinesque or 'Gloup Gloup Units'. We hid our ammunition in shopping bags and waited. Then suddenly Bill Gates arrived with all these sirens screaming. At that moment all the 'Gloup Gloup Units' gathered together to form a pastry whirl and then fell on him in a hurricane of flying pies.

(laughs) And what was his reaction?

At first he attempted an advertising smile but it soon shrivelled up and changed into a grimace. We shouted the war cry, "Let us flan, let us flan the tainted money!" and then went into action. In total he received three pies outside and a further one straight in the face when he entered the hotel lobby. He was so annoyed he fired his body guards the next day.

Other victims have been even less fortunate though. The pretentious French pseudo philosopher Bernard-Henri Levy has become a regular target of yours hasn't he?

Bernard-Henri Levy has been flanned five times so far and we are

HOW MUCH IS IT WORTH NOT TO BE FLANNED?
I'VE WRITTEN A NOTE TO BILL GATES SAYING THAT WE WILL FLAN
HIM AGAIN BEFORE THE END OF THE SUMMER UNLESS HE GIVES
THE EQUIVALENT OF ONE DAY'S SALARY TO THE ZAPATISTA
COMMANDANT MARCOS IN CHIAPAS, MEXICO

NOEL GODIN, ALIAS GEORGE LE GLOUPIER

currently planning the sixth operation. He has become so paranoid of being flanned that he has now lives in a complete psychosis. When he was in Belgium recently to talk about his latest film production he would only be interviewed if the journalist agreed to be picked up in a car and driven to a secret location. It got so ridiculous that many Belgium journalists wrote that he was turning totally insane.

So which pie is best suited for assassinations?
It has to be very simple and slapstick, the more orthodox the better. Very soft dough with mountains of cream so we don't have to throw the pies but instead we can lay them directly down onto the face of the victims. This way our hit rate is 95%. I am almost embarrassed to say that we hardly ever miss our target.

How do you choose your preferred victims?
Our main principle is to only flan people when they are in a very powerful position. In Levy's case, he uses his position to encourage either war as he did in Bosnia or his own profile as he is presently doing with the Algerian conflict. But we shall carry on flanning him until he learns his lesson. This year it will be the sixth time. We have the access code to his flat that was given to us by an English journalist. But Levy always has the option of ceasing hostilities. If on the next pie that he receives he sings the old French song 'Avez-vous le beau chapeau de Zozo' we will sign a peace accord.

You've written that a pie in the face is a good barometer of character. Is that always true?
A pastry assassination always reveals the true colours of its victim. When we hit Jean-Luc Godard in 1985 he showed himself to be elegant in defeat whilst most other victims are quick tempered. Godard was the great exception. When after the attack he heard that I had been banned from the Cannes Film Festival he called from Switzerland to demand that my pass was given back to me.
In contrast Bernard-Henri Levy after his fifth flanning in Cannes, demanded that I be banned for life.

Do you consider you pastry assassinations to be assassinations of the image then? A media assassination?
Exactly. On the one hand it is real terrorism but it is also a burlesque terrorism. It's very violent but only symbolically violent, a violence that can be found in Bugs Bunny cartoons or Monty Python.
If anyone is wounded it is only in their self esteem.
A pie in the face is a great leveller.

As in the spirit of Dadaist abusive letters sent to celebrities at the turn of the century.
I'm a great partisan of those abusive letters sent by the Dadaists, and those sent by the Surrealists, and the Situationists; in fact a pastry assassination is the perfect materialisation of the classic abusive letter. It's an abuse that becomes a reality, that explodes in your face.

The subversive power of humour...
We kill our victims with ridicule...
A cream pie transformed into a bomb!
I believe that we have to use the principal weapon of the enemy and that is the media. The Yippies and Hoffman understood that, they would accept an invitation to appear on television in order to mess around with water guns. That was a major force in amplifying the counter-culture movement. They may not be terrorists per se, they didn't kill but they were extremists. Once the Yippies managed to get one of their organisation inside the Pentagon and put a massive doss of LSD in the drinking water reserve. Other members burned dollar bills in Wall Street.

As contrasted by the activities of the more hard-core combat groups such as the Black Panthers or Weathermen.
All those groups were sympathetic but they lacked of humour. They took themselves far too seriously. Righteous Marxists who were very austere. There are a few groups that I feel sympathy for at that time. In particular, the English outfit called The Angry Brigade.

Who's your next target?
I've written a note to Bill Gates saying that we will flan him again before the end of the Summer unless he gives the equivalent of one day's salary to the Zapatista Commandant Marcos in the Chiapas.

And your main objective?
To declare Chanttily war on all heads of State. We vow to get Chirac within the next year, to cover Clinton from head to toe in chocolate Gateaux; Tony Blair, Fidel Castro and the Pope. That is the thing of real importance. I don't consider it a negative act to prostitute myself if it helps me to reach my goal. I know that some so called 'pure' revolutionaries say that you should never compromise in order to reach revolution but they always seem to be saying that while drinking in bars. They want to rebuild the world sat on their arses. I've nothing to loose by playing games. It can be dangerous of course but I trust myself. Nothing will make me recant. I say 'Let them all eat cake!'

Noel Godin's website which features images of his recent hit on Bill Gates and other favourites can be viewed on: www.gloupgloup.com

BILL GATES HIT BY CREAM PIE, the MPEG-movie at: http://www.bitstorm.org/gates/

BILL GATES HUMBLE PIE TOSS
http://www.politicallycorrect.com/gates/

TOSS A PIE AT YOUR FAVORITE BILLIONAIRE: BILL'S PIE TOSS:
http://www.risoftsystems.com/pietoss.asp

February 2, 1998: Brussels
BILL GATES FLANNED BY THREE CREAM PIES

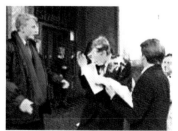

112

PASSENGER INFORMATION

WELCOME ABOARD SKYJACK AIR

BETTER SAFE, THAN SORRY

DISCLAIMER
To pull through the ordeal, you must play the game like anyone else and follow the tried and true guidelines below. Any deviations from these themes are taken at your own risk. Skyjack Air will not be liable for any events triggered outside the parameters listed. And remember, while Skyjack Air might not guarantee your safety—we certainly always deliver the terror!

We can only ensure you the thrill of a skyjack experience, but not your survival! Disaster is an unlikely probability, but there are no guarantees. Knowing what to do, and how to react, will pull you through the hostage event. However, one false move by victim or perpetrator can easily result in a catastrophe. Stick to the simple rules on this checklist, and you will most likely not fall victim to the aggression of your captors.

The hostage incident can spring at any instant the moment you check in at Skyjack Air. The element of surprise is part of the package deal. From now on one thing is of paramount importance: YOUR SURVIVAL!

PRE-DEPARTURE DO'S AND DON'TS

How you pick your seat will affect your proximity to the hijackers. Flying first class gives you more edge than flying coach. Terrorists often convert the first class cabin into their command post, since it accesses the cockpit and main exits, while its location controls a view and field of fire into the tourist section. As a result, first class gets you ringside seats during a shoot out. Moreover you attract attention flying first class, you are automatically considered wealthier or a potentially politically more valuable hostage. Aisle seats will get you singled out. Most shooting is directed down the aisles as gunmen fight their way into the plane. Mid-aisle seating arrangements and seats too far from emergency exits are a sure-fire way to miss out on the action.

Documents in your possession should preferably identify you as a corporate bigwig, secret agent, or something equally volatile. Additional hints as to your religious/ ethnic background, political propaganda and or pornography should stimulate your captors as well. The supply of tranquilizers in your hand luggage, could be a lifesaver in the case of a long, drawn out hijacking. Dress for comfort, hijackings are tedious affairs. Spice up an otherwise bland wardrobe with American flag colors, corporate logos (American), political slogans, jingoisms: "America the Beautiful", "Rocking in The Free World". Be colorful! What's more provocative than an American tourist? Bermudas, Hawaiian shirts and that Kodak hanging from the straps: Give 'em what they're looking for...

At airport terminals, linger— do that last minute duty-free spree. Savor that last cup o' Joe, that Big Mac. You are being watched, yes they are targeting you. Unattended luggage, look out! Chances are they contain the bomb that could make this amble through the terminal worth the muzak over the PA. Same for trash cans, telephone booths and news stands. If it looks suspicious, notify the authorities, it keeps the ball rolling.

Once inside the airplane, check beneath the seat and in the overhead compartment for any suspicious items i.e., a bomb or anything that resembles it. Lavatories are often a haven for hijackers to hide their weapons or explosives: take a look, visit the toilets. Lift the lids; frisk the closets and especially the waste bin. You might find something unusual.

HOW TO SURVIVE A HIJACK

A. DURING HIJACK

Do not panic
The first 15 to 45 minutes are the most crucial. This is when Skyjack Air will need to demonstrate absolute command of the situation: the hijackers are likely to be violent and nervous. Humiliation and intimidation will be used to prove to you and the other passengers that we mean business. Take the abuse without complaint; follow instructions to the letter. Your hesitation is likely to be met with violence.

Obey instructions
Do as you are told, without argument or complaint. You will be required to stay seated, with the window shades pulled down and your hands up on your head— this is usually relaxed after the initial stage of the hijack. You will probably be asked to give up your passport. The flight attendants will be made to participate in collecting these items.

Keep a low profile
Maintain a low profile and curb your vanity. The truth is you don't want to be targeted for special handling by the hijackers. Unless directly spoken to, avoid eye contact with the hijackers: during the initial stage of hostage taking this might be perceived as an aggression. Maintain a neutral demeanor. Keep your fear or anger in check, never turn your back on them, unless ordered to and never volunteer to do anything.

Don't be a hero
Attempting to overpower the hijackers or trying to be a hero will most likely lead to disaster. Avoid the John Wayne syndrome, instead be Zen and accept your situation. Be observant, memorize details about the terrorists: nationality, identity and languages spoken; race, sex and facial features; number of hijackers, their location and routines. Take note of types of weapons and explosives, and a report on any plans to be carried out by the terrorists. You may be released early, and this will be valuable information to the authorities in handling the incident.

Never speak unless spoken to
Avoid conversation. Don't complain. Don't argue and ask questions, it might agravate your captors. Keep your thoughts to yourself.

Don't move
All movement will be restricted and you will be buckled into your seats with seat belts. Once the initial adrenaline rush abates, it is going to be mostly boring. The hijackers may enter a negotiation phase that could last indefinitely and the crew may be forced to fly the aircraft to yet another destination. During this phase passengers may be used as a bargaining tool in negotiations, lives may be threatened, or a number of passengers may be released in exchange for fuel, departure clearing or food. This will be the longest phase in the hijacking. It's a good time

B. AWAITING RESCUE

Stay seated
Most likely you will survive the hijacking with a minimum of discomfort. Or not, in prolonged situations you will experience the stench of toilets overflowing; lack of air-conditioning; extremely hot when in the warm country, chilly in the cold ones. You might feel cramped and stiff. The situation will be become unbearable. Look on the bright side, worse things might happen. On occasion passengers have been singled out for demonstrative execution; there is no manual on how to avoid this.

 ## Obtain permission to use the bathroom

Toilets will be in terrible condition; toilet paper will be out of supply. If you are not permitted use the bathrooms, you will have the option to use your seat.

 ## Don't talk. Don't ask questions

Avoid conversation. Don't reason with your captors. Avoid arguments. Get yourself mentally prepared for questioning by the hijackers.

 ## Eat and drink what is offered to you

Food and water will appear on an irregular basis. Don't be a prima donna! Consume what is offered to you: who knows when next you'll be fed, or how long you will remain a hostage. Keep up your strength; eat everything offered to you. Avoid drinking alcohol, you want to be alert. Rest if possible.

 ## Avoid escape

Escape usually provokes retribution. You'll endanger yourself and the lives of your fellow passengers. We caution against this sort of strategy— Skyjack Air will not be liable for any ensuing tragedies. Wait it out.

 ## Prepare for the worst

Standard hijackings are over in 72 hours. Assume the worst—if terrorists are desperate enough to hijack a plane or die trying, be rest assured there is unpredictable behavior in the arsenal. Remember, here at Skyjack Air, our hijackers are better than the real thing. Passengers might be beaten, pistol-whipped or executed to meet their demands.

C. RESCUE & SHOOT-OUT

 ## Stay alert for possible rescue

Technology exists to determine what's going on inside the plane and to locate the hijackers. Be aware of your surroundings. In the event of an armed intervention, the noise will hit first, lights may go out and then the blinding flash of "stun grenades". Screaming and gunfire will follow: get down in your seat in crash landing position.

In case of an EXPLOSION: If a bomb goes off, there may be decompression: people and luggage will be sucked towards the hole. Keep your seat belt fastened to increase your chance of survival. The flight crew is trained to deal with these situations: follow their instructions.

 ## Hit the floor and stay down

Rule one during any explosion or shoot-out: hit the floor and stay down! Pull your arms over your head. The rescue team will not immediately distinguish passengers from terrorists. Whatever you do, don't stand up, even if the hijackers try to make you—you might get hit in the crossfire. A S.W.A.T. team will fire at anyone or anything that moves. Play dead.

 ## Get up when you're told

Once the rescue is initiated, don't get involved; just follow the exact orders. Only get up when you're told to do so. Don't pick up stray weapons. The rescue squad will probably shoot anyone with a gun. Come up only when you are sure the firing has stopped.

 ## Identify escape routes

An emergency plan comes handy. Look around; memorize the location of the exits. Know how to get out of the plane. Count the rows to all nearest exits, front and back. In the event of a rescue attempt or crash, the plane will be full of smoke. Stay low, in crawl position, to avoid being overcome by smoke and feel your way to the exit. Leave your possessions behind. It is only a matter of time before the airplane is blown up.

 ## Security measures

Once the mission is accomplished, the rescue will treat everyone like a terrorist until they have sorted the bad guys from the good guys. You might be frisked and questioned by the local authorities. Just cooperate.

 ## Photo Opportunity Available

The media will no doubt be on hand to turn you into a celebrity. This is the pay off for all those hours of fear and boredom. Have your story ready, get blood in the headlines, forget about politics.

CONNECTING FLIGHTS

Choose your airline company with care, some airlines are more likely to be targeted than others. US carriers were once considered safer than most airline companies, this is no longer the case: a glaring history of terrorist assault tends to indicate substandard security measures. Even so, West Germany's Lufthansa, and Israel's El Al, by virtue of having been frequent targets are more sophisticated in terms of safety. Experts agree that airliners from neutral countries such as Scandinavia, Switzerland and Singapore are less likely to be hijacked than carriers from the US or other major political blocs. India's national airline has been singled out by Shiite terrorists. More recently former Russia attracted lots of local hijackers since the country has been divided up amongst nationalist's fractions.

Boeing 727 and Douglas DC-9 are hijacker favorites. Terrorists avoid Boeing 747s; the size of the aircraft requires more manpower and coordination on part of the captors. Instead the trend has been to single out 747's for suitcase bombs more than any other plane. And that's not the sort of action you're looking for.

The above information pertains to SKYJACK AIR and may not be applicable to shared flight codes used by other airlines. Please refer to those airlines inflight material for their safety and service information.

CHECK YOUR CALENDAR

Terrorists often carry out their attacks to commemorate their heroes, demi-gods and important historical events. See our selection of high-risk areas on the skyjack routes. Brush up on your foreign affairs-- what's happening in the country you're likely to be diverted to? For certain religious and national holidays (depending on the final travel destination and stopovers) you may want to check the following calendar:

January 8: Palestinian Memorial Day

January 17: Bombing of Baghdad (surgical strikes)

February 1: The Ayatollah returns from exile

March 8: CIA sponsored car bomb, Beirut

March 21: International Solidarity Day for Palestinians

March 24: Bishop Romero (El Salvador) assassinated

April 9: Israeli raid on Beirut

April 15: Birth of North Korean president Kim Il-Sung

April 15: Reagan attacks Libya from the air

May 20: Cuban Independence Day

May 30: Lod Airport massacre by Japanese Red Army

July 3: Iranian Airbus downed by US Navy

June 5: Israeli-Palestinian conflict: Six-Day War

June 7: National Revolutionary Movement of Bolivia founded

July 4: US Independence Day

July 6: UFO crash at Roswell

July 19: Sandinista Revolution, Nicaragua

September 1: Anniversary of Muammar Qadaffi's revolution

September 5: Munich Olympic Games bus bombing

September 9: The Chairman (Mao Tse Tung) Dies

September 11: Chilean President Salvador Allende overthrown

September 15: Independence Day: El Salvador, Honduras, Nicaragua & Guatemala

September 16: Independence Day: Mexico

September 17: Independence Day: Chile

October 7: The death of Che Guevarra

October 18: Baader-Meinhof leaders found murdered in their cells

November 4: US embassy in Tehran seized

November 18: Mickey Mouse's Birthday

November 29: Proclamation of state of Israel

December 10: Founding of Popular Front for the Liberation of Palestine

December 26: The Chairman (Mao Tse Tung) is born

WE WELCOME YOUR COMMENTS!

You can reach us by eMail: <history@online.be>
If you'd like to write to us about our service, please send your letters to: zap-o-matik, Cooper Station, PO Box 1602, New York 10276

ENJOY YOUR DETOUR!
Skyjack Air

CYBERJACK CONTROL PAD INSTRUCTIONS

PREPARING THE SCREEN

1) Pull the screen upright out of the armrest to a vertical position.

2) Rotate the screen up.

3) Rotate the screen to face you and adjust to a comfortable viewing angle.

1) A handset with your CYBERJACK CONTROL PAD is located to the right of your seat.

2) Push button to release handset from cradle. Gently pull cord and lock at comfortable length.

3) Press on/off until display lights up. Select language for display screen information. Follow screen information for your selection.

4) When prompted swipe (credit billing) card with magnetic stripe facing up and to the left.

OPERATING INSTRUCTIONS

1) Cyberjack Control Pad

2) Display Panel: to select your channel number. The letters **A** and **B** will appear as options for alternate language choice. Press **Select** to change language.

3) Mode: returns you to the Main Menu

4) Overhead Reading Light On/Off

5) Cyberjack Up/Down

6) Volume Up/Down

7A) Hijacker Cancel Button

7B) Hijacker Call Button

8) Start: activates the Skyjack Route program

9) Credit Card Reader: allows you to pay for premium entertainment services by sliding your credit card through the slot. The magnetic strip should face down. Please slide the card from top to bottom slowly.

10) Game Buttons: activate the Cyberjack game.

HELP MENU

For your convenience, a help menu on the handset screen gives you step-by-step instructions. Just press **+** to access the help menu.

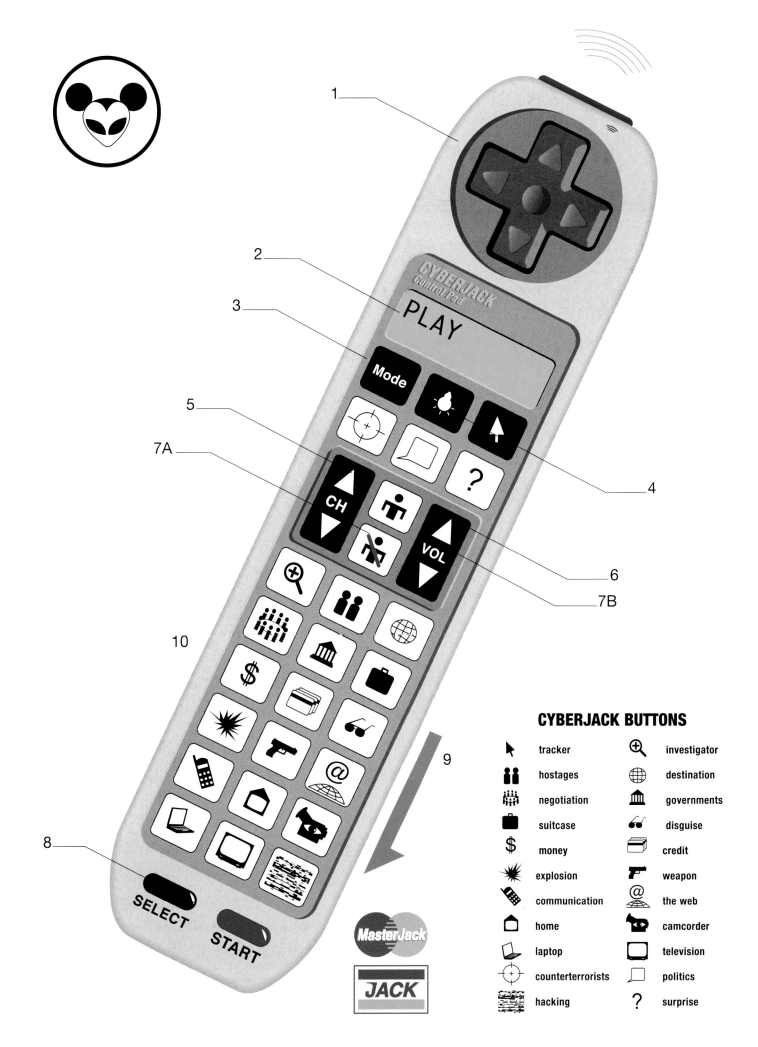

CYBERJACK BUTTONS

➤	tracker	⊕	investigator
👥	hostages	🌐	destination
🏃	negotiation	🏛	governments
💼	suitcase	👓	disguise
$	money	💳	credit
✳	explosion	🔫	weapon
📱	communication	@	the web
🏠	home	📹	camcorder
💻	laptop	📺	television
⊕	counterterrorists	💬	politics
▦	hacking	?	surprise

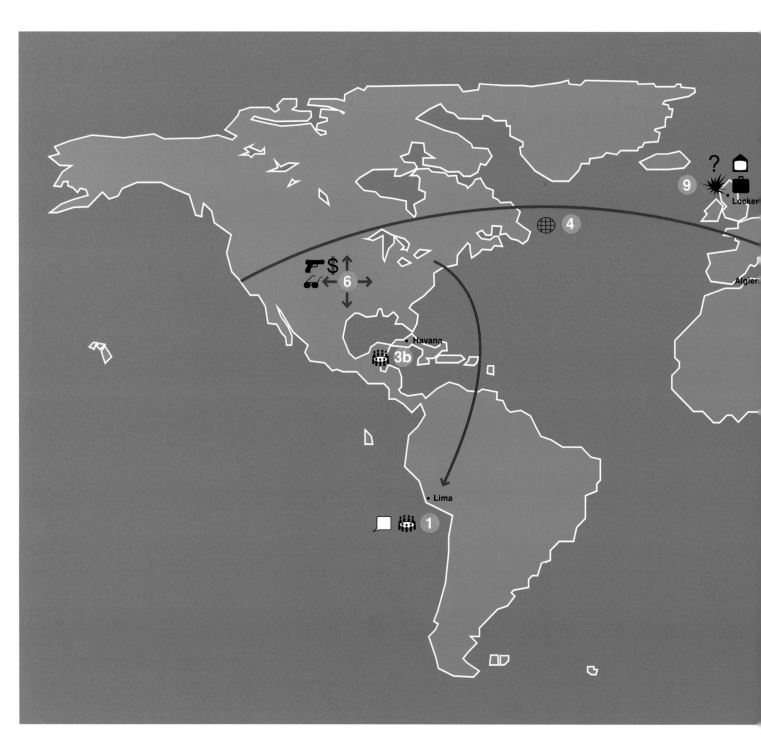

① **Peru, 1931: FIRST RECORDED HIJACK:**
Revolutionaries seize PanAm plane to drop pamphlets over Lima

② **1947-1958: THE PROPELLER YEARS:**
ALWAYS THE "WRONG SIDE" OF THE IRON CURTAIN

July 1947: First postwar hijack. Romanians go West.
September 1948: First skyjack across the Iron Curtain. Greeks go East.
No applause in the West.

1958: ENTER THE JET SET AND A NEW WORD: 'HIJACK!'

③ᵇ February 17 1958; Pusan to Pyongyang, North Korea: Red sympathizers skyjack
across 38th Parallel. *THE TIMES* adopts the term 'hijack'.

③ᵇ 1958-1972: Havana, Skyjacker's Haven: Fidelistas initiate hijacking as guerrilla
tactic. Hundreds of planes will change course to Cuba in years to follow.

④ **November 1969: FIRST TRANSATLANTIC HIJACK**
Vietnam Vet Raffaele Minichiello hijacks American airliner to Rome.

SKYJACK CAPTURES TELLY!

⑤ **March 1970: TOKYO STREETS DESERTED:**
MILLIONS WATCH FIRST TELEVISED HIJACK LIVE

Japanese Red Army seizes airliner with Samurai swords, destination North
Korea. New word enters Japanese vocabulary: "Haijakku"

⑥ **September 6, 1970: PFLP TURNS PALESTINE INTO HOUSEHOLD NAME**

SKYJACK SUNDAY OVER EUROPE: 600 passengers plucked from the sky.
Destination: 'Revolution Airstrip.' Security features now commonplace at airports
worldwide. *THE TIMES* proclaims 1970 as, 'Year of the Hijacker.'

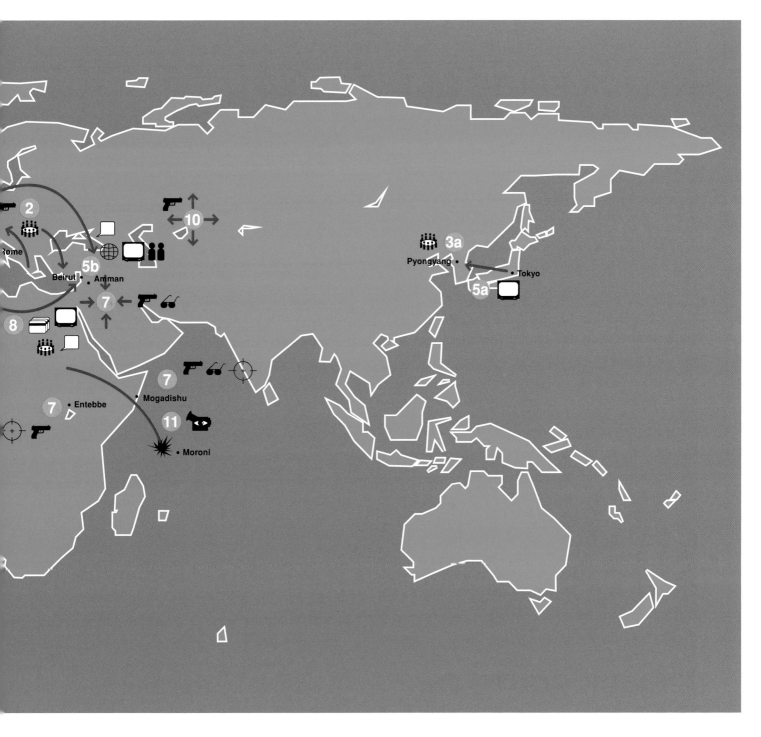

1971-1972; North America:
ENTER THE PARAJACKER. EXIT THE MONEY
Thank God it's Skyjack Friday! Hijack buzzer hits alert every week.

1972-77:
**TERRORIST (AND COUNTERTERRORIST) SWAP SHOP:
LET'S TRADE HIJACKINGS**

RAF, JRA & PFLP trade Kalashnikovs, passports and hijackings.

Counterterrorist forces trade stun grenades and pledge to "shoot-terrorist-on-sight"

1980s: **TERRORISM IS WHAT THE BAD GUYS DO: RONALD REAGAN HOSTS SHI'ITE PRIMETIME AND HIJACKS TV**
June 1985 (Beirut-Algiers): Shi'ites commandeer TWA Flight 847. Media spectacle deflects from Reagan administration's clandestine activities in Central America: the one American hostage killed in the Middle East eclipses 10 000 people killed in Central America.

1980-:
GOVERMENTS PLAY TERRORIST: JUMBOJETS DROP FROM THE SKY

1990s:
FROM CHECHNYA WITH LOVE: NEW NATIONS, NEW JACKS
Eastern block topples, skyjacking on the rise.

Larry King Live:
CAMCORDERS TURN SPECTATOR INTO HEROES
November 23, 1996; Moroni, Comoro Islands:
"HONEYMOONERS VIDEOTAPE HIJACK HORROR!"

SKYJACK ROUTE 2a: THE MIDDLE EAST

1968: PALESTINIAN SKYJACK WAR HITS THE WORLD

The 1967 Six-Day War leaves 700 000 Palestinians homeless. On July 23, 1968 the Popular Front for the Liberation of Palestine (PFLP) reclaims territory in the sky, commandeering an Israeli plane to Algiers.

August 1969: Leila Khaled takes American TWA Flight out of Rome on a 7-min detour over occupied homeland.

**REFUSHNIKS: OFFICIAL REQUEST DENIED
SOVIET JEWS SKYJACK THEIR WAY TO ISRAEL**

June 15, 1970; Smolny Airport: St.-Petersburg authorities give Jewish hijackers death sentence. In Jerusalem hundreds flock to Wailing Wall to demonstrate.

September 6, 1970: DESTINATION: REVOLUTION AIRPORT

"THIS IS A VERY GOOD AIRPORT; WE WILL FILL IT WITH AIRPLANES IF ALLAH IS WILLING"

2 JETS TO DESERT
3rd JET BLOWN UP ON CAIRO RUNWAY
4th PLANE FOILED, LEILA KHALED CAPTURED
5th PLANE SEIZED. DEMAND: KHALED'S RELEASE

May 8, 1972; Lod Airport, Tel Aviv: BLACK SEPTEMBER MASQUE!

First assault on hijacked plane: Israeli commandos in mechanic's gear. Palestinian girls in exploding girdles and detonator wonderbra!

**December 1975; Vienna:
SHOOTOUT AT OPEC (Organization of Petroleum Exporting Countries)**

Carlos, AKA the Jackal, kidnaps eleven oil Sheiks with plane.
Hilton provides take out services.

Counterterrorist teams at Entebbe (1976) and Mogadishu (1977) adopt "SHOOT-TERRORIST-ON-SIGHT" doctrine.

June 1985; TWA Flight 847 Beirut-Algiers: CREDIT IN THE REAL WORLD

Airport personnel demand credit card from Shi'ite hijackers to pay for fuel. Stewardess comes to the rescue— charging $12 500 worth of gasoline to her personal credit card.

February 4, 1986:
Israeli fighters pirate Libyan air in an attempt to capture Palestinian leader. Security Council at the United Nations condemns Israeli airpiracy. US vetoes.

SKYJACK ROUTE 2b: THE CUBAN JOYRIDE

**1958: NEW GUERRILLA TACTIC:
FIDELISTAS SKYJACK THEIR WAY TO POWER**

1959: BOOMERANG
Refugees hijack out of Cuba. US grant first political asylum to skyjacker.

**Summer 1960:
UN INVITES CASTRO TO NEW YORK. US IMPOUNDS CASTRO'S JET.**

1961 -1972: HONEY! WE'RE GOING ALL THE WAY TO... CUBA.
BOOMERANG 2: Flux of homesick Cubans jumpstart wave of hijackings to Havana

**1969: HIJACK INN:
CUBANS WINE AND DINE AMERICANO'S**
Havana airport expands to accommodate hundreds of unscheduled joyrides.

August 2, 1970: FIRST JUMBO JET 747 HIJACKED

**1968-72: SKYJACK ROUTE TO CUBA:
BLACK PANTHERS ON THE RUN**

1980-90s: BOOMERANG 3
New wave of hijackers flee Castro's regime.

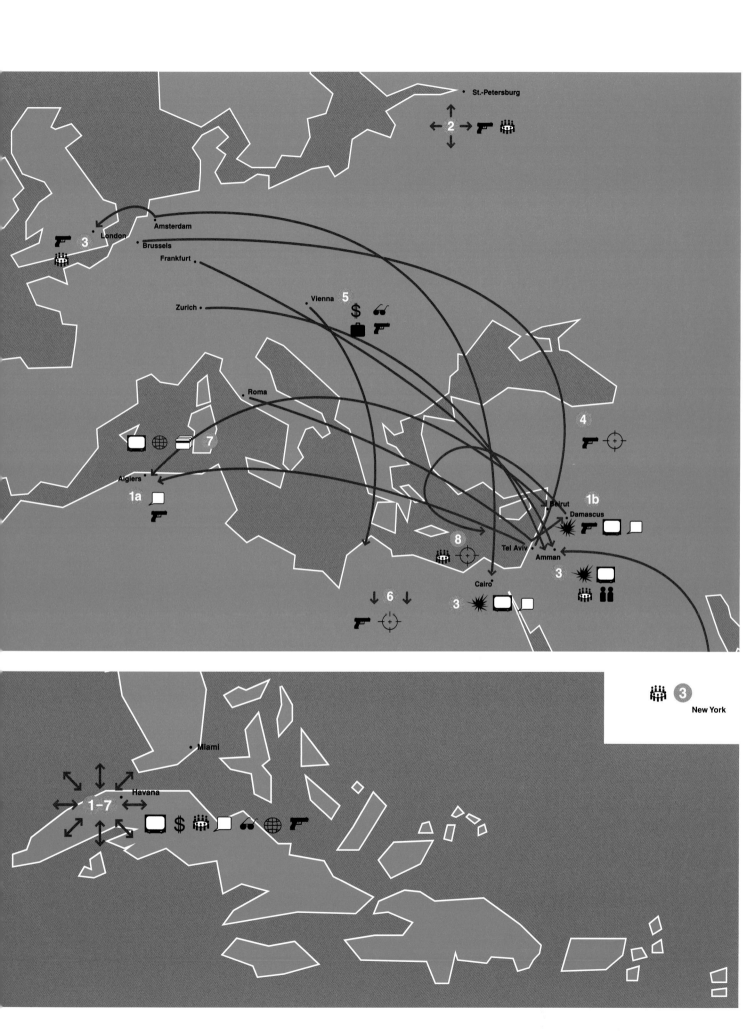

SOLO ENDEAVOURS

① **October 31, 1933; Chesterton, Indiana: FIRST STEWARDESS TO DIE MIDAIR**
United Airlines transcontinental: 1st US-reported midair bombing.

② **May 7, 1949: Manila: EX-CON**
Woman and lover hire ex-convicts to place bomb on Philippines Airliner to kill husband.

③ **November 1, 1955; Denver: BLOW MOMMA FROM THE PLANE**
John Gilbert Graham buys a $37 500 insurance policy from an airport vending machine, then puts his mom on a plane with a suitcase filled with 25 sticks of dynamite!

④ **March 23, 1976; Tokyo: BANZAI!**
Mitsuyasu Maeno crashes kamikaze style into billionaire Yoshio Kodama's, house. Kodama is suspected of laundering money for the Lockheed Aircraft Corporation.

1970-90s:
GOVERNMENTS PLAY TERRORISTS: JUMBO JETS DROP FROM THE SKIES.

⑤ **December 28,1968:**
Israeli commandos swarm Beirut Airport blowing up 13 Arab jets—in reprisal to a PFLP attack on an Israeli Boeing 707

⑤ⓑ **February 21, 1973: MISTAKEN IDENTITY**
Israeli fighter plane shoots down stray Libyan passenger plane.

⑥ **September 1, 1983: JAMES BOND**
The "Evil Empire" strikes again! Soviet fighter launches missile at Korean passenger plane that strays into sensitive USSR military zone. The downed plane crashes, killing 269. Genuine spy mission enlisted by the Reagan administration? Flight number: 007!

⑦ **April 4, 1986; London, Heathrow: BUSTED!**
Nezar Hindawi puts unsuspecting (and pregnant) girlfriend on a flight to Israel; her bag lined with enough semtex to blow up the plane. Inside the bag a pocket calculator fitted with detonator. Luckily, she was busted. Rumors of a double agent double cross.*

⑧ **July 3, 1988; Persian Gulf: MISTAKEN IDENTITY 2**
USS Vincennes misidentifies Iranian civilian airliner as a hostile F-14 military fighter plane. The plane, carrying 290 Muslims on Hajj to Mecca, is downed. US claims non-liability in 'Right of Self-Defense at International Law'. Legally suspect: the US is not officially at war. Iran, however, calls it an act of war.

⑧ⓑ **December 21, 1988; SUITCASE "HOT POTATO"**
Iranian Ministry of Interior contracts Syrian based Ahmed Jabril (PFLP-GC) to blow up American airliner in retaliation for the downed Iranian Airbus. Mission fee: $10 million. Result suitcase bomb rips PanAm Jumbojet out of sky over Lockerbie; 270 lives lost. PanAm blames CIA; CIA blames Libya; Terrorists worldwide claim blame.

⑨ **August 24, 1988; Rawalpindi, Pakistan: FIRST HEAD OF STATE TO FALL FROM THE SKY**
Plane carrying Pakistani President, Zia ul-Haq, explodes midair. Lone survivor: a single copy of the Koran. Bomb suspected to be KGB plant on behalf of Afghan rebels.

⑩ **July 1996; TWA Flight 800 TURNS X-FILE**
Satellite images suggest missile as cause of explosion for TWA Flight 800. Other sources link the incident to a UFO scenario. US government has no comment.

BOOMBOX

⑪ **February 21, 1970 Vienna: STEREO BOMBING**
BOOMBOX triggered by barometric pressure to detonate while airborne: Austrian airliner explodes minutes after take off and limps back to airport with fuselage missing. Less fortunate, Swissair Flight, bound for Israel, blasts out of the sky the same day: 47 die.

⑫ **September 1974; Mediterranean: BRIGHT PINK SAMSONITE**
Investigators conclude that an innocent looking *BRIGHT PINK LADIES' SAMSONITE* suitcase contained the bomb that brought down TWA Boeing 707.

⑬ **June 23, 1985; Tokyo: SANYO "STEREO"**
A suitcase headed for Flight 003, explodes at Narita Airport, before boarding. The bomb was built into a *SANYO MODEL FMT 611K RADIO*. 55 minutes later an Air India Jumbojet 747, bound for Bombay, explodes off the coast of Ireland; 329 lives lost. The testing of the Star Wars program, space debris, Russian rockets and UFOs are speculated as open possibilities for the downing.
(source Blaise & Muhkerjee, 1987:41)

⑭ **April 2, 1986; TWA Flight 847: COFFEE, TEA or SONY?**
Bag of lingerie conceals *SONY WALKMAN* detonator. Greek shepherd watches bodies falling from the sky.

⑮ **November 29, 1987: SHOPPING**
North Korean agents posing as father and daughter, leave shopping bag with a *PANASONIC RADIO* aboard. A time bomb destroys South Korean Air Flight 858 on its way from Baghdad to Seoul, killing 115. When captured, the pair swallow cyanide pills.

⑯ **December 21, 1988; Lockerbie: HOW MANY UMBRELLAS?**
TOSHIBA RADIO-CASSETTE PLAYER bomb hidden in a *BRONZE-COLORED SYSTEM 4 SAMSONITE SILHOUETTE 4000* along with a blue cotton baby jumpsuit and one umbrella. (Five umbrellas in total recovered from the plane wreckage).

⑰ **May 18, 1990: COUNTERFEIT HITACHI**
Jim Swire smuggles a replica of the suitcase bomb that downed the PanAm Flight 103 through customs, hidden in a *HITACHI MODEL TRK510ER RADIO-CASSETTE PLAYER* to draw attention to the lack of aviation security. He's able to fly across the Atlantic with the fake bomb. Nobody notices.

* The official version being that the bomb was allegedly crafted by Syrian intelligence operatives and passed to Hindawi by his Syrian handlers. However, French Prime Minister Jacques Chirac (*Le Monde* Nov.11 + *Washington Times* Nov.10) cites the West German Government as authority for the alleged involvement of the Israeli Secret Service in the attempted bomb plot as a provocation designed to embarrass Syria and destabilize the Assad regime (McWhinner 1987: 177). Patrick Seale explored the scenario of Hindawi being a double agent planted by the Syrians, but controlled by Israel, whose mission was to smear Syria as a terrorist state. The Heathrow bomb was never intended to go off, and its discovery by an Israeli security guard was a mere charade. President Assad claimed in an interview (*Time Magazine*, Oct.20) that the Israeli intelligence had planned the operation to isolate Syria internationally (Seale 1992:249-252).

DEATH BY COMPUTER

1980: Air traffic controller attempts to create mid-air collision by tampering with the computer terminals. A Soviet plane, with former Soviet Ambassador Anatoly Dobrynin en route to the US, is deleted from the screen.

HACK HARDER

1990; Washington DC: US Special Forces Sergeant turns terrorist. First he cyberjacks the control tower of Dulles International Airport. Next he recalibrates the ILS (Instrument Landing System) to 200 feet below sea level, so that planes crash into the tarmac. As negotiations ensue, twenty planes, fast running out of fuel, circle the airfield, ready to drop like flies out of the night sky. Enter action hero Bruce Willis to save the day. The movie is: '*Die Hard 2: Die Harder*'.

CONTROL TOWER HACK: FACT OR FUTURE?

A 1997 scenario depicts a cyberterrorist's hack attack on an air traffic control system, causing two large civilian airliners to collide. (The Future of Cyberterrorism' by Barry Colin)
March 10, 1997: Teenage computer hacker disables a telephone company computer and unwittingly cuts the power supply to the control tower at the regional Worcester Airport in Massachusetts. Hysteria over fact resembling fiction leads to the teen hacker being scapegoated for what was essentially a self-fulfilling prophecy.

"IRANIAN MULLAHS BRIBE RENEGADE SOFTWARE WRITERS TO HACK AIR TRAFFIC CONTROL SYSTEMS"

GAME BOYS:
March 23, 1995; US National Defense Research Institute (RAND) develops InfoWar Game to explore hypothetical infowar crises. US National Security and US telecommunication companies participate, simulating presidential advisors.*

Cyberwar is launched at 12 noon, May 20, 2000; Atlanta, Georgia. A barrage of fake transactions set off automatic bank teller machines. CNN intermittently goes off air. May 22: Sophisticated logic bombs infect the landing control software in all latest model Airbuses AB-340 and AB-330— Airbuses full of American tourists drop one by one from the sky over Chicago.

INFOWAR GAME #2: DROP HARDER

September 1998: During a Bosnian flare-up, Serbians cyberjack a NATO controltower. Two military planes collide. CNN broadcasts a statement with the cyberactivists' web address. Millions hit the site within 24 hours, however the website distributes a Trojan horse deleting the hard drive of all those accessing it, including state intelligence organizations. (1998 "Information Warfare Research Competition") **

PILOT FORGETS HOW TO FLY

September 17, 1993: X-File case # X-1.02-091793.

X-FILES HACK

March 1994: British X-Files addict Matthew Bevan hacks US Air Force to find out about alien business.

PRONTO!

May 5, 1995, Rome: Late for his Caracas-bound flight, a passenger, driving to the airport sends in a bomb-threat via mobile phone in an attempt to delay his flight. Police track the call and arrest him at the check-in.

1996: HACK A UFO

An underrated weatherman hacks into the mainframe of an alien "mothership" with his powerbook. Aliens destroyed, world saved, White House beamed to pieces. ('*Independence Day*')

BRITISH AIRWAYS GROUNDED

April 6, 1997: Phone-In-Sick-Day event responsible for halting British Airways. Thousands collude to synchronize 'sickouts.'

BILL GETS FLANNED

February 2, 1998; Brussels: Microsoft Mogul Bill Gates gets flanned by three custardpies.

June 1998; Spain: COACH POTATO ZAPS PLANE

Skyjacker holds-up plane with a TV remote control.

SKYJACK ROUTE 4: CYBERJACK!

ERCEPTION MANAGEMLENT

95: PENTAGON PLAYSTATION

a bid to upstage Nintendo, Pentagon unveils latest infowar dget: a $70 million aircraft operating "Commando Solo." atures include: "SOFTWAR—SOFTWARE", the strategic alter- g of the opponent's perception of reality through hijacking tire national television system. Sadam Hussein was to be oadcast on Iraqi TV with ham sandwich and Whiskey in hand ring Gulf War.***

ecember 16, 1997; Tokyo: STUNNING SHOW!

okémon, a popular Japaneses TV cartoon, triggers convul- ns, vomiting, and eye irritation in over 600 children. The izures are induced by an exploding "vaccine bomb" in the rtoon, followed by five seconds of red flashes in the eyes of kachu. (CNN, Tokyo, Dec.17, 1997)

AGNETIC STRIP

stralia: Disgruntled scrap metal yard employee cranes a large ectromagnet over the office building. Entire computer data is ped out by switching the device off and on repeatedly, send- g immense electromagnetic pulses through the building. ****

THE FLY WHO BUGGED ME

ROACH CAM

1997: Japanese researchers develop remote sensored cock- roach with surgically implanted surveillance cameras. US Defense commissions research into smart bugs to potentially spy in hostage incidents. *****

SURVEILLANCE DUST WATCHES

Pentagon develops surveillance dust conceived as a screen of thousands of electronic eyes and ears, equipped with miniature floaters to send them aloft. (New York Times: January 27, 1997)

LOOKING FOR TROUBLE

Martin Libicki proposes a mesh of bobbing airborne sensors immune to detection. Sensing hostile aircraft they swarm the enemy like fleas on a passing dog. Precision-fitted with chemi- cals, the killer-ants eat through the aircraft's system or alterna- tively explode in a rain of carbon fibers, obliterating the plane's engines. (1994:19-51)

INFOWAR: PAPER PLANE ASSAULT

March 30, 2000; Amador Hernandez, Chiapas: Zapatista's attack Mexican Federal Army encampment with thousands of paper airplanes. The aircrafts carry propaganda tailored to incite the enemy troops to rebel.

May, 2000: LOVE BUG

e-virus sweeps world, taking out hard drives to cost of $10 Bililon. Impossible to resist with the anouncement 'ILOVEYOU'.

McDOLLAR

1992: Task Force on Terrorism and Unconventional Warfare claims Iranian and Syrian governments pose a national security threat by engaging economic warfare by counterfeiting US cur- rency. The same claim is made again in 1996: billions of coun- terfeit $100 bills printed by Iranian government! The question arises: is this an act of War and is the US justified to act in self-defense?

1997, West Virginia: Teenager uses Photoshop to replace Benjamin Franklin's face with his own, on phony dollar bills. The ruse is discovered when his uncle buys a Value Meal at the local McDonalds. (New York Times, August 18, 1997)

* Molander, Roger C./Riddile, Andrew S./Wilson, Peter A.,(eds.): *Strategic Information Warfare: A New War*, National Defense Research Institute, RAND Corporation, Santa Monica, 1996 / ** Mentioned in: Van Tijen 1999:411. See: http://≠www.ndu.edu/ndu/preswell.html
*** Stocker 1998:14-5; Campen, Dearth & Goodden 1996: 203-218; Denning 1999:102 /
**** Dennings 1999:153 / ***** Associated Press; Denning 1999:194

INFLIGHT ENTERTAINMENT:
BIBLIOGRAPHY

Alexander, Yonah & Sochor, Eugene (Eds.): **Aerial Piracy and Aviation Security** Dordrecht, The Netherlands; Martinus Nijhoff Publishers 1990

Arey, James A.:**The Skypirates**, New York: Charles Scribner's Sons, 1972

Arquilla, John & Ronfeldt, David: **Cyberwar is Coming!** In: Arquilla, John & Ronfeldt, David: **Athena's Camp. Preparing for Conflict in the Information Age,** Santa Monica: RAND National Defense Research Institute 1997; pp. 23-60

Ashwood, Thomas M. :**Terror in the Skies,**New York: Stein and Day Publishers, 1987

Baum, L. Frank : **The Wonderful Wizard of Oz,** New York: Dover Publications, Inc. 1960

Beer, Gillian: **The Island and The Aeroplane: the Case of Virginia Woolf** In: **Homi K Bhabha, Nation and Narration**, pp. 265-90, New York, Routledge, 1992

Bellamy, Robert V. & Walker, James R.(eds.): **The Remote Control in the New Age of Television**, Westport, Connecticut; Praeger, 1993
—& Walker, James R.: **Television and The Remote Control, Grazing on a Vast Wasteland**, New York / London; Guilford Press, 1996
—& Walker, James R., Traudt, Paul J.: **Gratifications Derived from Remote Control Devices: A Survey of Adult RCD Use**. In: Bellamy, Robert V. & Walker, James R.(eds.): **The Remote Control in the New Age of Television,** Westport, Connecticut; Praeger, 1993, pp. 103-112

Bey, Hakim: **T.A.Z., The Temporary Autonomous Zone, Ontological Anarchy, Poetic Terrorism**, Willliamsburgh, New York: Autonomedia 1985, 1991
—See also: Peter Lamborn Wilson

Blair, Ed (with Captain William R. Haas): **Odyssey of Terror,** Nashville, Tennessee: Broadman Press, 1977

Blaise, Clark & Bharati Mukherjee: **The Sorrow and the Terror; The Haunting Legacy of the Air India Tragedy**, Viking, 1987

Blum, Howard: **Out There: The Government's Secret Quest for Extraterrestrials** New York, Pocket Books, Simon & Schuster, 1990

Branwyn, Gareth: **Jamming the Media. A Citizen's Guide. Reclaiming the Tools of Communication**, San Francisco: Cronicle Books, 1997

Braunig M.J.: **The Executive Protection Bible,** Aspen, Colorado: ESI Education Development Corporation, 1993

Brown, David J. and Merrill, Robert: **Violent Persuasions: The Politics and Imagery of Terrorism**, Seattle: Bay Press, 1993

Burroughs, William S.: **Fore! Cities of the Red Night,** New York: Holt, Rhinehart & Winston, 1981

Campen, Alan D. & Dearth, Douglas H. & Goodden Thomas R. (eds.): **Cyberwar: Security, Strategy and Conflict in the Information Age**, Fairfax, VA; AFCEA International Press, 1996

Carlson Kurt: **One American Must Die, A Hostage's Personal Account of the Hijacking of Flight 847**, New York: Congdon & Weed, 1986

Channels Magazine, How Americans Watch TV: **A Nation of Grazers**, New York: C.C. Publishing, 1989

Choi, Jin-Tai: **Aviation Terrorism. A Historical Survey, Perspectives, and Responses.** New York: St. Martin Press, 1994

Clyne, Peter: **Anatomy of Skyjacking,** London: Abelard-Schumann, 1973

Colin, Barry: **The Future of Cyberterrorism** In: **Crime and Justice International**; March 1997

Cox, Matthew & Foster, Tom: **Their Darkest Day. The Tragedy of Pan Am 103 and its Legacy of Hope**, New York: Grove Weidenfeld, 1992

Critical Art Ensemble, Video and Resistance: **Against Documentaries in The Electronic Disturbance**, New York: Autonomedia, 1994
—**Electronic Civil Disobedience, and Other Unpopular Ideas**, New York: Autonomedia, 1996
— & Pell, Richard: **Contestational Robotics** In: **Nettime: README!, ASCII Culture and the Revenge of Knowledge** New York: Autonomedie, 1999; pp295-301 (http://www.nettime.org)

Dallin, Alexander: **Black Box, KAL 007 and the Superpowers** Berkeley / Los Angeles / London: University of California Press, 1985

Dean, Jodi: **Aliens in America. Conspiracy Cultures from Outerspace to Cyberspace** Ithaca, London: Cornell University Press, 1998

DeLillo, Don: **Mao II** , New York: Viking Penguin, 1991
— **White Noise,** New York: Viking Penguin, 1985

Denning, Dorothy E.: **Information, Warfare and Security,** Reading, Massachusetts: Addison Wesley Longman, Inc., 1999,

Deppa, Joan (with Maria Russell, Dona Hayes and Elizabeth Lynne Flocke): **The Media And Disasters. PAN AM 103**, New York: New York University Press, 1994

Der Derian, James: **Antidiplomacy. Spies, Terror, Speed, and War,** Blackwell Cambridge MA & Oxford UK, 1992

Emerson, Steven & Duffy, Brian: **The Fall of Pan AM 103. Inside the Lockerbie Investigation**, New York: G.P. Putnam's Sons, 1990

Fawcett, Bill: **Making Contact. A Serious Handbook for Locating and Communicating with Extraterrestrials**, New York: Avon Books, 1997

Foehling, Oliver: **Internauts & Guerrilleros, The Zapatista Rebellion in Chiapas, Mexico, and its extension into cyberspace**. In: Crang, Mike/Crang, Phile/May, John (Eds.): **Virtual Geographies; Bodies, Space & Relations,** London / New York, Routledge, 1999

Friedman, Robert I.: **Sheikh Abdel Rahman, The World Trade Center Bombing and the C.I.A.**, Open Magazine, Pamphlet Series, 1993

Garrin, Paul: **Invisible Harvest (of the Data Bodies).** In: Stocker, Gerfried/Schöpf, Christine (eds.): **InfoWar.** Wien / New York, Springer / Ars Electronica '98; 1998; pp. 251-255

Geller, Matthew & Williams, Reese (Eds.): **From Receiver to Remote Control: The TV Set**, New York, The New Museum of Contemporary Art New York, 1990

Genet, Jean: **Prisoner of Love**, translated by Barbara Bray Hanover / London, New England: Wesleyan University Press, 1992

Giroux, A. Henry: **The Mouse that Roared, Disney and the End of Innocence** Oxford / Lanham; Rowman & Littlefield Publishers, 1999

Guisnel, Jean: **Cyberwars. Espionage on the Internet,** Massachusetts, Cambridge: Perseus Books, 1999

Groening, Matt: **Bart Simpson's Guide to Life, A Wee Handbook for the Perplexed** London, Harper Collins Publishers, 1996

Gunther, Max: **D.B.Cooper: What really happened** Chicago, Contemporary Books, 1985

Hacker, Frederick J.: **Crusaders, Criminals & Crazies,** New York: WW Norton, 1976

Hanson, C.: **How to Wrest Control of Your Set** In: **The Chicago Tribune**, Dec.19, 1993; sec.6, p. 8

Hubbard, David G.: **The Skyjacker: His Flights of Fantasy** New York: The Macmillan Company, 1971
— **Winning Back the Sky: A tactical analysis of terrorism** San Francisco / Dallas / New York: Saybrook Publishers, 1986

Khaled, Leila: **My People Shall Live: Autobiography of a Revolutionary** London, Hodder & Stoughton, 1973
—**Die Waffe gab mir Würde. Die ehemalige Luftpiratin Leila Chalid über Palästina, den Frieden und den Tod**. Spiegel–Gespräch; In: **Der Spiegel** 11/1996, Redakteur: Jürgen Hogrefe, S.; pp. 158-162

Klausmann Ulrike, Marion Meinzerin & Gabriel Kuhn: **Women Pirates and the Politics of the Jolly Roger**, Montreal / New York / London: Black Rose Books, 1997

Langley, Noel & Ryerson, Florence & Woolf, Edgar Allan: **The Wizard of Oz (screenplay of the movie)**. London / Boston: Faber and Faber, 1991 (first published by Dell Publishing, 1989)

Lesce, Tony: **Wide Open to Terrorism,** Port Townnsend, Washington: Loompanics Unlimited, 1996

Lesce, Tony & Rapp, Burt: **Bodyguarding: A Complete Manual** Port Townnsend, Washington: Loompanics Unlimited, 1995

Libicki, Marin C.: **The Mesh and the Net: Speculations on Armed Conflict in a Time of Free Silicon**, Washington DC: National Defense University Press, 1994

Lightbody, Andy: **Terrorism Survival Guide, How Not to Become a Victim** New York, Dell Publishers, 1987

Livingston, Steven: **The Terrorism Spectacle**, Boulder / San Fransisco / Oxford; Westview Press, 1994

Livingstone, Neil C. (with Steve Ryan, Don Heney, Dave Chateller & Corporate Training Unlimited): **The Complete Security Guide for Executives** , Lexington, Mass. Lexington Books, 1994

Livingstone, Neil C. : **The Cult of Counterterrorism, The Weird World of Spooks, Counterterrorists, Adventurers and the Not-Quite Professionals** Lexington, Mass. / Toronto; Lexington Books, 1990

Mc Girk, Tim: **Wired For Warfare; Rebels And Dissenters Are Using The Power Of The Net To Harass And Attack Their More Powerful Foes**. In: Time Special Report / **The Communications Revolution / Languages of technology,** October 11, 1999 VOL. 154, NO. 15

Mc Gran, John: **My UFO Abduction—By TV Star Rhonda Shear: I'm pregnant with Space Alien Twins!** SUN, Vol.13-#21, May 23, 1995, pp. 20-1; Rouses Point, NY; Globe International Inc.

Mc Whinner, Edward: **Aerial Piracy and International Terrorism,** Dordrecht, The Netherlands; Martinus Nijhoff Publishers, 1987

Mellencamp, Patricia: **High Axiety. Catastrophe, Scandal, Age & Comedy**

Bloomington & Indianapolis, Indian University Press, 1990

Molander, Roger C./Riddile, Andrew S./Wilson, Peter A., (eds.): **Strategic Information Warfare: A New Face of War,** Santa Monica, National Defense Research Institute, RAND Corporation, 1996

Paletz, David L. & Schmid, Alex P.: **Terrorism and the Media,** Newbury Park / London / New Dehli: Sage Publications, Inc., 1992

Phillips, David: **Skyjack. The Story of Air Piracy,** London: Harrap, 1973

Rich, Elizabeth: **Flying Scared. Why We Are Being Skyjacked and How to Put a Stop to It,** New York: Stein and Day Publishers, 1972

Richmond, Doug: **How to Disappear Completely and Never to be Found** New York: A Citadel Press Book, Carol Publishing Group, 1995

Rhodes, Bernie: **D.B.Cooper, The Real Mc Coy,** Salt Lake City, University of Utah Press, 1991

Romano, Mike: **The Politics of Hacking.** In: **Spin,** Volume 11, Number 11, November, 1999

Rushdie, Salman : **The Satanic Verses,** New York: Viking Press, 1988

Said, Edward W.: **Covering Islam: How the Media and the Experts Determine How We See the Rest of the World,** New York: Pantheon, 1981

Sato, Bunsei: **Hijack, 144 Lives in the Balance.** Los Angeles: Gateway Publishers, 1975, (Originally published, in 1974, in Japanese, under the title **Haijakku** (Hijack), by Kodansha (Publishers) Ltd., Tokyo)

Sayle, Murray: **KA007. A Conspiracy of Circumstance** In: **NY Reviews of Books,** April 1985

Scafritz, Jay M. / Gibbons, EF. jr. / Scott, Gregory E.S. : **Almanac of Modern Terrorism** New York, Facts on File, 1991

Schöfbänker, Georg: **From Plato to Nato.** In: Stocker, Gerfried/Schöpf, Christine (eds).: **InfoWar,** Wien / New York, Springer / Ars Electronica '98; 1998; pp. 101-118

Schwartau, Winn: **Information Warfare,** Thunder Mouth Press, 1996

Scotti, Anthony J.: **Executive Safety and International Terrorism. A Guide for Travellers** Englewood Cliffs, New Jersey: Prentice-Hall, 1986

Seale, Patrick: **Abu Nidal: A Gun for Hire,** New York: Random House, 1992

Simon, Jeffrey D.: **The Terrorist Trap, America's experience with terrorism** Bloomington / Indianapolis; Indiana University Press, 1994

Snow, Peter & Phillips, David: **The Arab Hijack War. The True Story of 25 Days in September, 1970,** New York: Ballantine Books, 1970

Sobchack, Vivian: **Child / Alien / Father: Patriarchal Crisis and Generic Exchange** In: Penley, Constance & Lyon, Elisabeth & Spigel, Lynn & Bergstrom, Janet (Eds.): **Close Encounters. Film: Feminism and Science Fiction,** Minneapolis / Oxford: University of Minnesota Press, 1991
—**The Persistence of History. Cinema, Television, and the Modern Event.** London / New York, Routledge, 1996

Spigel, Lynn: **From Domestic Space to Outer Space: The 1960s Fantastic Family Sit-Com.** In: Penley, Constance & Lyon, Elisabeth & Spigel, Lynn & Bergstrom, Janet (Eds.): **Close Encounters. Film: Feminism and Science Fiction** Minneapolis / Oxford: University of Minnesota Press, 1991

St.John, Peter: **Air Piracy, Airport Security & International Terrorism: Winning the War against hijackers,** New York, Quorum Books, 1991

Stein, George J.: **Information Warfare: Words Matter** In: Stocker, Gerfried/Schöpf, Christine (eds).: **InfoWar** Wien / New York, Springer / Ars Electronica '98; 1998; pp. 51-59

Stocker, Gerfried/Schöpf, Christine (eds).: **InfoWar,** Wien / New York, Springer / Ars Electronica '98, 1998

Gary Stollman: **My Father is a Clone.** In: Keith, Jim (Ed.): **Secret and Suppressed, Banned Ideas & Hidden History.** Portland, Feral House, 1993

Taylor, Paul A.: **Hackers. Crime in the Digital Sublime** London / New York: Routledge, 1999

Testrake, John (with David J. Wimbish): **Triumph over Terror on Flight 847** Old Tappan, New Jersey: Fleming H. Revell Company, 1987

Thieme, Richard: **Stalking the UFO Meme.** Internet Underground', November 1996 and In: Kroker, Arthur & Marilouise (Eds.): **Digital Delirium,** New York, St.Martin's Press, 1997; pp. 257-8

Tripician, Joe: **The Official Alien Abductee's Handbook** Kansas City, Andrews and McMeel, 1997

Tyler, Michael: **The missiles that cut down TWA Flight 800** In: **UFO Universe Special**; issue "Conspiracies and Cover-ups" New York, Goodman Media Group, Inc., Summer 1999, pp. 72-73

Vague, Tom: **Televisionaries, The Red Army Faction Story 1963 - 1993** Edinburgh / San Fransisco: AK Press, Vague 26, 1994

Van Tijen, Tjebbe: **Digital Ways of Forgetting: Ars Obliviscendi** In: **Nettime: README!, ASCII Culture and the Revenge of Knowledge** New York: Autonomedia, 1999; pp. 409-416 (http://www.nettime.org)

Vankin, Jonathan & Whalen, John: **The Evil Empire Strikes Back.** In: **The Fifty Greatest Conspiracies of All Time. History's Biggest Mysteries, Coverups, and Cabals**; pp. 274-9, Carol Publishing Group, 1995
—**Pan Am Flight 103**; pp. 280-7. In: **The Fifty Greatest Conspiracies of All Time. History's Biggest Mysteries, Coverups, and Cabals,** Carol Publishing Group, 1995

Verton, Daniel: **Spies turn to high-tech info ops; PCs, Internet used for manipulating images, public opinion.** In: **Federal Computer Week,** May 25, 1998; pp. 39-40

Virilio, Paul: **Devant la Liquidation du Monde: Paul Virilio; Entretien avec Ariel Kyrou et Jean-Yves Barbichon.** In: **Blocnotes #9,** pp. 49-53
—**The Overexposed City.** In: Feher, Michel & Kwinter, Sanford (eds.): **Zone 1/2** New York: Zone Books, 1986
—**Cyberwar, God and Television:** Interview with Paul Virilio by Louise K. Wilson In: Druckrey, Timothy (ed.): **Electronic Culture. Technology and Visual Representation.** New York: Aperture, 1996

Wallis, Rodney: **Combating Air Terrorism,** Washington: Brassey's, 1993

Weiman, Gabriel & Hans-Bernd Brosius: **The Newsworthiness of International Terrorism** Communication Research 18-3 (1991), 333-353

Wilson, Peter Lamborn: **Pirate Utopias, Moorish Corsairs & European Renegades** Brooklyn, New York: Autonomedia, 1995

Yallop, David: **Tracking the Jackal, The search for Carlos, the world's most wanted man.** New York: Random House, 1993

Zaatari, Akram: **The Terrorist's Media. A Strategy in Cultural and Political Resistance** Media Studies Program, The New School for Social Research, fall 1994

Ziegler, Chris: **Hacktivism. The New Digital Resistance.** In: **Punk Planet,** Lumberjack Distribution, Inc., Issue 33 September/October 1999; pp. 66-73